Post-Work

Post-Work

The Wages of Cybernation

edited by
Stanley Aronowitz
and
Jonathan Cutler

Routledge
New York and London

Published in 1998 by
Routledge
29 West 35th Street
New York, NY 10001

Published in Great Britain by
Routledge
11 New Fetter Lane
London EC4P 4EE

Library of Congress Cataloging-in-Publication Data

Post-work : the wages of cybernation / edited by Stanley Aronowitz and
 Jonathan Cutler.
 p. cm.
 Includes bibliographical references and index.
 ISBN 0-415-91782-4 (cloth). — ISBN 0-415-91783-2 (pbk.)
 1. Technological unemployment—United States. 2. Displaced
workers—United States. 3. Occupational retraining—United States.
4. Hours of labor—United States. 5. Labor policy—United States.
I. Aronowitz, Stanley. II. Cutler, Jonathan.
HD6331.2.U5P67 1997
331.13′7042—dc21 97-26548
 CIP

Contents

Quitting Time
An Introduction

Jonathan Cutler and Stanley Aronowitz

Is the labor movement finished? Are predictions
that U.S. unions are destined to represent no more than 5
percent of the U.S. labor force by the year 2000 accurate?
Are recent statistics that show wages and salaries among
non-union workers growing at a faster rate than those of
union workers an anomaly, or do they indicate a long-term or
even permanent reversal of the historic trend of union-driven
income? As this book went to press the Teamsters' smashing
victory against the United Parcel Service (UPS) seemed to
belie such prognostications. For the first time since the con-
cessions movement that followed the 1981 air traffic con-
trollers' debacle, expecially the Teamsters' UPS contract that
established the two-tier system, Organized Labor launched
an offensive to restore the all but lapsed principle of equal
pay for equal work—and won. Needless to say, one victory
does not a rejuvenated labor movement make, even as the
AFL-CIO pledged $10 million a week to supplement the de-
pleted Teamster strike fund. It is too early to tell whether the
encrusted habits of a generation of labor leaders will dissolve
in the sunlight of the UPS strike. Indeed, contrary to con-
ventional wisdom, which holds that unions grow in times of
economic upswing, unions have made no substantial orga-
nizing or bargaining gains in the 1990s even though six years
of this decade have seen sustained economic growth. While

union membership has remained roughly constant, the forty-five-year downward trend in union density (the proportion of union members to the labor force) has not been reversed despite a renewed determination by union leaders and rank-and-file activists to revive the labor movement. In fact, although some unions—notably the Service Employees and the Laborers—sustained aggressive organizing programs in the dismal 1980s, union spending on recruiting is, on the whole, still fairly small in comparison to the funds spent on administering contracts and insurance programs and maintaining union offices. Despite evidence that some efforts to change the proportions between organizing and service are being undertaken, unions still resemble insurance companies more than social movements. The full-time union official typically devotes the lion's share of her/his time to grievances and other membership services.

Nor has the nearly fifteen years of concession bargaining been reversed in any major contract. At best, union negotiators are pleased if they succeed in holding the line against further concessions or in making modest wage gains. For all intents and purposes, collective bargaining remains the religion of the labor movement only as a ritual performance. Almost invariably, workers continue to surrender hard-won protections and have not even made any innovative proposals at the bargaining table, let alone succeeded in winning any of the traditional demands for substantial wage increases and shorter hours.

In sum, economic indicators are no longer reliable predictors of trade union membership growth, workers' bargaining power, or the extension of unionism to hitherto unorganized sectors. For example, labor's decline in all of these areas—and its declining social and political influence—(in 1997 a newly reelected President Clinton did not even choose the AFL-CIO's preferred candidate for Secretary of Labor), seems relatively impervious to the six-year economic upturn. Longer term and deeper causes must be at work in the continuing slide.

Organized labor's fate seems precarious, and yet it is not clear what ails it. The cure, should one exist, will not come without a clear diagnosis of the disease. The central prob-

lem is to identify the *sources of strategic power* which are available to the labor movement. Among these sources none ranks higher than the revival of a militant rank and file prepared to fight against capital's nearly quarter-century assault on labor's postwar gains. For the days when unions as veritable insurance companies were able to negotiate for their members without more than sporadic mobilization, especially around contract time, seem definitely over. In the wake of capital's globalization, which has given employers new weapons against unionized workers such as outsourcing, the runaway shop, the ability to recruit replacement workers for strikers, and a Democratic president willing to use antilabor legislation to delay strikes and weaken unions, union leaders still hesitate to intervene aggressively to protect labor's positions. Many unions have become leadership cabals that, at best, are service providers to individuals and, at worst, self-enclosed bureaucracies. In many instances the union offices and halls are empty of rank-and-file members, except when individuals or groups have specific grievances or, as is the case of many locals in large cities, the union offers services such as legal and benefits assistance, English classes for foreign-born members and their families, or medical clinics. Their capacity and will to mobilize members have been severly tested since President Ronald Reagan's firing of 11,000 air traffic controllers, and both have been found wanting.

Others have suggested that the major ill is that many unions are no longer, if they ever were, democratic organizations. Some unions are downright corrupt. The recent contest between Teamster president Ron Carey and challenger James P. Hoffa, the son of the iconic former leader of the union, was conducted on this issue. The one-term incumbent Carey claimed that during his five years in office he had begun the long journey from Mob control to clean, democratic unionism and accused his opponent of getting into bed with the old-time, corrupt union barons who still controlled many locals and district councils. Hoffa accused the Carey administration of watering down the once feared bargaining power of the union and of arbitarily and undemocratically taking over allegedly corrupt union locals. He promised to

restore the union to its once militant and powerful position. In an election in which half the union's 1.2 million members voted, Carey won the election by a slim, 16,000-vote majority. In the end, Hoffa's message got through to nearly half the voters, many of whom remained unimpressed by Carey's anti-corruption message; they evaluated union performance by its shop-floor and organizing record and found it wanting. Ironically, labor insiders credit Carey's support with the victory of John Sweeney's insurgent slate for AFL-CIO leadership, which promised to reverse the years of labor's decline by aggressive organizing and political action. However, in his first five-year term the Teamsters were consumed by internal reform, did their share of concession bargaining, and did not display the old vaunted power that once sent tremors through employers' hearts. That power, we may add, was wielded by a string of leaders whose ties to the Mob and other traditional sources of union corruption were legendary. Jimmy Hoffa, father of the recent challenger, might have had questionable morality but, in terms of militancy, he compared favorably with most clean leaders.

But while blatant corruption can be shown to be a problem confined to fairly few industries, most of which are associated with services where the Mob has as much power among employers as unions, some observers focus on a problem whose symptoms may be described as a different type of corruption: labor oligarchy. This view stresses the power of the relatively honest labor bureaucracy over union affairs; local unions, the closest institutions to the rank and file, are typically subordinated to the control of international unions who have centralized many, if not most, union functions. In contrast to the highly visible, membership-based vote for top officials in the Teamsters, the vast majority of national union leaders are elected by indirect means, by delegates to a convention rather than by the rank and file. (In fact, the direct election in the Teamsters Union was the result of a court order rather than by a provision of the union's constitution or bylaws.) Perhaps more to the point, most unions at all levels are typically administered by full-time officials who, with some exceptions, tend to regard the membership as a collective client which needs to be con-

trolled lest the economic and political position of the union be undermined by rank-and-file recalcitrance. The formation of a permanent labor bureaucracy becomes, in this view, the sufficient explanation for poor organizing performance, the demobilization of the rank and file in the wake of the corporate offensive against labor's historical gains and the palapable unpopularity of organized labor among the general population, a deficit which inhibits labor's chances to convince Congress and the state legislatures to enact its programs and also inhibits building public support for strikes and organizing campaigns. Plainly, if the rank and file is disempowered by undemocratic union practices, they are not likely to respond favorably to eleventh-hour appeals by leaders they have come to distrust if not despise.

Another explanation for labor's decline points to the prevailing unfavorable economic, political, and cultural climate that has afflicted working people for the last quarter-century. Accordingly, labor is held *virtually* blameless for its shrinking membership and declining power. The main culprits, in this view, are the transnational corporations and the emergent global economy they control. Transnational capital has surely placed labor in competition with itself on a world scale, but labor movements remain largely imprisoned by national borders and parochial politics and culture. This mode of explanation talks eloquently of the runaway shop, of labor-destroying technologies, the reemergence of those nineteenth- and early twentieth-century practices of child labor and homework, of a labor-relations law that works overtime to restrict Labor's ability to organize and, in the main, has reduced collective bargaining to trench warfare. It explains union acquiescence to employer demands for "cooperation" by the threat that if they don't go along they will lose everything. Advocates of this view remind us of the Taft-Hartley amendments to the labor relations law, especially the provisions that permit employers to replace strikers with non-union workers, enable employers to procure court injunctions against mass picketing, and impose huge fines against unions that sanction strikes during the life of contracts (almost all of which contain a strike prohibition). But it can be shown that unions have chosen to

work within adverse labor relations laws because they have determined a bad law is better than none. Having no law would subject unions to the prevailing laws of capitalism: competition and the marketplace. Unions would be required to *strike* for higher wages, shorter hours, and other benefits. And for many union leaders, especially in the public sector (now a major segment of the American labor movement), the strike weapon has been virtually renounced in return for collective bargaining. Perhaps collective bargaining and labor relations laws were a Faustian bargain. This bargain may help explain why unions have been reluctant to challenge their political allies to enact labor law reform, much less choose confrontational tactics to advance labor's demands.

For some time, social movement theorists have identified the *mobilization of resources* as the key to movement success (see especially Shorter and Tilly 1974; Tilly 1978; Zald and McCarthy 1987). There are generic problems associated with the resource mobilization perspective. For example, while there is almost certainly some correlation between resource accumulation, institutionalization, and bureaucratization, on the one hand, and movement power, on the other, it is not clear whether resource mobilization is a cause or an effect (McAdam 1983). It may well be that resources, institutional forms, and bureaucracies tend to *follow* the scent of movement energy rather than *providing* the gas necessary for its combustion.[1] Nevertheless, while a lack of resources may well plague the spirits of many activists,[2] this cannot be said of those in the labor movement. Machiavelli, if asked by the Princes of the labor movement for strategic advice, would be laughed out of the royal court for suggesting that a failure to effectively *mobilize resources* was the root of labor's troubles.

The labor movement has been in a serious crisis for some time now, unable to win significant victories. And yet, the problem simply *cannot* be said to be attributable to a lack of means. There is no shortage of institutionalization within the contemporary labor movement. The instrument, that is to say the bureaucracy, has been called many things, but underdeveloped is not one of them. The appearance of this

fissure between feats of resource mobilization and defeats of movement power is entirely unexpected, not simply from the perspective of the theorists of resource mobilization, but from the perspective of contemporary witnesses present at the birth of the postwar labor movement (Mills 1948). And yet, during the period immediately after World War II, when Big Labor was at the zenith of its institutional intensity and the crest of its resource riches, it faced some of its most infamous upsets.[3] Some labor historians today are in a mad rush backward in time, each uncovering significant losses that, they argue, were actually the beginning of the end for the postwar labor movement. Each historian fixes the first moment of decline closer and closer to the birth. And yet, in so doing, *none* of these historians have ever thought of attributing the decline to a lack of resources.[4]

The importance of resource mobilization (especially in terms of fiscal resources) must be considered alongside other movement factors. As Klandermans (1984) argued, this involves a shift in the notion of what constitutes a resource, and most of the redefinition has been toward cultural and ideological resources as strategically significant variables.[5] It may prove critical to understanding the fate of social movement for analysts to understand the way a movement strategically frames its *constituencies, grievances, plans, expectations,* and *visions.* Indeed, more recent emphasis within social movement literature has been to appreciate the importance of "framing" and discourse, and this is surely a salutary development for anyone wishing to understand the fate of the labor movement (for discussions of "framing" which consider cases from labor history, see Babb 1996; Clemens 1996; Klandermans 1984; Voss 1993; Voss 1996).

The significant theoretic innovation is not based in the "discovery" that the ideational realm is "socially constructed." The point of emphasizing the existence of strategic logics is not to argue that these are "automatic" logics, but to notice *how many* different logics are always "available" to the labor movement and *how influential* these logics can be on the fate of the labor movement. Some are clearly more sustainable than others. Our task, then, is to elaborate some of the significant logics available from

within the repertoire of labor history. We are particularly
interested in their sustainability.[6] One analytic tool which
may be helpful in mapping the various strategic logics of
the labor movement is to look at labor movement strategies
as efforts to achieve power by creating a "tightness" be-
tween the supply of their labor and the demand for it on the
market.[7] As Marx noted, such market tightness dramatically
and decisively strengthens labor and its *pretensions*, while
the existence of a large supply of labor in excess of the de-
mand for labor undermines labor's power (Marx 1976,
792).[8] Labor's power derives from the inability of employers
to replace pretentious workers with workers willing to settle
for less. It is possible, based on this labor market model, to
begin to identify a few of the multiplicity of strategic logics
available to the labor movement in its attempts to keep
labor markets tight. The labor market model immediately
opens up two distinct strategic pathways: increasing the de-
mand for labor and/or diminishing its supply. The former is
associated with the corporatist tradition of the labor move-
ment while the latter path is associated with the syndicalist
tradition.

The trade union emerged as a syndicalist effort to dimin-
ish the supply of labor on the market by exploiting the skill
requirements common to many pre-industrial labor pro-
cesses. The labor process, and its basis in skilled work, did
not create craft unions. The demand for skill simply divided
the labor market *analytically* and implied no necessary flow
of power relations. The demand for skilled labor does not,
in itself, determine the supply of skilled labor, nor does it
mean that all skilled laborers are powerfully positioned
within the labor market. The labor market respects supply
and demand, not skill; a market flooded with skilled work-
ers is no different—in terms of power flows in market rela-
tions—than a market flooded with unskilled workers, even
if production is dependent on skilled labor (Tilly 1988).[9] To
the degree that there is a greater supply of skilled labor than
demand for it, so too, to this degree are skilled workers
likely to enter into a bidding war which devolves toward
desperation and despair. One way of limiting the supply of
laborers delivered to the labor market is to *mark* a piece of

the job market—the sub-set of the market which depends on skilled workers—and restrict access to skills required for these jobs.

This is the basis of the craft union movement. Members of a trade union then are able to *trade* on their skills from a strong bargaining position. One central question, then, for *all* movements seeking to accomplish this form of restriction is how to *mark* a portion of the population "deserving" of access, and how to keep the rest of the population from acquiring these skills. The establishment of the "training apparatus" itself is not the difficult political struggle. Rather, the question becomes one of negotiating *who* will learn the skills, and *who will be excluded* from learning skills. The problem, to borrow a phrase from Benedict Anderson, is the creation of "imagined communities" or *the creation of identities and exclusions* which keep the skilled labor supply limited (Anderson 1983; Mink 1986). Who will become an apprentice? Who will be excluded from learning these "secret" skills? While exclusions are *essential* to this process, and not merely epiphenomenal, the power of those who have become skilled remains a consequence of the ratio of demand for skilled labor to the supply of skilled labor, and not the ratio of skilled labor to unskilled labor. Nevertheless, exclusivity remains absolutely and permanently essential to the logic of the "craft." To *criticize* the tendency of the old craft unions for their failure to "organize the unorganized" is either to completely misunderstand the logic of craft unionism or to call for its abolition. The constituency of a craft labor movement must be *exclusive*. For the movement *in general* it does not matter *which* criteria are used for selection, so long as the criteria are differential; and it doesn't matter *who* is excluded, so long as the labor market proportions are right when it is all over.

Of course, the great weaknesses of this strategy are now well known, especially to employers. The first threat to skill-based power is the difficulty, for those members already inside a craft-based labor movement, of maintaining exclusive control of the "secrets" of the craft. Knowledge is notoriously troublesome as private property because, unlike other properties, it is not lost by an owner when seized by a

thief.[10] By acquiring knowledge and skill without the consent of the trade union, the excluded can effectively undermine the basis of their exclusion. Similarly, struggles for "open admissions" to the institutions which control labor market skills are struggles for the end of skill as a strategic logic of exclusion within the labor movement. The other great vulnerability of a craft labor movement is the success of employers in their struggles to de-skill the labor process (Braverman 1974; Montgomery 1979). This is undertaken by employers to destroy their dependence on the exclusive sub-set of skilled workers and therefore to be able draw on the larger, and presumably unfettered, supply of labor provided by the larger population.

While skill served as the analytic basis for the strategy of exclusion behind craft unionism, the logic of labor market exclusion may transcend skill. Any differential mechanism of exclusion can potentially be used to reduce the supply of laborers to the labor market or to a niche within the labor market. This strategy, accomplished with more or less success in term of sustainability, depends in large measure on the ability of the *imagined community* to capture the imagination of the community at large. It does not depend on skill; skill can drop out altogether. Indeed, the list of identities which have been, or continue to be, invoked as restrictive criteria is astonishingly long. However, it is worth identifying some of the major (and often overlapping) "imagined communities." Almost all of these identity-based exclusions have been adopted as strategic logics, at one time or another, within the major American craft unions and the American Federation of Labor (AFL) as a whole. Many continue to serve as effective ideological strategies in other institutional settings, and quite a few survive without any of the resources mobilized by *formal* institutional backing. Skilled craftsmen have mobilized as groups against those outside the membership (Fraser 1991; Yellowitz 1977). Age has served as the basis for solidarities of exclusion in several ways. Within particular firms, senior workers have imagined themselves as a worthy community with labor market primacy in relation to newer workers (Lichtenstein 1988). In the larger labor market, "middle-aged" workers have been "empowered" through the with-

drawal of elder workers (retirement) and child laborers (Graebner 1980; Nasaw 1985). "Whiteness" and the ideology of its supremacy has functioned extremely well to justify the exclusion of people "of color" (Roediger 1991). National, ethnic, and religious identities have been remarkably successful as the basis for excluding other national identities (Mink 1986). Moreover, the long and continuing history of efforts by men to keep women from supplying labor to the labor market falls within the category of labor movement efforts at market tightening (Gabin 1991).[11] All of these strategies can survive only so long as the excluded do not effectively contest their exclusion. Exclusions from particular sectors of the labor market usually imply lower subsistence levels relative to those who work in such sectors. However, exclusions from the labor market do not necessarily translate into exclusions from subsistence altogether; this would be altogether unsustainable.[12] The logic behind the exclusion of women and children from the labor market has always implied that the family was the most fundamental unit of income sharing and labor supply regulation. However, not only did this create well-known difficulties for orphans, but it also *bound* women and children to the family, and to a man whose market bargaining position was the sole source of market power. Indeed, the problem of being *excluded from sacrificing years of life in return for a wage* would seem to be no problem at all, were it not for this dangerous *binding* involved.

The problems associated with the exclusivity of craft unionism, and more generally, of divisiveness within the working class, were quite familiar to many observers of the early craft union tradition. What is the basis of an alternative logic? It must be noted, first of all, that the *interest* in "industrial unionism" and the fate of the excluded, relatively powerless segments of the working class has been enormous. We would argue that this has been due less to the arrival of a clear alternative logic than to enormous waves of anxiety arising from the many historic failures of the craft union logic and other forms of exclusivism to effectively come to terms with the excluded masses of the population, including immigrants, the unskilled, the unemployed, the elderly, the national, ethnic, and religious

subaltern, women, and children. Those committed to moral crusades on behalf of the subaltern and those committed to leading "revolutions" among the industrial working class have been passionately *interested in and committed to* these constituencies. Moreover, significant numbers of those whose exclusive labor market positions look increasingly threatened by these constituencies have been committed to finding ways of avoiding a swift decline into indigence (Hanagan 1988). The Knights of Labor and the Congress of Industrial Organizations (CIO), for example, were both efforts by such concerned craft unionists, looking for a new strategic logic.

So what else is there? Plenty of actual industrial unionism, but with surprisingly little articulation of a clear strategic logic. In the early years of industrial unionism, it may have seemed like nit-picking to notice this; a bit like asking, "O.K., it works in practice, but does it work in theory?" However, it must be noted that the rise of industrial unionism, and particularly the successes of the CIO, occurred during years of extraordinary turmoil. Significantly, the inspiration for industrial unionism emerged from economic crisis and war (especially World War I and the Depression), but its power was not realized until the beginning of the largest wartime mobilization in history (Fraser 1991; Lichtenstein 1982).

Depression-era industrial unionism, especially during the early months of 1937, may have at first been based less on a labor market strategy than on a strategy of workplace action, combined with the threat of violence, during a capitalist crisis of popular legitimation. One might argue that the famous sit-down strikes represent an actual incipient strategic logic. This logic was not based on a labor market strategy but, instead, on the enhanced workplace costs which workers could impose on business in industries with high fixed capital investments (Tilly 1988). In fact it might be argued that the factory occupations were *alternatives* to a labor market strategy. Since relatively unskilled industrial workers are easily replaced, their power resides in preventing similarly deskilled or unskilled labor from replacing them, which under conditions of a surfeit of unemployed labor was best achieved not by

picketing or otherwise withholding their labor but by seizing the production site. Any work stoppage is immediately more costly to capital-intensive industries. The occupation of facilities during the sit-down strikes dramatically increased the threat to investments, as workers held the plant itself hostage. These seizures depended, in turn, on the often-noted unwillingness of political elites to protect GM property by storming plants and risking violent confrontation during a period of general economic and political crisis (Fine 1969; Kraus 1985). However, sit-down tactics never emerged as an actual strategic tendency. By all accounts, postwar industrial unionism marked a decline in the role of workplace-based strategies for preserving power. In the capital-intensive industries employers sought to prevent any kind of work stoppage that might destroy machinery. Rather, extended no-strike pledges during long contract periods signified a strategy of labor-management cooperation (Lichtenstein 1995). Moreover, it is questionable whether the drama of the sit-down strike was a sustainable strategic source of power so much as it was an expression of power. The basis of this power was not in a strategic logic, but in the mid-Depression rise in production, employment, and labor market tightness. In the economic downturn which followed the sit-downs in 1937, the industrial unions, left with no autonomous strategy apart from exogenously determined labor market conditions, faced a crisis of confidence and power.

Industrial unionism ultimately found success in a tight labor market created not by a relative withdrawal of labor supply, but a dramatic increase in the demand for labor brought on by the needs of wartime production. In this context, workers were willing to fight for the satisfaction of many different demands, and the resolution of many grievances. The pretension of the rank-and-file industrial workers was enormous, with relatively unskilled production workers participating in wildcat strikes over a range of grievances and demands, large and small. The first round of postwar collective bargaining was the occasion for the largest strike wave in American history, as workers threw off the burdens of wartime sacrifice and exercised their labor market power in a climate of heightened labor demand.

Workers knew the power of the hand they were dealt, and they played their cards enthusiastically (Glaberman 1980).

It is only at this time that men like Sidney Hillman, one of the leading ideologues of industrial unionism, emerged as C. Wright Mills's (1948) New Men of Power. But ironically, these labor leaders became important to industry leaders, politicians, and the military at this time precisely because the rank and file had begun to use its new power, created by wartime production. When Sidney Hillman addressed himself to questions of labor supply, he did so during a time of labor shortage. Moreover, his concern was to *facilitate* widespread training and manpower development *against* the protests of the trade unions (Fraser 1991). From this perspective, the strategic logic of industrial unionism was for the enhancement of the prestige, as responsible labor statesmen, of leaders like Hillman, Murray, and Reuther who committed themselves to the effort of taming the labor market pretensions of the rank and file.

As the war came to an end, Walter Reuther, the innovator and acknowledged strategic leader of the postwar industrial union movement, came out strongly in support of the job-creation strategies which comprise the corporatist strategic logic of increased demand for labor. In the wartime boom, industrial unionists had learned the benefits of tight labor markets based on elevated demand. They would spend the postwar decades trying desperately to recreate these heady days of labor's power and prestige. One such effort has been based on the idea, promoted vigorously by economist and official in the Truman administration Leon Keyeserling, that the *government* should be the employer of last resort or that, in a more Keynesian mode, government purchasing of goods and services should be used to enhance consumption, then production, and finally, labor demand. In practice this has meant that the industrial labor movement becomes ideologically committed to promoting the benefits of government spending (and thus, either borrowing or taxing) on "public" goods, the production of which would not compete with private sector industries (and, more to the point, private sector jobs). Accordingly, in the logic of this Keynesian strategy, industrial unions would

be indifferent to the actually nature of the "goods" to be produced. At UAW conventions after the war, Reuther spoke frequently of the need for the government to increase spending on housing, schools, highways, etc. His many pronouncements to this effect aligned him, in the public mind, with the idea that industrial unionism meant not simply tight labor markets, but also "social unionism" based on concerns for the well-being of the entire working class (Lichtenstein 1995).

It is strange, then, that Reuther did not also become more clearly associated in the public mind with a tradition of "war unionism." For Reuther considered the maximization of defense spending, throughout the Cold War, to be a critical strategic tool for maintaining the labor market power of unskilled production workers (Lichtenstein 1995).[13] Finally, Reuther considered it strategically worthwhile to try to help maintain job demand by helping the company with its business. This included several strategies, some of which again earned him a reputation as one committed to a radical extension of the union mission, from an allegedly narrow business unionism to a vision, borrowed from the postwar German labor movement, of labor-management co-determination. In practice, this meant that Reuther was frequently found requesting (but rarely establishing) joint labor-management committees for consideration of a large number of production considerations. Co-determination also meant a pledge to help strengthen markets for products, both domestically and abroad. Finally, it meant a controversial series of long-term no-strike pledges, "company security" clauses, and bargaining demands based on a company's ability to pay. Ultimately, the strategy of industrial unionism became a strategy of caution. Its mission was to cooperate enough to avoid killing the goose that laid the golden egg. As the years passed, companies found themselves in crisis with accelerated frequency, and with each new wage round industrial unionism devolved into concession bargaining, as unemployment hit postwar highs and left industrial unionists without a strategy, unable to achieve strength through increased demand for labor (Moody 1988; Preis 1964).

Moreover, the dream of the industrial unionists, to move beyond the exclusivist tradition in order to embrace the broader working class, met with limited success. Of course, the strategy of union membership shifted from craft logic of strength through restricting membership to an industrial logic of "wall-to-wall" organizing, where union size was a source of prestige. Membership did rise (Galenson 1960). However, membership was not itself a guarantee of market power within the strategic logic of industrial unionism. Rather, within industrial unionism, worker interest in joining unions—which has consistently remained strong—signifies a *will* to power on the part of workers, not a strategy for achieving power.

Membership reached its peak in 1953, and the industrial union movement in the United States never extended beyond the core industries, representing about 34 percent of the workforce during its most successful postwar years (Goldfield 1987). As that percentage stabilized and began to decline, many of the old divisions resurfaced, including significant rebellions of skilled workers within industrial unions and increased emphasis on seniority. Seniority itself operated at the expense of those marginal production workers which the industrial union movement was intended to serve (Lichtenstein 1995). Racial solidarity, always tenuous, deteriorated in many cases, although unionization among blacks and women remains quite strong, especially in the public sector where the corporatist, job-creating efforts were most successful (Aronowitz 1983; Goldfield 1995). As industrial union members, especially in large scale and defense-related industries, came to look increasingly like a labor aristocracy themselves, frequently earning wages several times higher than other area workers, popular support for strikes was undermined. In major industrial disputes, union members were frequently thwarted by the resentment of their own less-fortunate neighbors who—shorn of all pretension and pride—were now willing to undermine the union by becoming strike breakers and replacement workers. Such activities are, as noted from the start of this discussion, the fruit of slack labor markets.[14] So is that it? Is the labor movement left without a viable strategy for labor

market strength? Perhaps not. There is one crucial strategy which has been lost in the logic of industrial unionism: the shorter hours movement.

The shorter hours movement—including the traditional fight for a shorter workday, a shorter workweek, and the struggle against speedups[15]—certainly falls within the category of a syndicalist logic of reducing the supply of labor. But its strategic logic is unique in several respects. The logic of solidarity at the heart of the shorter hours movement consists in its maintenance of tight labor markets through the withdrawal of a *portion* of the supply of labor provided by *each person*, rather than through the withdrawal of the *entire* supply of labor provided by a portion of the population of workers. This withdrawal avoids the establishment of exclusivist cleavages within the population, while accomplishing the reduction in labor supply necessary to tighten labor markets.

The shorter hours movement does have a history. Indeed, as an alternative tradition within the syndicalist strategic perspective, the fate of the shorter hours movement sheds a surprising light on conventional assumptions in American labor history. As a bargaining demand, the topic of shorter hours has arisen in diverse camps throughout the last 160 years (Hunnicutt 1988). Moral reformers and progressives have opposed "excessive" hours as unhealthy, promoting a "normal" workday in order to prevent illness and death from exhaustion. Some communitarians and Jeffersonian democrats have been advocates for family life and political life, respectively, as uplifting alternatives to work life. Conversely, some libertarians and anarchists have seen liberation from the regulated and routinized life of work as the necessary condition for emergence of freedom and the possibilities of diversity, and perversity, in everyday life.

However, within the labor movement itself, the shorter hours movement existed, not simply as a bargaining demand, but as a profound strategy for developing bargaining power. Indeed, throughout the history of the AFL, the movement for shorter hours—while not *overcoming* the AFL's exclusivist strategies—was the only serious alternative to the exclusivist strategic logics of craft unionism,

nativism, racism, sexism, etc. The leaders of the AFL were strikingly aware of the logic of solidarity that forms the basis of the shorter hours movement (Roediger and Foner 1989). Under the influence of thinkers like Ira Stewart and George McNeill, Samuel Gompers (president of the AFL) became convinced of the logic of the strategy. Indeed, Gompers declared, "According to my own understanding, the eight-hour day was a revolutionary force that altered all the workers' relations, both industrial and social, and raised standards of living and work" (Gompers 1925). Moreover, the infinite applicability of the strategy was also clear. In 1887 Gompers argued, "As long as we have one person seeking work who cannot find it, the hours of work are too long." The movement became one of the most significant elements of AFL strategy and, significantly, had all the appearances of a vital social movement, including rallies, pamphlets, parades, marches, and strikes (Roediger and Foner 1989; Rosenzweig 1983). The logic was clearly articulated by George McNeill in 1888.

> Men [sic] who are compelled to sell their labor, very naturally desire to sell the smallest portion of their time for the largest possible price. They are merchants of their time. It is their only available capital. They feel that, if they flood the market,—that is, sell more hours of labor than the market requires,—stagnation will follow.

> The growth of the population, greatly enhanced by artificially stimulated emigration from the long-hour and cheap-labor countries of Europe, tends to crowd the streets with unemployed men. Men out of work will underbid the men at work, and so wages are affected and sometimes governed, not be the value of the service rendered in time or skill, but by the number of the unemployed.

> The instincts of the wage-workers are wiser than the philosophy of the schools. The demand for less hours of labor for the employed means more hours of work for the now unemployed. It is the demand for a better

distribution of work, as well as a demand for an in-
crease value on each hour's service (McNeill 1887).

The shorter hour movement contested the exclusivist logic
of syndicalism as the primary labor strategy within the AFL.
The AFL was at its best when it was associated with the
movement, and Gompers was himself aware that the pres-
tige of the AFL was enhanced through its association with
the popular movement. The fight was also largely success-
ful, with the reduction of the standard workday to ten hours,
then eight, and with the introduction of the forty-hour
week. The AFL had begun taking bold steps toward the
thirty-hour week during the early years of the Depression.
William Green, then president of the AFL, was never more
bold than when he declared that the AFL was prepared, if
need be, to lead a general strike in favor of the thirty-hour
week (Roediger and Foner 1989). But the AFL record of
success in its prior efforts was not matched by its experi-
ence with the thirty-hour fight. What changed? Industrial
unionism had emerged on the scene with its new, compet-
ing logic of corporatism. A united labor movement had been
victorious in its struggles for a shorter workday. But a di-
vided movement, with the hesitant logic of job creation and
labor-management cooperation at the heart of industrial
unionism, could not triumph. Hillman opposed the AFL-led
thirty-hour fight, as did Reuther throughout the postwar era
(Fraser 1991; Lichtenstein 1985). While the movement for
the shorter workweek continued to have resonance with
much of the rank and file, proving to be one of the few is-
sues which gave Reuther factional trouble within the United
Automobile Workers (UAW) after his consolidation of power
in 1947, it has been largely ignored in the afterglow of post-
war industrial union power (Preis 1964).
But the logic remains as strategically sustainable today as
ever. In the wake of the corporatist logic of industrial union-
ism, the shorter hours movement stands out as a neglected
strategy, even as neo-exclusivist strategies become more
prevalent. The object is not to tighten a portion of the mar-
ket or tighten the entire market for a portion of the popula-
tion. Rather, the aim is the tightening of the entire market

for everyone, without necessary regard to skill or identity. The aim is not to imagine communities, but to imagine *increased bargaining power through progressive freedom from work*. The strategic logic becomes particularly clear when the struggle for shorter hours is related to old social movement problems about selective incentives and the logic of collective action (Olson 1965; Gamson 1990). The logic of the shorter hours movement is based upon a win-win strategy, which significantly overcomes the free-rider problem. The old incentive debate within social movement theory is usually understood as a conflict between the partial, self-interested, embodied desires of a single actor, on the one hand, and on the other hand, the need for those interests to be *transcended*, if not sacrificed, to the interests of the collective good. Thus, the development of collective identity and collective sanctions—like shame and moral scorn—are frequently seen as a precondition necessary for the overcoming of "individualism" toward a culture of solidarity and self-sacrifice (Gamson 1990). Indeed, these are common themes within movements for social change.

However, no necessary conflict of this kind emerges within the struggle for shorter hours. At the heart of this movement is a "selective incentive": less work. Indeed, the demand for less work is unique within our discussion precisely because it is *simultaneously a means to power and a demand of those who have it*. The point is not that "free time" is always necessarily the top demand of workers with the power to make demands. Higher pay, safer working conditions, and so on, are enormously important to workers. Indeed, in our discussion of strategic logics, we have been hitherto concerned primarily with bargaining positions, not bargaining demands. But the demand for better lighting at work, for example, is different from the demand for less work in that better lighting does not help position workers to make other demands. There is no strategic pathway from better lighting to higher pay or less work. But there is a clear *strategic logic* which leads from less work to higher pay, better lighting, and *even less* work. No other bargaining demand simultaneously enhances bargaining position.

Furthermore, no other strategic logic initiates a continuous virtuous cycle in which each victory establishes the conditions for strength in the next struggle. Craft unionism is defeated by the effective struggles of capital to de-skill the labor process. Luddite attempts to maintain skill-based labor processes may meet with some successes, but they represent an uphill battle on a steep incline. Industrial unionism is weakened by its own dependence on capital's increasingly feeble commitment to a "job pact." Rather than preserving jobs, capitalists have struggled in the postwar era to break union pretensions through the introduction of labor-saving (thus, job-destroying) technologies.

In contrast to the difficulties of craft and industrial unions, the movement for shorter hours does not anticipate or depend upon a corporatist truce in the dynamics of class struggle. It is has no need to fear its own victories, nor be cautious in its approach. The strategic logic of the shorter hours movement is capable of anticipating and ongoing progressive and dynamic struggle. In this struggle, shorter hours tighten labor markets. Tight labor markets drive up labor costs. High labor costs generate capitalist efforts to reduce labor costs through automation, computerization, and work reorganization. Further reduction in hours further tightens labor markets. On and on it may go.

With a strategic logic capable of embracing the entire working class and a sustainability capable of responding to capitalist offenses, the shorter hours movement is strategically capable of sustained industrial class struggle in ways that the revolutionary socialist tradition, for example, has never imagined. The strategic logic of the shorter hours movement does not aim to end class struggle or create of a world in which labor rules itself. Rather, it is a movement to persist and prosper through class struggle, as its dynamic yields a harvest of opulence and ease through the progressive struggle for the liberation from work itself.

Some of the essays that follow were first presented at a conference titled "The Wages of Cybernation" sponsored by the Center for Cultural Studies at the Graduate Center of the City University of New York. Others have been written

expressly for this volume. The conference itself would not have been possible without the efforts and support of Mae Ngai, Joe McDermott, Kristin Lawler, Mike Roberts, and Mark Halling.

The essays in this book are directed to helping us to better understand the nature of various economic and political changes underway, their consequences, and what labor and other social movements might do about them.

After this introduction, "The Post-Work Manifesto" leads the volume with a critique of contemporary economic trends and a call to action. The manifesto concludes with a program that may infuse many social movements as we edge toward the millenium. Michael Lewis, William Di-Fazio, and Lynn Chancer discuss poverty, welfare policy and the guaranteed income. Lewis argues for income as a moral right; based on years of work in a Bedford-Stuyvestant soup kitchen, DiFazio's long ethnographic and theoretical study of poverty helps explain why there is no movement of the poor in America; and Chancer's essay is an extended analysis of guaranteed income proposals that have from time to time engaged social policy. Lois Weiner discusses the education to work controversy; Stanley Aronowitz asks why the professoriat is under attack and tenure has become a target of university administrations. Joan Greenbaum, whose work on computerization has attracted worldwide attention, explores one of the crucial aspects of the current economic debate, the impact of computers in the white-collar workplace. The final two essays reflect an attempt, initiated by the organizers of the "Wages of Cybernation" conference, to fuse the discourses of political economy and cultural radicalism. In his essay, Andrew Parker argues that it is impossible to bridge the divide which separates these two discourses without first challenging the cultural productivism and workerism of the Marxist left. Social and cultural critic Ellen Willis contributes a piece on the logic of austerity in an effort to understand how cultural conservativism and economic austerity are mutually reinforcing. If worktime is simultaneously a locus of capitalist exploitation *and* cultural discipline, then it is definitely *quitting time*.

Notes

1. When such *forms*—which are themselves quite inevitable— do have effects, these relate less to force and direction, than to velocity. Form is the coagulation of soul, and as such is *essentially slow and, literally, conservative.* That this process is a matter of *constraint* is always clearest during the emergence and growth of new movements. The conservative essence of form becomes less clear during periods of movement decline because the sheer viscosity of bureaucracy may *slow the pace of decline* and thus appear, to movement supporters, as a source of salvation. This misrecognition is prevalent today among many observers of the labor movement and its bureaucracy.

2. One is constantly being reminded by frustrated activists that their losses result from being "outgunned" by opponents. The "facts" of resource inequality may be indisputable, but the explanation for this remains underdeveloped.

3. Especially the enactment of the Taft-Hartley Act by the 78th Congress and the failure of "Operation Dixie" to effectively challenge the anti-union South. See Goldfield (1995), Griffith (1988), and Lichtenstein (1995).

4. See especially Aronowitz (1973, 1983), Davis (1986), Fraser (1989), Goldfield (1987), Goldfield (1995), Montgomery (1979), and Moody (1988).

5. Ironically Klandermans's now-classic essay (one of the first to shift the emphasis toward ideational considerations) is actually a case study of a major Dutch strike for a shorter workweek. However, Klandermans does not explore the importance of the introduction of this union strategy, relative to others. Rather, he is interested in the effects that expectations of success have on success. But even this is ironic since the key exogenous factor which dampens expectations of success is the failure of a German strike over the same issue. But the German strike in question marked not only the introduction of the shorter workweek as a major demand within the German labor movement, it was also considered the first major break with the postwar tradition of industrial cooperation and the most significant postwar return to class

struggle in Germany. Klandermans does not concern himself with the reasons for the German failure. However, this might be a fascinating area for follow-up, especially since the next major German effort toward a shorter workweek met with considerable success. Enthusiasm for the movement quickly spread across Europe (*The Economist*, February 11, 1984; *The Economist*, December 21, 1985). Also, see Blyton (1992) and Bosch, et al. (1993).

6. Not all of these strategic logics take the traditional forms of collective action most common to social movement analysis (e.g., riots, marches, strikes, demonstrations), but they should be considered for their substantive importance, rather than the form of their appearance. Similarly, not every traditional demonstration can be considered a strategic logic for *gaining power*. Sometimes such "events" are simply *demonstrations of power*—achieved through a potentially unrelated strategic logic—by those who have already acquired the power necessary for achieving a particular goal. For the argument that strikes may well be an instance of workers using power that they have previously acquired, see Shorter and Tilly (1974).

7. The use of the market as a category in no way implies that there are "natural" forces at play, removed from historically indeterminate power struggles. On the contrary, the labor market is the *site* of some extremely contentious and often violent power struggles. Moreover, its composition is the result, almost exclusively, of social movement effects. To speak of the labor market is always to speak of social relations.

 Also, it should be clear that consideration of labor market tightness and the use of a labor market model is a tool of analysis and not a tool *of movement*. It is doubtful that workers will gain power marching under the banner, "Markets of the World, Be Tight!"

8. The particular power in question is based on a labor monopoly which can extract "rent" in various forms, including but not limited to wages. This rent has no necessary upper boundary. However, wages and working conditions do have a lower floor if some kind of labor activity is to be extracted from humans: the caloric flow of energy through the worker which enables bodily activity to continue. This is a constraint

on the use of human labor for the production of commodities and it transcends market relations.

9. The use of the term unskilled simply refers to the fact that a large proportion of production jobs could be learned in very little time.

10. Parenthetically, there is absolutely no reason to restrict the discussion of this strategic logic to *trade union* apprenticeships. Many such guilds function *effectively* for members in labor market relations without the actual "union" label. Such guilds are now simply called professions, and their training facilities are known as universities. Access to their apprenticeships are tightly controlled—with more or less success, depending on the same factors facing any other craft union. Access is controlled by "admissions officers" whose sole purpose is the exclusion and restriction of candidates. While relative merit is one criterion (it is only *relative* merit that could ever serve; the logic is purely *differential*, not substantive, regardless of it the particular criteria) used for selection, some traditional craft union selection criteria—especially "family legacy"—remain in play. Some of these guilds—especially medicine—are being undermined in all the same ways that other craft unions have been undermined. However, with the members of all such professions properly categorized for what they are, it would be fair to say that the death of the American craft union tradition has been greatly exaggerated.

11. None of these traditions of exclusion are presumed to be *caused or maintained* by the labor movement alone. The desire for "identity" and for membership in a community is not necessarily an effect of labor market strategies. However, there *is* a strategic logic which would lead a labor movement to support such exclusions. Therefore it is particularly confusing when observers are surprised by the record of the union movement with regard to struggles around issues of race, gender, immigration, etc.

 Also, the mere fact that a strategic logic exists does not mean that it is sustainable over time. Nor is a strategy necessarily moral.

12. Although, given the number of people who starve in the world, it is not unsustainable enough.

13. This is most apparent in Reuther's remarks from a January 1952 UAW conference called to discuss unemployment and the Korean War. "Official Proceedings: National Emergency Conference on Problems of Unemployment" in folder 3, box 250, Walter P. Reuther Collection, Wayne State University Labor Archives.

14. See the excellent series of articles by Barry Bearak describing the failure of the UAW strike against Caterpillar. *Los Angeles Times*, May 14–18, 1995 and December 4–5, 1995.

15. A stretch-out is simply a speed-up calculated on a daily, rather than hourly, basis. The issue in either case is effort per unit of time.

References

Anderson, Benedict (1983) *Imagined Communities: Reflections on the Origin and Spread of Nationalism*. London: Verso.

Aronowitz, Stanley (1973) *False Promises: The Shaping of American Working-Class Consciousness*. New York: McGraw-Hill Book Company.

Aronowitz, Stanley (1983) *Working Class Hero: A New Strategy for Labor*. New York: Adama Books.

Babb, Sarah (1996) " 'A True American System of Finance' ": Frame Resonance in the U.S. Labor Movement, 1866 to 1886." *American Sociological Review* 61: 1033–1052.

Blauner, Robert (1964) *Alienation and Freedom: The Factory Worker and his Industry*. Chicago: University of Chicago Press.

Blyton, Paul (1992) "Learning from Each Other: The Shorter Working Week Campaigns in the German and British Engineering Industries." *Economic and Industrial Democracy* 13: 417–430.

Bosch, Gerhard, Peter Dawkings, and Francois Michon, eds. (1993) *Times Are Changing: Working Time in 14 Industrialised Countries*. Geneva: International Institute for Labour Studies.

Braverman, Harry (1974) *Labor and Monopoly Capital*. New York: Monthly Review Press.

Clemens, Elisabeth S. (1996) "Organizational Form as Frame: Collective Identity and Political Strategy in the American Labor Movement, 1880–1920," in *Comparative Perspectives on Social Movements: Political Opportunities, Mobilizing Structures, and Cultural Frames* edited by Doug McAdam, John D. McCarthy, and Mayer N. Zald. Cambridge: Cambridge University Press.

Davis, Mike (1986) *Prisoners of the American Dream*. London: Verso.

Fine, Sidney (1969) *Sit-down: The General Motors Strike of 1936–37*. Ann Arbor: University of Michigan Press.

Fraser, Steve (1989) "The 'Labor Question,'" in *The Rise and Fall of the New Deal Order, 1930–1980* edited by Steve Fraser and Gary Gerstle. Princeton: Princeton University Press.

Fraser, Steven (1991) *Labor Will Rule: Sidney Hillman and the Rise of American Labor*. Ithaca: Cornell University Press.

Gabin, Nancy (1991) "Time out of Mind: The UAW's Response to Female Labor Laws and Mandatory Overtime in the 1960s," in *Work Engendered: Toward a New History of American Labor* edited by Ava Baron. Ithaca: Cornell University Press.

Galenson, Walter (1960) *The CIO Challenge to the AFL: A History of the American Labor Movement, 1935–1941*. Cambridge: Harvard University Press.

Gamson, William (1990) *The Strategy of Social Protest*. Belmont: Wadsworth Publishing.

Glaberman, Martin (1980) *Wartime Strikes: The Struggle against the No-Strike Pledge in the UAW*. Detroit: Bewick Editions.

Goldfield, Michael (1987) *The Decline of Organized Labor in the United States*. Chicago: University of Chicago Press.

Goldfield, Michael (1995) "Was There a Golden Age of the CIO? Race, Solidarity, and Union Growth during the 1930s and 1940s," in *Trade Union Politics: American Unions and Economic Change, 1960s–1990s* edited by Glenn Perusek and Kent Worcester. Atlantic Highlands, NJ: Humanities Press.

Gompers, Samuel (1925) *Seventy Years of Life and Labor*, 2 vols. New York: E.P. Dutton.

Graebner, William (1980) *A History of Retirement: The Meaning and Function of an American Institution, 1885–1978*. New Haven: Yale University Press.

Griffith, Barbara S. (1988) *The Crisis of American Labor: Operation Dixie and the Defeat of the CIO*. Philadelphia: Temple University Press.

Hanagan, Michael (1988) "Solidary Logics: Introduction." *Theory and Society* 17: 309–327.

Hunnicutt, Benjamin Kline (1988) *Work Without End: Abandoning Shorter Hours for the Right to Work*. Philadelphia: Temple University Press.

Kalleberg, Arne L. and Aage B. Sorensen (1979) "The Sociology of Labor Markets." *Annual Review of Sociology* 5: 351–379.

Klandermans, Bert (1984) "Mobilization and Participation: Social-Psychological Expansions of Resource Mobilization Theory." *American Sociological Review* 49: 583–600.

Kraus, Henry (1985) *The Many and the Few*. Urbana: University of Illinois Press.

Lichtenstein, Nelson (1982) *Labor's War at Home: The CIO in World War Two*. Cambridge: Cambridge University Press.

Lichtenstein, Nelson (1985) "UAW Bargaining Strategy and Shop-Floor Conflict: 1946–1970." *Industrial Relations* 24: 360–381.

Lichtenstein, Nelson (1988) "The Union's Early Days: Shop Stewards and Seniority Rights," in *Choosing Sides: Unions and the Team Concept* edited by Mike Parker and Jane Slaughter. Boston: South End Press.

Lichtenstein, Nelson (1995) *The Most Dangerous Man in Detroit*. New York: Basic Books.

Lipset, Seymour Martin, Martin Trow, and James Coleman (1956) *Union Democracy: The Internal Politics of the International Typographical Union*. New York: Free Press.

Marx, Karl (1976) *Capital: A Critique of Political Economy*. New York: Vintage Books.

McAdam, Doug (1983) "The Decline of the Civil Rights Move-

ment," in *Social Movements of the Sixties and Seventies* edited by Jo Freeman. White Plains: Longman.

McNeill, ed., George (1887) *The Labor Movement: The Problem of Today.* Boston and New York: M.W. Hazen Co.

Mills, C. Wright (1948) *The New Men of Power: America's Labor Leaders.* New York: Harcourt, Brace and Company, Inc.

Mink, Gwendolyn (1986) *Old Labor and New Immigrants in American Political Development: Union, Party, and State, 1875–1920.* Ithaca: Cornell University Press.

Montgomery, David (1979) *Workers' Control in America: Studies in the History of Work, Technology, and Labor Struggles.* Cambridge, England: Cambridge University Press.

Moody, Kim (1988) *An Injury to All: The Decline of American Unionism.* New York: Verso.

Nasaw, David (1985) *Children of the City: At Work & at Play.* New York: Oxford University Press.

Olson, Mancur (1965) *The Logic of Collective Action: Public Goods and the Theory of Groups.* Cambridge: Harvard University Press.

Preis, Art (1964) *Labor's Giant Step: Twenty Years of the CIO.* New York: Pioneer Publishers.

Roediger, David R. (1991) *The Wages of Whiteness: Race and the Making of the American Working Class.* London: Verso.

Roediger, David R. and Philip S. Foner (1989) *Our Own Time: A History of American Labor and the Working Day.* London: Verso.

Rosenzweig, Roy (1983) *"Eight Hours for What We Will": Workers and Leisure in an Industrial City, 1870–1920.* Cambridge: Cambridge University Press.

Schwartz, Michael and Shuva Paul (1992) "Resource Mobilization versus the Mobilization of People: Why Consensus Movements Cannot Be Instruments of Social Change," in *Frontiers in Social Movement Theory* edited by Aldon D. Morris and Carol McClurg Mueller. New Haven: Yale University Press.

Shorter, Edward and Charles Tilly (1974) *Strikes in France, 1830–1968*. Cambridge: Cambridge University Press.

Sorenson, Aage B. (1996) "The Structural Basis of Social Inequality." *American Journal of Sociology* 101: 1333–1365.

Tarrow, Sidney (1994) *Power in Movement: Social Movements, Collective Action and Politics*. Cambridge: Cambridge University Press.

Tilly, Charles (1978) *From Mobilization to Revolution*. Reading, MA: Addison-Wesley.

Tilly, Charles (1988) "Solidary Logics: Conclusions." *Theory and Society* 17: 451–458.

Voss, Kim (1993) *The Making of American Exceptionalism: The Knights of Labor and Class Formation in the Nineteenth Century*. Ithaca: Cornell University Press.

Voss, Kim (1996) "The Collapse of a Social Movement: The Interplay of Mobilizing Structures, Framing, and Political Opportunities in the Knights of Labor," in *Comparative Perspectives on Social Movements: Political Opportunities, Mobilizing Structures, and Cultural Frames* edited by Doug McAdam, John D. McCarthy, and Mayer N. Zald. Cambridge: Cambridge University Press.

Yellowitz, Irwin (1977) *Industrialization and the American Labor Movement, 1850–1900*. Port Washington, NY: Kennikat Press.

Zald, Mayer N. and John D. McCarthy (1987) *Social Movements in an Organizational Society*. New Brunswick: Transaction Publishers.

1　■ The Post-Work Manifesto

Stanley Aronowitz, Dawn Esposito,
William DiFazio, and Margaret Yard

Introduction

The bottom is falling out and with it our sense of well-being. For two centuries, despite depressions and wars, America was the "golden door" behind which beckoned the call of the Good Life. Yet, as the twenty-first century approaches, the United States is more accurately characterized as the home of downsizing jobs and lost security, of disappointed hopes and expectations. For many, recent economic and political developments point to the withering away of comfortable full-time jobs "with a future." With jobless futures have also come deteriorating and lost benefits, from quality health care to assurances like social security that were once guaranteed—if only minimally in the United States—by the employment contract.

If the current situation is allowed to continue on its present course, only the few will be able to enjoy life without the constant stress of economic worries. The rest of us will be so buried in work without end, anxious about procuring or simply sustaining our livelihoods, that even the freedom to imagine a different kind of life will seem more and more like a luxury. It has become increasingly difficult to find the time just to reflect, to write, to feel—to change. Ours is a moment when private and public employers regularly demand "give-backs," from health benefits to pensions and

holidays. It is anxiety—certainly not the economy—which becomes democratized as the quest for secure paid labor consumes more and more of our time, uniting people in divergent job and class strata from blue-collar to middle and upper managements as perhaps not for centuries before. For no one is immune as these distinctions themselves commence to collapse, and are rendered increasingly meaningless by the immensity of socioeconomic transformations emblematic of our age.

Most people are likely to understand that industrial workers suffer an ever-present threat of runaway shops and technological change. Thirty years ago many working people fought against employers' efforts to get more work out of them for the same or less money and less free time. But at the end of the twentieth century, fearful of losing jobs, this group of working people now silently suffers more speed-up, compulsory overtime and work accidents (lest the boss pull up stakes and leave). Even as statistics show economic growth, legal factory jobs continue to shrink while illegal factory labor has grown. Moreover, in the past decade, we have seen the return of what we thought had been banished forever: the sweatshop. Many people are working "off the books" in the underground economy, translating into ten- and twelve-hour days at wages below legal minimums. In these sweatshops, which make more of our clothing and toys than ever, child labor has reappeared. Children work next to their parents or alone and are often beaten by the bosses, chained to machines and locked in poorly ventilated rooms.

It is not just industrial or blue-collar workers who have been profoundly affected. Doctors are working for salaries in health maintenance organizations (HMOs) and in the relentless drive for cost-cutting are losing control over their own work. In the new world of the HMOs the manager, not the doctor, decides who is sick and who is not, who deserves treatment and who doesn't. And many other professionals are being subordinated to the steady drumbeat of downsizing. For example, as a group, academics are freer than most people in the sense of having time to do one's own work and to speak one's mind in a classroom. Yet

tenure itself is no longer secure: as a form of guaranteed income, a kind of entitlement, it is not surprising to find this—like any little security offered most of us is—beginning to be threatened. And just at the moment when a college education seems to be a ticket to a better chance for steady work, tuition at public and private colleges has skyrocketed. Many students can no longer afford to go to school, for pleasure or to pursue careers more instrumentally oriented, because student aid is also rapidly disappearing. Tuition costs in public institutions have increased so rapidly that working-class students, many of whom are minorities, need to work at one or more part-time or full-time jobs while having little time to study. Colleges are once more becoming the province of the privileged.

But an alternative direction to the one in which we are now headed is also possible. This other road would lead to shorter working hours, higher wages, and best of all, our ability to control much more of our own time. In such a different and improved world, we would still produce the goods and services that society needs but we would spend less time doing it. There's plenty to produce: we need millions of homes at rents people can afford. Our environment needs to be cleaned, improved and maintained; depleted drinking water supplies need to be restored and pollution levels reduced. There's also plenty to do: kids need childcare and recreation activities. Ordinary people might run television channels and, together with independent film and video makers, become more genuinely involved with contemporary media. Neighborhoods would have their theaters, concert halls, sports facilities, and collective meeting spaces. Libraries would become full-time again. And people would have time to use them. And, as in much of Europe, many of these services would be free or offered at small prices. The seemingly impossible dream of shorter hours may lead to a life where we are relatively freed from the oppressiveness of time as we now commonly experience it.

Are we headed for freedom or hell? Are current trends towards corporate, government and educational "downsizing" a natural event or are they produced by real people for specific purposes? Can we afford the "free" market which puts

two million people on the street without shelter, produces poverty for more than a quarter of Americans, and puts a million more children under the poverty line each year? Do we want an economy which depresses wages for about 80 percent of the working population and continues to ship jobs to low-wage countries? Whose market is it anyway? The middle class does not really benefit when the poor lose with the ending of "welfare as we know it" and the looming privatization of Medicare and Social Security. Those employees shed by the welfare state simply flood the labor market, undermining the bargaining leverage of middle-class workers in the private sector. Only the multimillion dollar salaries and stock options of corporate executives remain in place—and then, not even for these men all that securely—as the rest of our jobs are cut or cut back.

What's going on? What does the overused term "globalization" mean for the average working person? When President Clinton signed the North American Free Trade Agreement in 1993, his administration promised that more U.S. workers would get jobs than those which were lost to Mexico. But the reverse has occurred. In 1995, American workers lost more than 40,000 jobs to Mexico, and less than 10,000 new jobs for U.S. workers were created by the NAFTA treaty. The Big Three auto companies have outsourced auto parts to border plants where workers are paid $80 a week compared to $400–$500 paid to workers doing comparable jobs in the U.S. Much work keeps flowing out of the country, replaced by temporary, part-time and contingent work, which the statisticians optimistically call "jobs."

Moreover, the consequences of the application of numerical controls, robotics and laser technology to the manufacturing workplace have been devastating for many production workers in the U.S. Organizational changes such as the merger of large corporations and the gobbling up of littler ones by the giants have thinned the ranks of middle managers and many professionals. Computers are now a staple of virtually every office. Voice mail eliminates secretaries; new software packages have dramatically reduced the need for accountants and bookkeepers.

And, for tens of thousands of clerical and technical work-

ers, computers now mean taking work back home. After nearly a century when homework was regarded as a wage-busting tool, computers have made it easier for employers to revive this practice. With pagers, cellphones, and laptop computers, all time becomes work time. Moreover, today the word processor, the editor, telemarketer, even the programmer often loses her steady job but characteristically returns as a "contractor" who works part-time on a contingent and benefit-free basis. It is rare for such contractors to enjoy basic health insurance, vacations, holidays and pension benefits. Are such persons entrepreneurs or simply benefit-free temporary workers also negatively affected by the huge loss of jobs and by growing economic insecurity?

Economic growth doesn't necessarily mean *real* job growth anymore, even if temporary bursts of contingent job creation do occur. Everyone knows the joke: "Millions of jobs created . . . and I've got four of them." Yet, the bare fact is that technological change can now be used to displace all categories of workers, including managers and professionals. A few examples may better illustrate the point. Computer programmers invented Computer-Aided Design (CAD) to relieve engineers of time-consuming tasks like drafting so that these engineers could spend more time in design work. Today, the drafting profession is all but a memory: ironically, CAD soon began to relieve many engineers of their jobs.

Another example: the health care system is now dominated by managed care. In 1996, 60 percent of all insured people were in the system of managed care plans. Managed care corporations have advised mental health professionals to use drugs to replace therapy on penalty of not being paid for treatment. Whether drugs are better for patients than therapy, they are now prescribed because they are "cost-efficient." But, in the process, this treatment can be used to wipe out hours and hours of high-paid professional work time.

Finally, mergers and acquisitions result in layoffs of headquarters and research and development staffs. After all, why duplicate the full array of managerial, technical, scientific, professional and clerical employees when one organization can replace two or three and communications technologies

allow the same level of output? Today a fifty-year-old manager in a financial services or retail corporation is, like the spotted owl, an endangered species.

In an era when almost any company can merge with another and machines regularly replace people, can *any* working person honestly say that her or his job is safe? Are we heading for a future in which the good job rapidly becomes the subject of museum shows? It requires a leap of naivete to accept at face value many politicans' and economists' assurances that the Great American Job Machine is purring. Consumer confidence has never been higher. But worker insecurity is simultaneously invoked as the cause of restrained wage inflation.

This is what we know: even as statistics show a 5 percent unemployment rate, large corporations show no signs of reversing their drive toward the destruction of jobs. The mere threat of job destruction (and the vivid imagery of massive layoffs) keeps workers off balance and, consequently, overworked and underpaid. Even as politicians and the media claim that the economy is bouncing upward, more of U.S. have part-time, temporary and contingent jobs which are counted by statisticians as if they are full-time. Despite the "help wanted" signs in the windows of retail chains like McDonald's, wages continue to stagnate. According to a recent study by anthropologist Kathryn Newman, there are fourteen applicants for every McDonald's job in black and Latino neighborhoods. Even many professionals are forced to work as "consultants." Translation: a new form of part-time work with no benefits and job security has emerged. Some may have confidence that the American job machine can spit out low-paying jobs like popcorn. But most will choke on the hard kernel of desperation at the heart of our economy.

We must look at the fact that of the millions of jobs created over the years of the Clinton presidency, at least half of them paid below the national average. Many were not real jobs at all but part-time, temporary or contingent work, the kind that does not even provide adequate health, vacation and pension benefits. For, even as the politicians tell us we have it better than ever, wages over the last twenty years

have slipped 20 percent. As big corporations pay their executives an average 8 percent to 12 percent increase each year, most workers received raises of only 2.5 percent on average, a figure which has not even kept up with inflation. If the average American household income has not declined in this period, it is because the two-paycheck household has become the rule rather than the exception. In many cases, two or three incomes are needed to make as much as one person earned, in real terms, twenty years ago. A few million industrial workers are making more money than ever because many are putting in sixty- and seventy-hour weeks while the majority of industrial workers are scraping to keep their heads above water. Some auto workers pull in as much as $90,000 a year but have no time to enjoy it. Nor is there enough time to spend with family and friends, who are themselves likely to be caught in the same trap as well. The wages are great, but the work is too much. Labor strife in the auto industry today is caused by worker resistance to mandatory overtime and inadequate staffing levels. The auto workers' demands are obviously unreasonable: they want to get a life. Are we doomed to accept lower wages and salaries, fewer benefits on the job and serious deterioration in public goods such as education and health? The strike by French truck drivers in the fall of 1996 for shorter hours and early retirement ended in a victory for the workers. The admirable determination of these workers provides an important illustration of how alternative paths to that of submission *are* possible for workers suffering the physical and spiritual hazards of endless work. Among other gains won by these workers was a ban on Sunday driving, full retirement benefits at age 55, a substantial pay increase, and smaller work loads. In contrast, American truck drivers and other workers are putting in longer hours, have won relatively small wage increases and have lost many of their benefits. Most of us can no longer afford to retire at age sixty-two or sixty-five; social security "reform" has already lifted the age for near-future retirees to sixty-seven, and there is talk of boosting it again to age seventy. Older workers may be useful in order to flood the market, but only after their sense of job security has been destroyed by a few layoffs and age-biased firings.

French, German and many other European workers are engaged in a determined struggle for shorter hours—in many French workplaces, this has succeeded in cutting the workweek to thirty-seven hours, in German workplaces to thirty-five, while it is common in both countries to find five- and six-week paid vacations. Meanwhile, few American workers have as much as even three weeks vacation and average U.S. working hours has been steadily climbing.

More than ever, we worry about work and are working longer hours; we are more than ever driven, nervous, seemingly trapped. At the very same time, and paradoxically, the twenty-first century bodes a time of post-work: of automation and work reorganization replacing people at faster and faster rates. But nothing good will come without a fight for this future. So what is to be done?

At a fundamental level, the first thing required is a change in *ideas*, in perceptions which by now are badly out of sync with our circumstances. Unless we begin to think differently about work itself—whether jobs will exist and can be made to exist, whether we want to work long hours at multiple jobs anyway (sometimes working ourselves to death), about the kind of life we can and deserve to have in the next century—collective anxieties are likely to steadily worsen. Unless we rethink our basic vision there will be little hope for people in the middle and working classes—or for those who are poor—in generations to come. Discontentment will be what unites us so long as dangled expectations continue to be disappointed.

In 1992, Bill Clinton rode to the presidency, if not to effective power, lambasting his conservative predecessors for ignoring the unmet needs of working Americans. He particularly derided conservatives' apparent state of deep denial about the economy. As the recession of the early 1990s seemed to hang on beyond the predictions of forecasters, his campaign promised to lead the country into a new era of security and prosperity. Clinton promised to deliver some of the most important features the welfare state had failed to provide: a real universal health care program, job creation for the chronically unemployed, new boosts in education and job training. But none of this happened. And, clearly, as

the economy recovered slightly from a five-year recession, Clinton and his key economic advisors did not conceive of unemployment as a structural problem. Rather, for Clinton and his advisors unemployment was merely the product of a mismatch between skills and the needs of a rapidly changing workplace. Four years later, after the Clinton administration abandoned all but its most modest proposals—a scaled down service corps, an only slightly raised minimum wage and, after a failed effort to win health care for all, only portable health benefits for laid-off workers—many Americans gave up hope that government would be able to solve the puzzle of an economy that creates millions of jobs at the same time it wipes out millions more.

Because the Democrats backed down on their own promises and expectations, it is not surprising that in 1994, Americans expressed disappointment by politically swinging back in the opposite direction—toward a Republican Congress headed by the conservative likes of Newt Gingrich and Bob Dole. Only to find, of course, disappointment again. For the Republican response didn't work either. To most Americans, the Republican Congress was itself too extreme in its drive to cut back hard-won social benefits like Medicare, or to throw poor children into orphanages (as Gingrich proposed early on, before he realized his mistake in going too far). Gingrich made us nervous yet again, contributing to a sense of no-win politics-as-usual. Yet there are alternative ways to conceive the world so that it no longer seems hopeless and set in stone. With this goal in mind, we have organized the manifesto as follows:

Part I opens with an analysis of the structural character of the socioeconomic transformations we have been describing. Once it has been shown that our problems are not superficial but deeply rooted in the structural character of a globalizing economy, Part II addresses why and how the "business as usual" answers now circulating in the cultural air cannot work in the longer run. In addition to showing the flaws in blithely accepted claims, this segment contains analyses of several other key and interrelated issues. First, the history of labor's reaction to job destruction; second, our belief that the state as we know it has become hollowed

out, likely to be resuscitated only if conceived anew (and on the basis of explicitly acknowledging the repercussions of late-twentieth-century capitalist transformations); third, the ongoing determination, especially in the United States, to keep scapegoating those who are poor and "non" white rather than confronting our structurally rooted predicament head on; and, fourth, Americans' ongoing faith—tantamount to a contemporary American religion—in the alleged virtues of an unfettered free market, regardless of its actual failures and inequities. Part III is built around looking past a now too dreary looking future: specifically, how could things be otherwise, and our anxieties more genuinely addressed? Here, we detail the advantages of shorter hours and guaranteed income as concrete policy measures before elaborating—in Part IV, and by way of conclusion—the kind of vision that could fulfill in practice what remain our more humane collective dreams.

All of this raging indignation will prove ineffective and circular—never allowing us to see beyond the superficial, or deal with more than the symptomatic—unless we cut to the heart of our difficulties. For the time has come to admit that many of us are working so hard, if working at all, that we hardly have time to enjoy our lives or even to seriously consider what else beyond the present could actually materialize. It is time to demand reductions in our workweek, to insist upon higher income and to refuse to work ourselves to death. It is time to get a life.

Let us see what happens, though, if we tilt the lens and change our perspective. How can we place our present situation in historical perspective while forging a future that drastically improves upon our past? After all, though aggravated in the 1990s, our predicament is anything but new. Late capitalist society is engaged in a long-term historical process of destroying job security, while the virtues of work are ironically and ever more insistently being glorified.

Part I: Structural Transformations

As we write, 40,000 AT&T workers, including 24,000 managers, are being laid off in the United States. As corporations reorganize, re-engineer, delay, automate and down-

size their operations, workers of all collars have faced the staggering reality of massive layoffs. The list of major corporations that have laid off workers is impressive:

- Sears Roebuck–50,000 in January 1993
- Boeing–28,000 in February 1993
- IBM–63,000 in July 1993
- GTE–17,000 in January 1994;
- NYNEX–16,800 in January 1994
- AT&T–15,000 in February 1994
- Delta Airlines–15,000 in April 1994
- Digital Equipment–20,000 in May 1994.

Even though the layoff pace decreased for 1995, the headlines continued with Lockheed Martin laying off 15,000 workers; Chemical/Chase Manhattan Bank 12,000; General Motors 5,000; Kmart 5,800; Eastman Kodak 4,000 and Apple 1,300. In 1996 the biggest layoffs occurred in the apparel and fabrics industries; 141,000 jobs vanished in 1995. In 1996 one of the more dramatic instances of downsizing was the decision of the Sunbeam corporation to lay off a third of its 20,000-person work force. In December 1996, TransWorld Airlines (TWA) announced it was reducing routes, and experts believed hundreds of jobs would disappear with them.

The layoff of such massive numbers of workers occurred in an economy officially dubbed "prosperous" with the Dow Jones Industrial Average on Wall Street breaking records on a daily basis. Even the Wall Street boom has not rendered workers on the stock exchange and in financial services immune from layoffs. For, even as Merrill Lynch and Co. announces huge profits, it simultaneously lays off 250 employees. The city has not reached its securities industry employment peak of 162,000 reached in 1987. Equity capital levels alone have doubled to $23 billion in the last five years. But even for those considered to be the best and the brightest in a booming industry, more profits mean lean management strategies and fewer workers. All of this has left the working and middle classes—that is, pretty much everyone except the extremely well-to-do—with great anxiety over their futures even as the economy continues

to grow. The extraordinary paradox is that official unemployment rates are low at the same time job insecurities are legion. Hence low unemployment, but no wage increases.

What has precipitated this turn of events? In the past, productivity-driven economic expansion might produce more job growth and better wages. In the new global high-technology economy, however, workers can be replaced by what has been called "economic restructuring" and by computerized machinery such as lasers, robots, numerical controls, electronic communications and word processors. From 1971 to 1990 technological change, runaway shops and mergers and acquisitions combined to destroy eight million factory jobs. High-wage skilled workers in the machine tool industry lost jobs to automation as well as to international competition. Rubber, glass, textiles and garment manufacturers lost half their work force. In November 1996 a European textile manufacturer reported using a weaving machine that produced three times the fabric of the standard in the industry, a development which enables employers to either replace textile workers and/or to drive down wages by threatening automation.

Forty years ago, when large auto corporations introduced automation into their engine plants, both the threat and promise of labor-saving machines were simultaneously glimpsed. What would these machines mean for working hours, leisure, incomes and jobs?

In a legendary encounter in the mid-1950s, UAW President Walter Reuther and a Ford engineer had the following exchange. According to author John Bernard, "When Reuther toured a new highly automated Ford engine plant in Cleveland, a company engineer taunted him with the remark, 'You know not one of these machines pays union dues to the United Automobile Workers.' Reuther shot back, 'And not one of them buys new Ford cars either.' " Of course, machines replacing human labor is nothing new but originated in an early industrializing era when most people were still farmers or peasants. By the end of World War II, approximately twenty-five million people, or 40 percent of the labor force, still worked in factories. Because of ad-

vanced machine technologies, output was increasing but jobs were staying constant. For instance, auto workers turned out five and a half million cars in 1946 and eleven million cars in 1960. In 1990, under pressure from automatic technologies such as robotics and numerical controls (and because of longer working hours), output rose to thirteen million cars and trucks while employment started to decline, dropping in this industry alone by 25 percent or 150,000 jobs.

The destruction of jobs was even more dramatic in steel. In 1959, the basic steel industry employed about 600,000 production and maintenance workers, the same as in 1945. By 1990, computerization was eliminating the labor-rich blast and open hearth furnaces with the Basic Oxygen Process and mechanical rolling mills with computerized controls. The new smaller equipment and labor-saving technologies made possible the creation of mini-mills. And company mergers combined with the growth of imports to reduce employment by 60 percent to 225,000. Yet, just as had happened in the automobile industry, domestic steel output had increased rather than declined through this thirty-year period of technological change alongside diminishing employment.

In the textile and garment regions of the South, more than 700,000 workers have lost their jobs in the 1990s (half of this particular labor force). In many cases, a plant closing means that a mill community will become a ghost town since many southern communities depend on a single employer for their sustenance.

No wonder many people by now are frightened and anxious. But where was the union movement amidst all this? Where are we now?

Part II: A Critique of Contemporary "Common Sense"

At the end of the century, America is hunkered down, sensing a castraphophe has occurred and holding its breath to avoid the next blow. Somehow, someway—and even if not employing a language of "structural transformations"—

many people sense that beneath the surface, our economic problems may not just disappear so easily.

Whether or not the media highlights our contemporary plight—let's call it an anxiety epidemic—the fact remains that even as companies like McDonald's and supermarket chains plead for part-time and low-wage help, the middle- and upper-level managerial jobs on which the "American dream" depended for its own credible survival are being lost. Having shed thousands of production workers in the early 1990s, IBM, Kodak, AT&T and dozens of other leading employers have announced plans to lay off not merely "workers" (as traditionally defined as the blue-collar and clerical "pink"-collar working class) but also managers, professionals and technical staff who have been forced into early retirement (though their incomes are not sufficiently comfortable unless supplemented by part-time work or diminished unemployment benefits). Many who are forty-five or older find that they are unable to find jobs in relatively skilled occupations even when willing to accept lower salaries. A surprisingly large number of experienced managers and professionals have taken sales and line technical jobs, and technical workers are being pushed into production work. Thus the qualifications for even entry-level employment are being pushed up by the falling salaried middle class.

This anxiety reaches into the once-stable world of public employment. For example, even as the government announced optimistic economic statistics in late 1996, New York's Health and Hospitals Corporation—operating eleven municipal hospitals and employing thousands of workers—was threatening to displace nearly the entire 1600 person nurse supervisory staff and many doctors. And, whether or not all 1600 eventually lose these positions, the threat itself can and does serve to both sustain anxieties and to quell opposition through fear of losing one's livelihood. The federal government, too, boasts—as though a badge of honor rather than something about which any society ought properly be concerned—that it has already sent pink slips to nearly a quarter of a million of its employees in an allegedly healthy burst of "re-inventing government."

A devil's advocate would say, well, jobs have been lost but so what? New jobs are coming back even faster than we replace them—that's the strength of the U.S. economy. But are lost jobs really being regained? If we delve deeper, the picture shifts and not in the direction of rosier colors.

What *kind* of new employment has come into being while well-paid factory and public service jobs, as well as an increasing number of supervisory and professional jobs, were disappearing? The overwhelming job growth has been in retail and wholesale (half in food services and other retailing such as McDonald's, Wendy's and Burger King); in chain department stores; in non-union construction of every description; and in businesses employing fewer than twenty-five workers, which offer lower wages and salaries and fewer benefits than large employers. In 1992 retailing paid about $14,000–$20,000 a year for non-supervisory workers, about half the average rate for industrial workers.

Clearly new jobs are being created. But it would be a huge error to mistake the quantity of new jobs for the substance and quality of enjoyable, lucrative and secure jobs that can allow us to relax about our futures. Rather, it is more likely for people to become engaged in piecemeal and subdivided jobs which are likely to be worse paying, and which offer sharply fewer benefits, than the jobs most people held before. According to the authors of the famous *New York Times* series, "The Downsizing of America" (later published in book form), most people who lose a full-time job get a new one that pays less than the old or is only part-time. Therefore, one may find oneself feeling "grateful" or "lucky" simply to have a job (though, at the same time, frustrated and/or resentful at having to be grateful), and much less likely than in previous decades to question the inadequate benefits or wages likely to come along with that newly scarce position. Under such circumstances, people may not even think to question whether a particular job is interesting and allows one to feel valued as a human being.

Thus, the conditions under which new jobs come into being may in part explain why many people continue to feel anxious rather than cheery about their own economic security and long-term prospects. New jobs come along with a

price, namely, that we are so happy just to have employment in a job-destroying economy that we are willing to accept a great deal—from diminishing benefits and wages to lessened (or non-existent) feelings of satisfaction. And indeed, on the whole, working people—in factories, offices, in the professions—seem to have gained few if any benefits since the 1970s. Large numbers of people work longer hours, while real wages and salaries have fallen steadily since 1973.

Take wages. Many of the new jobs pay as much or better than the $400 average weekly wage. But close to 60 percent pay sub-standard wages and salaries, and many of these jobs were at or slightly above the minimum wage. On a forty-hour basis, the 1996 federal minimum wage is $170 a week, far below the national average and nearly $150 less than the poverty wage for a family of four. Even if federal minimum wages were raised by a dollar from $4.75 to $5.75 an hour the increase would still leave a $100 week deficit to reach the poverty wage and still amount to nearly $200 a week less than the average income per person.

Take benefits. Even where pay is relatively good, benefits such as health care, pensions and paid vacations are often non-existent or inferior in new jobs that do not afford the relatively better protections of large corporate plans or unionized shops.

Most retail firms are not subject to union contracts, which typically provide health insurance programs with relatively low deductibles and employee vested pension plans. Even when small firms or giant retail corporations do offer such benefits, they typically contain steep deductibles, do not provide long term care and catastrophe insturance and rarely have employees vesting in pensions. When employees quit or are laid off, as is common in the high turnover retail industry, workers have little or nothing to show for their service.

Of course, even amidst these harsh times, which in their insensitivity evoke Dickensian London, a few workers near or at retirement age have been able to leave their jobs with a more or less comfortable package of pensions and benefits. But many have also been coerced into leaving, sometimes seemingly more gently (by being encouraged to take

"early retirement" even without assurance of future jobs) and sometimes simply let go. Many people thus find themselves out of work around the vigorous ages of forty to fifty; many feel they have been left stranded. Others who thought they had vested pension money have discovered their employers snatching pension funds to pay debts or line their own pockets. Still others, after a typical year or more of unemployment, frequently find their savings nearly gone by the next job because state-administered unemployment benefits halted abruptly after only six months' time.

But there is still another crucial point to be made, however much it flies in the face of the "common sense" which is being presented as fact all around us. Just as a marker of our time involves widespread anxieties and fears, so too can it no longer be said that impoverishment itself affects only the poor. Poverty is becoming increasingly "ordinary."

Yet, ironically enough, the direction of changes in our late capitalist economy has begun to make it more and more difficult to persist in isolating the poor from the middle classes. It is *not* only the poor who increasingly have reason to be afraid. Rather, ever larger numbers of people in the proverbial American middle class (and even upper middle class) are beginning to feel the effects of a skewed economy.

With all the talk about prosperity, more than a quarter of Americans are officially living below the level required for a decent standard. This represents a 50 percent increase since 1973. Contrary to biased public perceptions that the poor are mainly drunks, druggies, promiscuous women and welfare cheats, only a minority of persons so classified are actually unemployed. The secret story of poverty is that most of the poor work for a living but cannot make it on their inadequate wages. Most of the working poor need food stamps (a form of assistance which may no longer even be available to them) to get by, and an increasing number of the working poor show up at privately sponsored soup kitchens daily in order to obtain a decent meal. Of course, welfare is not only a subsidy to the poor but also to their employers. One of the more paradoxical effects of income assistance programs is they permit lower wages than workers need in order to live. Thus workfare survives in order to force workers to flood the

labor market while simultaneously using tax money to subsidize private sector labor costs.

What we are saying is that the most explosive story of the 1990s is that the American dream is being shattered for *most Americans*, not only for the poor. Indeed, it is precisely these neat and habitual lines between "middle class" and "poor" which are now being blurred by the structural transformations already described. Although factory jobs took an enormous hit in the late 1970s, 1980s and early 1990s, the 1990s has been a decade of similar losses among clerical, professional and low- and middle-managerial employees as well. Of course, the number of factory jobs continues to slide; there is almost no job growth in this sector that typically pays two and a half times the minimum wage. But, as long as jobs were being created for knowledge-workers, computer programmers, managers and other professionals, many believed we could afford to lose "rust belt" factory jobs and relatively lower-paid clerical jobs. The future was in what former Secretary of Labor Robert Reich called "symbolic analysts," mostly college educated and professionally trained people. The Northeast could suffer economic stagnation, even decline, but other sections of the country would prosper.

Reich and many other economists continue to assure us that unemployment is caused by undertraining. In his view, government should help young people get a good education. It should assist displaced workers to receive the re-training they need to qualify for careers in *symbolic analysis* (computer programming, financial services, policy analysis). The problem with this scenario, however, is that it cannot explain why so many qualified people with college and postgraduate degrees are looking for work. Why, for one instance, are nurses and doctors also being laid off? Why, for another, are tens of thousands of middle managers getting pink colored paper parachutes? Some computer people—the prototypical symbolic analysts—are hunting for work and often, after finally finding work, discover the pay is much less than what they last earned. Accountants, financial managers and many other professionals, all of them manipulators of symbols, are switching to "consulting"—a

fancy word for casual labor. And tens of thousands of highly educated academics who work with nothing but symbols are working as part-time, temporary teacher/adjuncts because they cannot find full time jobs. Increasing the supply of workers trained for these jobs simply floods the market more, as the rising tide of skilled workers sinks all high-tech economic lifeboats.

One recent headline proclaimed, "People Are Spending Briskly and Keeping the Economy Strong." It may be that some stores and manufacturers are humming with sales and profits, but many economic reports show there is growing personal debt. In 1996, more than a million individuals declared personal bankruptcy; others are buying necessities on near-capacity credit and are kept afloat only because banks remain eager to lend people money. For example, some people earning $20,000–$25,000 a year have been offered $10,000 credit lines. If they purchase $5000 worth of goods at 18 percent interest they might have as much as a $200-a-month minimum payment and it would take almost three years to pay the loan off. But, of course, this indefinite extension of credit cannot last. Eventually, the next downturn is certain to increase the number of people who are forced to default on their loans because of layoffs and wage reductions.

The most unstable part of the recovery is ballooning personal debt. More personal bankruptcies, more layoffs. But this time, full of holes, the shrinking safety net will catch fewer victims.

Part IV: The Reaction of Labor

How did the labor movement respond to the changes and problems we have been describing? Most unions chose not to fight for work-sharing and shorter hours to deal with the job-destroying effects of technological change. Unions like the Auto Workers and the Steelworkers responded by negotiating various forms of indirect shorter hours which included extended "sabbatical" leaves for high-seniority workers, company-paid supplementary unemployment benefits for up to two years, and full pensions after thirty years

of service. But these gains were limited to workers covered by the union contract and did not help the growing millions of workers who were non-union or those who worked in industries where technological change was not yet a major problem. Moreover, these responses saved high-seniority workers leaving young workers to bear the burden of industry layoffs.

One version of technologically-driven reform was initiated on the waterfront. In return for permitting stevedoring companies to install "containerization" (a kind of automation), the two longshore unions won a Guaranteed Annual Income (GAI) for a limited number of workers. This meant that workers were paid their full annual wage whether working or not. In effect, then, workers exchanged their control over the workplace for leisure and the income to enjoy it. Longshore is the leading case of the institutionalization of post-work.

But the institutionalization of GAI became the exception, not the rule, even though some printers of major metropolitan daily newspapers settled for GAI when management proposed to replace them with "cold type" (the industry's name for computerization). Apart from New York construction electricians, however, the promised six-hour day or thirty-hour week remains unfulfilled to this day, despite the massive introduction of computer-based work in manufacturing, offices and professions.

Making matters even worse was that the shorter hours movement—which had been the key historical response of labor to technological change and economic ups and downs—came to a crashing halt just at the moment when, after two decades of the Great Depression followed by post–World War II economic reconstruction, it was expected that the demand for fewer hours would once more take center stage in the labor movement and on progressive political platforms. Instead, in industries of all kinds from autos to aircraft, the survivors of major layoffs are working fifty and sixty hours a week while millions of other workers are not even so "privileged." The simple fact is that companies prefer to pay overtime at time-and-a-half to fewer workers because it is less expensive than the cost of benefits

for a new full-time group of workers. Such companies also benefit from a high unemployment rate because it facilitates keeping the wages of employed workers down. Therefore, not as many new workers are hired when business picks up; rather, additional work is simply piled on the existing, employed labor force.

In the most highly labor-intensive industries it is often cheaper for employers to shift the work to low-wage areas within the United States, and/or to countries in Latin America, Asia and Eastern Europe where wage levels are attractively lower even when compared to the rock-bottom pay offered to non-union workers in the American South. For example, thousands of textile and garment workers have lost their jobs as employers shift work to Mexico, China and Poland. But high-paid jobs are leaving as well. United States–owned plants on the Mexican borders, the so-called maquiladores, are making auto and machine parts and appliances as well as clothing. These plants have high-tech machinery and compete quite successfully with United States plants. Among other things, employers have used their ability to shift work to these plants to threaten United States workers. Typically, union bargainers are faced with employer demands for the right to "outsource" work, to hold wages and benefits low and to obtain greater "flexibility" over the production process (a fancy term for speedup and other unsafe working conditions).

At the same time professionals, especially design engineers, computer programmers and medical and other scientific workers are at risk, as corporations find cheaper sources abroad of highly educated labor. Indians and Chinese are developing software for United States based corporations; India's and China's scientific laboratories and engineering firms are making deals with United States medical and industrial corporations to design plants and to develop products as only U.S. laboratories and design companies once did. Like many United States universities, they are exchanging their right to patent discoveries and inventions for funds to perform their research. In the process, the idea of "American" science or "American" technology is rapidly made into a historical relic.

The situation can be summed up quite simply. The historic slogan of the labor movement, "equal pay for equal work," is dead: all kinds of labor has been put in competition with itself on a global scale. During the 1950s and 60s, labor was able to win through building strong unions and pushing for decent wages and benefits. When U.S. and European corporations could not control their national markets and were faced with competition from corporations in neighboring countries of Europe and Asia (particularly Japan and Korea), they took a number of survival steps. First, they formed international or transnational corporations with their competitors under the premise "if you can't beat 'em, join 'em." For example, General Motors entered into partnerships and joint ventures with German and Japanese firms, most recently with Toyota to build a factory in the United States. And they shipped more and more work out of the highest-paid regions to lower-paid regions of the United States, to Asia (especially Korea and China), and to Latin America and anywhere else where cheap labor was available.

With the help of the Defense Department and the United States government, particularly the provisions of a U.S. tax code that rewards capital investment regardless of whether it destroys labor, corporations developed new labor-destroying technologies. These technologies allowed them wide flexibility to locate work anywhere on the planet, even cyberspace, and to defeat the labor movement that had forced upon them the decent living standard they now sought to escape as transnationals. For corporations, employing fewer workers at lower wages is best, and this has fast become the global strategy as more and more people are being pushed out of the workforce. It is difficult to make ends meet, the standard of living has declined and the hardships of poverty have increased.

Welfare State

The "welfare" state consists only in a small measure in direct payments to unemployed individuals. The big ticket items are education, veterans benefits and health care. Since the Reagan era, which, as President Clinton and the

rest of us discovered, did not end when he was elected, so-called "big government" has been reduced, especially its role as a player in economic growth and providing for the social safety net. It has given up its role as job creator, is rapidly retreating from its important role in providing a floor under income and is giving away its role as business regulator as fast as business wants. Where laws on occupational safety and health to protect working people are still on the books, the number of inspectors needed to enforce them are cut and penalties are trivial, leaving employers to flagrantly violate the law without the threat of real regulation. And transport deregulation has increased cargo loads, reduced truckers' income and, as speed limits have risen in order to reduce delivery time, road safety in many states is in a shambles.

The transnationals have reduced the government to what we call the "hollow state." We live within its era. In the last twenty-five years under Democratic as well as Republican administrations, the resources of government to support broad-based popular needs such as health, education, recreation and low-cost transportation have been reduced while the military budget remains huge for meeting the new post–cold war policing tasks and remains a significant source of new capital investment. Otherwise, government seems to be disappearing before our very eyes. In the era of the roaring return of the once discredited idea that everyone is on her or his own and government should be restricted to its policing function and its role as an adjunct to the interests of large corporations, the legacy of the era of the "compassionate state" is being erased as fast as the corporations and their political allies can manage. They are hollowing out these compassionate functions, leaving intact only the tasks associated with fighting crime, deploying the army to police the world, and negotiating international business deals often coded as government diplomacy.

Rather than provide universal health care and other measures to provide for the security of most Americans, government has strengthened its criminal justice system. Laws have been enacted to criminalize any kind of illegal drug use and sale and billions have been invested in prison

construction to house and maintain the tens of thousands sent there every year. Today, more than six million Americans, or two and one half percent of the adult population, is either behind bars or under the control of the criminal justice system. In many communities the prison has become the largest employer and, lacking other income, the town or county is forced to bid for more facilities to put construction workers, guards, cooks and mechanics to work.

But as important as fighting crime is, we can't have full employment by putting half the country to work in order to guard the other half unless we want to criminalize jay walking, smoking in public places, watching pornography and drinking beer, wine and hard liquor. Now that the Soviet Union has collapsed, and Noriega and Hussein have proven to be paper tigers, we might also find a new Cold War partner. Perhaps Syria could fill the role, or Khaddafi or both. But even war is not the job machine it used to be. Short of an even more intense police state, the hollowness of the state is all too apparent.

The state's democratic purpose too, has eroded. Increasingly, the very definition of democracy is being restricted to voting. Democracy stops at the factory gate or office door.

Public cynicism rises and only 50 percent of Americans bother to vote in national elections, even fewer in local ones. Many people, not only the poor but also substantial portions of the middle class and youth, feel the government means little in their everyday lives. They understand the state is indeed hollow and have less reason to engage in the symbolic act of giving their consent to a paralyzed government by voting. Indeed, Bill Clinton acts like a middle manager for powers that seem beyond his grasp. It's not only that his knee jerks in a conservative direction, it's also that his administration has become publicly aware of the limits of affirmative government. He proclaims the "days of big government" (read the regulatory and welfare state) are over and after much agonizing, signs a Republican-crafted bill to effectively end the sixty-year system of guaranteed payments—never adequate—for those who need income for various reasons including that there are simply not enough jobs. Any presidential or congressional act that offends the

two principal government advisors—stock market and bond market—may spell disaster for the economy. People may not articulate to themselves the problem in these terms, but increasingly many feel it in their gut—the government is a public relations scam. Or the government is the cops. But the government does not mean a better life and it certainly is not "me."

The bare fact is that, under current global economic and conservative political conditions, the positive role of the government is all but exhausted. And as long as there is no effective political opposition things are likely to stay that way. The federal administration functions as a world policeman guarding United States–based transnational investments in oil, manufacturing, communications, culture and agriculture. Apart from policies that provide armed forces and diplomatic power to support their global interests, these corporations want three things from the national states: no regulation that it doesn't agree with, low taxes and an educated work force. Of course, one cannot fail to notice the contradiction between lower taxes and providing education, which is the key expense of most state and local governments. The answer? Educate fewer but better; use schools and prisons to control the rest. In sum, the transnationals want a government that gets out of their way, but can control the underlying population. And every national administration since World War II has been all too willing to accommodate them. What is missing now is a contract with the people which stipulates that in return for social peace, the ruling economic interests agree to pay their fair share for the social amenities such as schooling, pensions and health care that inspire a sense of security for most people. The welfare state is not the problem, the hollowed-out state in the service of the profits of the transnational is. But so long as there is no threat to social peace, there will be no social wage.

People are being told that the federal government is in crisis; the debt is destroying our future and that of our children as well. We are told that the debt is the result of "the welfare state" we have become. The United States government has supported the poor, those too lazy to work for too

long. The solution is to impose austerity on them, and to balance the budget at the expense of food stamps, Aid to Families with Dependent Children (AFDC), Medicaid, Medicare, education, and housing. The rumor is that all of these programs are too costly, they don't work, they keep taxes high and the budget unbalanced. Their combined total cost is $137 billion a year: AFDC costs $14 billion, food stamps $27 billion and Medicaid $96 billion. Cutting them would not balance the budget, and the fact is, they are relatively small compared to other government programs for the middle class and the wealthy. Medicare, a broad, chiefly middle-class program, costs $177 billion and Social Security $335 billion.

At the same time, the defense budget at $271 billion in 1996–97 is enormous, especially when you consider that the cold war is over and we do not have a major military enemy. The wealthy who have been militant about cuts for the poor are silent about the $400 billion that they receive annually from the government in subsidies and tax breaks. They get $100 billion in tax deductions for business loans (more than foodstamps and AFDC combined), $2 billion for cost breaks for livestock grazing on public lands for ranchers, $20 billion in subsidies to AT&T for a satellite communications system, $97 billion in subsidies to nuclear industry, $1 billion to the Agency for International Development to help the U.S. companies move jobs to cheaper labor markets out of the country. Corporate welfare far outweighs welfare to the poor but most Americans seem unaware of this, and few complain. Balancing the budget would be easy if cutting these subsidies to the corporate sector was taken into consideration. What we have is subsidies and tax cuts for the rich and service cuts for everyone else.

The budget crisis is treated as an instance of bad accounting, a situation that, if not remedied, will ruin the lives of future generations of Americans. What isn't mentioned is that the budget crisis benefits some while it hurts others. It zoomed under the Reagan years as his administration increased military spending while giving tax breaks to the upper and upper middle classes. When he finished

his presidency, Reagan left us with $2 trillion in deficits in eight years. This was a political strategy to transfer public monies from 80 percent of Americans to the top 20 percent of Americans. The rich became richer and the middle class, working class and the poor lost in this equation. In the Savings and Loan debacle that cost the government $500 billion, we are told that this transfer of public monies to the richest sector of the society is good for everyone. Somehow it will trickle down to us.

The hollowing out of the state leaves only its repressive functions intact. But it also lowers expectations that through public action economic and social equality may be achieved. The hollow state means that the stakes of our liberal democracy are lowered as both major political parties increasingly stand for the same things. There are differences, of course, but they tend to be less important than before. Under these conditions we should expect voters who believe, correctly, that the stakes of voting are dramatically lowered to stay away from the polls in droves. Consequently, we may realistically ask: who does the government represent, anyway? Is the government itself becoming an interest group?

The answer has always been: organized interests but, with the relative decline of the labor movement, the collapse of many independent, community-based movements such as those of the poor, and the weakness of the feminist and black freedom movements, the main difference between the Democrats and the Republicans seems to be at the level of show. President Clinton *must* include the requisite number of women and minorities among the top figures of his second-term cabinet. Secretaries of state and health and human services are women; a black woman is named secretary of labor and a black man heads veterans affairs, a Latino serves as energy secretary. But the underlying policies remain those which have animated national government since the 1970s: emphasis on foreign policy, especially on limited wars or policing; and cut the heart out of the historic compromise between capital and labor forged sixty years ago by the New Deal. Apart from the President's acute political sense there are no significant differences

between his administration and his Republican predecessors, he knows how to keep his large, diverse political constituency in their places, even as his administration does the unmitigated bidding of the transnational corporations. They could not have invented a better friend.

Scapegoating the Poor

The salaried middle class's fear of falling into the lower class increases and they become more protective and conservative. Lacking the power to reverse the fall, many scapegoat the poor.

The prevailing myth is that the poor can find work if they really want but as long as they are stuck in a "cycle of dependency" they will resist gainful employment. Many also believe that people on welfare cheat and that women on welfare have children because they want to increase their benefits.

The rumor is that poor people are mostly members of racial minorities but in actuality 65 percent of the poor are Caucasian. In terms of AFDC, where it is believed that only a few white women receive benefits, the fact is that whites and blacks receive almost the same amount of benefits, 38 percent are white and 39 percent are black. Often we are told about the lazy people who receive welfare, but most people would work if decent jobs were available. In terms of AFDC this isn't applicable because only 4.5 million are adults while 9.4 million recipients are children. Not only are the majority of recipients children but 60 percent of these children are under the age of six. Should we deregulate child labor and go back to the good old days when children worked as hard as adults? If not, how can proponents of the so-called welfare reform justify cutting people off public assistance after two or five years?

The rumor is that these programs don't work and that people stay on welfare for their whole lives. In actuality 70 percent of women are off welfare within two years. All across the country, benefits are meager, barely enough for anything but a minimum life. In New York City for a family of three, the maximum monthly public assistance grant is $577 and $270 for food stamps, which is only 81 percent of

the poverty rate. These allotments are now being cut by 25 percent. But the cut is deeper than that because at the federal level the money is going to be block-granted at a specific sum of money rather than being determined by the total count of the people who need assistance.

The Six-Hour Day

The workday, as an agreed upon exchange of labor for money, has seemingly taken on a reality all its own. It is regarded by many as an act of nature, a projection of human desire actualized in the world. This notion connotes an image of human pleasure and contentment with this enforced organization of our days. The day is seen as a reflection of who we are and what we want rather than an enforced structuring of human energy to the impulses and tendencies of an economic system bent on breaking the human spirit.

The workday is not an extension of human nature; long working hours are not rooted in need and are not something that workers have willingly, freely or joyfully agreed to. On the contrary. The history of all societies where people are paid wages (a compulsion dictated by the need to procure daily bread rather than by desire) is marked by conflict between workers who find every possible means to avoid labor and employers who insist that every minute, every scintilla of mind and body be devoted to production. The long working day began at the dawn of capitalism in the sixteenth century. Since then workers have struggled to shorten it. In 1886 American workers and their unions took the initiative among the world's workers and raised the banner of the eight-hour day. Since that time in every industrialized country the length of the workday has been hotly contested between capitalists and workers.

Workers in some industries won the eight-hour day even before the New Deal ratified these gains in the Wage and Hour Act of 1938. Many believed the eight-hour day was just a beginning in the struggle to reduce working hours further. But capital and its agents never lost sight of their counterdream: to to re-impose ten- and twelve-hour days as a *cultural* standard against which any reductions are

considered unethical. Until recently the key issue in the history of the labor movements was whether a severely lengthened workday would be accepted as "normal." When working people have adopted a different standard, when they regard more hours as an unwarranted imposition, they have staged strikes, sit-ins and demonstrations to reduce them.

The struggle for determination of the workday is not new in American history. From the dawn of the modern labor movement in the 1870s, up to the 1960s, workers and their unions placed shorter hours at or near the head of their lists of demands. Even during the early 1930s, years of weak unions amidst mass unemployment, organized labor nevertheless put forth the demand for the six-hour day at no reduction in pay—at a time when many who had jobs were typically working eight or ten hours. The existence of this struggle speaks to the truth that what is considered normal is a matter of social power and cultural mores. After their history of leading the industrial world in the quest for shorter hours, workers in the United States have had to be conscripted into the notion that paid work is intrinsically rewarding, and the means to human fulfillment. Their resistance is demonstrated by the fact that there was a steady decline in the hours of work throughout the nineteenth century. This struggle for shorter hours was made in the face of capital's tendency to enforce work without end by threatening workers with their livelihoods.

The terms and conditions of this struggle, as well as the events that precipitated its end, are worth re-exploring, because, while the hours of work have steadily increased, the gains to workers, tenuous as they have always been, are fast eroding. Standards of living are not increasing, quality leisure time is not being enjoyed, stress and its social manifestations are rampant, and the golden future we were all planning is collapsing fast. The struggle to set the hours of the workday has been waged within a binary, framed between increased work and wages or shorter hours. But in the United States today this desire no longer takes the form of shorter hours, but of the sporadic rebellion against company-imposed and union-sanctioned compulsory over-

time. The desire for shorter hours was most recently evidenced in the 1994 strike against General Motors, in which workers in Flint and Lansing Michigan demanded an increase in hiring in order to end the mandatory overtime being forced upon them. After the strike resulted in sharply reduced production throughout the entire GM chain, the company gave in and immediately hired nearly 800 new workers in Flint and many more at other plants. In these instances, shorter hours meant the *return* to the eight-hour day and the right of workers to refuse overtime.

At the turn of the twentieth century, shorter hours connected to higher wages were discussed in terms of the benefits to work, the benefits to the family, religion, morality and to the pursuit of happiness. The assumption behind the desire to limit the workday was that material progress was a means to non-material ends. Work was understood to be a means to the rest of life. During the 1920s, progressive intellectuals and social reformers advocated for a "leisure ethic" that pushed for free time as an alternative to work. This ethic pushed for the benefits of capitalism to be reaped by workers as the enlargement of free time, not by capitalists as profit. It understood that the tendency of the economic system to use technology as a means to expand productivity made it possible for workers to be free from the compulsion to work long hours. The recognition that technology could expand time away from work for most did not go unnoticed by capitalists. They understood that the possibility of leisure meant that basic needs were being met and the traditional motives for work were no longer salient.

Consumption was created as a new motive; a new "human nature" was constructed around an insatiable need to shop and accumulate commodities of all kinds. This ideological construction has been amazingly successful in establishing the debate around shorter hours. As recently as 1992, economist Juliet Schor, who is sympathetic to a reduction in the workday, argued that workers will have to give up consumption in order to work less hours. Scarcity and sacrifice have become the conditions attached to less work. We disagree. We insist that the technological revolution makes possible shorter hours *and* a rising living standard.

During the early 1920s, shorter hours were also re-
garded as a quick fix to the irrationality of capitalist
production. Working less was regarded as a cure for over-
production and unemployment and was accordingly sup-
ported by business. "Share the work" became a popular
phrase during the Hoover administration and a basis for ra-
tional legislation during the Depression. The Depression
prompted new binary thinking: share the work through
shorter hours or increase the work and spread it among
workers. The options were either those posed by many in
the labor movement and some liberal politicians who advo-
cated for a thirty-hour workweek bill as a solution to
unemployment, or the creation of public works and a min-
imum wage favored by F.D.R. The AFL, then the largest
federation within organized labor, supported limiting hours
by law but opposed the minimum wage as government
interference in the settling of wages. The share-the-work
option was easily constructed as sharing the poverty, as dis-
couraging a thought then as it is now. The legacy of this
connection between shorter hours and low wages is evident
in contemporary thinking that a reduction in the workday
has to be experienced as a reduction in wages rather than
simply less work. The favored option, vigorously pro-
pounded by the Roosevelt administration, was increasing
production leading to increased consumption. Shorter
hours became equated with less productivity, less spending
and less growth. Workers were offered publicly created jobs
through the WPA programs instead. These programs called
for the kind of work that went directly against the possibil-
ity of shorter hours. The jobs were labor intensive and were
intentionally constructed to avoid the use of labor-saving
technology.

A total of about a million people were employed in these
work programs. Many jobs were devoted to public works
such as building new roads or post-offices and cleaning up
rivers and forests. Others employed artists, writers and mu-
sicians who used their time to enrich our culture. But we
should remember that jobs programs were offered at a time
when federally enacted shorter hours legislation was promi-
nent on the national political agenda. The Senate actually

passed the Black thirty-hour bill. Job creation was an alternative approach for dealing with unemployment and sharply reduced income.

F.D.R.'s administration reinserted the notion that work rather than the freedom from it was everyone's right. It was founded on the belief that people suffered mentally and emotionally without work. This ideological link between idleness and self-destruction operates as a fear that keeps us from embracing a curtailment of work. F.D.R.'s policy of expanding employment and economic growth as the way of dealing with the Depression went against the very feature of capitalism that the Depression made clear: that science and technology succeeded too well and put people out of work. Clearly this tendency had to be corrected if the work and consumption cycle was going to successfully be offered as the American birthright. A primary intention of government-managed capitalism was the reduction of scientific efficiency and the use of science to create jobs.

The ideological connection between decreasing work, leisure and economic collapse was consolidated in the New Deal's rejection of Senator Hugo Black's labor-backed thirty-hours bill and the eventual substitute norm of a forty-hour workweek at a time when the workweek was forty hours or less anyway. The economic gear-up precipitated by World War II strengthened the notion that leisure was a destructive, un-American tendency and that happiness could be achieved only by increasing the productivity of labor. Originally intended as a deterrent to longer hours, under circumstances of America's postwar world economic dominance overtime was welcomed by many workers, now loaded down with bills. Still, some fought for shorter hours well into the 1950s. And, in the 1960s young people began to perceive the possibilities inherent in cybernation for introducing a new post-scarcity culture. We can understand the political history of the last thirty years in terms of the largely successful effort of the Right to impose social amnesia on the American people, to snuff out the memory of a time when as a people we began to seriously consider a postwork future.

Organized labor has given up its historical demand for shorter hours at no reduction of pay and has instead come to accept the thinking that shorter hours involves a reduction in total wages. Labor has abandoned its engagement in the struggle for control over the workday. People no longer imagine the possibility of the end of work.

The "workaholic" model, once regarded as an individual pathology, has become the enforced, ethically approved standard; the workday has again become the central feature of human existence. The increase in the workday since 1983, which amounts to one extra month a year, hasn't been a subject of public discourse, though if the current trend continues, the average worker could be on the job sixty hours a week, fifty weeks a year.

It is time for a discourse that imagines alternatives, that accounts for human dignity beyond the conditions of work. It is time to demand and get a thirty-hour workweek. As most studies demonstrate, sharing the work increases individual productivity while reducing unemployment. A reduction in the workweek is in line with the type of job currently being produced by the economy—twenty or thirty hours a week—thus putting an end to the notion that the full-time job is the standard for late capitalism and revealing the possibility for shorter hours at full-time wages. Sharing the work breaks workers free from the binaries imposed by capitalism. We can have shorter hours and leisure and a life sustaining wage. All the previously imaginable possibilities for human development, intellectual growth, community involvement and civic responsibility, family life with mothers and fathers spending time with their children, can become reality. And with the right salary, we can all still shop and sustain our consumer based economy until the time when we imagine an alternative to that as well.

The Case for a Guaranteed Income

Mention the idea of guaranteed income to most people in the 1980s and 1990s and, ironically enough, one is nearly guaranteed to see a look of disbelief cross a listener's face. "How can you be talking about guaranteed income in the conservative era of the last several decades?" someone is

likely to inquire (not only people who are politically right-wing, but many liberals and leftists in nearly as much amazement too). For whether or not one has been exposed to the specialized debates of academic economists and policymakers, many people across the political spectrum have a broad overall notion of what "guaranteed income" signifies. It may not be clear how much a guaranteed income policy would cost, or how it would be implemented, but something like the following understanding is still common in many people's minds.

Most people correctly perceive that if guaranteed income existed in the United States, a commitment would have been made to providing each and every human being with enough funding to live at current levels of material culture *regardless of work*. That is, everyone would be assured a standard of living that met basic nutritional, housing and recreational requirements. Related to this, although less widely recognized, is that guaranteed income will *not* remove all incentive to work since people—then, as now—will surely wish to supplement assured incomes well above only basic levels of comfort. Nor does guaranteed income mean that people will be free never to work, or that socially necessary labor can magically be done away with. Not at all: instead, everyone would assume responsibility for producing public goods and engaging in socially necessary labor (collecting the garbage, running a police force, being clerks or waiters); in addition, a large burden would be placed on the private production sector to induce people to engage in routine labor, presumably at wage rates higher than the guaranteed income and equal to tasks in the public sector. No, the key characteristic of guaranteed income is not that it would suddenly strip us of our desire to work, or remove expectations of local communities for its members to minimally engage in socially needed labor. *The key point about guaranteed income, quite correctly perceived, is that it means we will no longer allow people to starve nor to become increasingly enslaved by and to work*. And it is for precisely this reason—that guaranteed income forecloses desperation and impoverishment, providing a floor below which we will not permit income to slip—that the idea seems so very preposterous, utopian and radical in

the social and historical context of the United States at the close of the twentieth century.

But what does it say about our culture that we find it so strange and objectionable to propose a basic policy measure which insists that people not be allowed to starve? And is guaranteed income indeed so preposterous a notion anyway? One can make a very strong case for just the opposite claim: namely, that the need for some kind of guaranteed income has been rendered extraordinarily *realistic* by the loss of work in late capitalist America. Things have reversed, insidiously, so that now the expectation of finding well-paying real jobs amidst historical shifts toward part-time and temporary jobs and joblessness is itself *utopian* and increasingly *absurd*. As is often the problem with individualistic assumptions, pressure is placed on people to find good jobs that no longer seem to exist; we then end up blaming ourselves for ills that are rooted in the structure of the society around us, not merely in our psyches. Like social security when it developed, then, guaranteed income is, if anything, pragmatic and sensible. It entails *acknowledging rather than denying* that we need protection not just against the uncertainties of old age and death (as in the now culturally accepted, but once seemingly "communist" idea of social security) but against the very social obsolescence which capitalism too—in its old age—is creating: an obsolescence which involves loss of job security at all ages, forces us to work harder and harder, and tends to pit people competitively against one another simply to survive.

Then there is another reason why guaranteed income ought not necessarily to strike us as so preposterous: by no means is it new or, for that matter, untried. Western European countries already have forms of guaranteed income through income allowances that exist to protect people who are out of a job. Moreover, the idea is even more alive than ever in Europe, and is being popularized by economists like Claus Offe for exactly the reason—increasing joblessness and economic insecurities created by globalizing capitalism—why guaranteed income makes sense. Thus, from France to Sweden and Norway, living

proof exists that no one chooses to simply stop working when types of guaranteed income are in place. There is no evidence that things just fall apart, or that basic services and needs are no longer provided and maintained. On the contrary, guaranteed income *attests* to the relative economic well-being of societies where forms of it are and remain in place. It is a mark of a well-to-do society, and therefore reasonably *should* and *could* be easily implemented given the richness of the United States. Nor, for this matter, ought the idea even to be new or strange in the American context. Daniel Moynihan's *The Politics of a Guaranteed Income* was published in 1973, and was a passionate plea to the Nixon Adminstration to accept the idea that some kind of income assurance made sense; Moynihan was annoyed with liberals for allowing the idea to fade out of disagreement over *how much* the guarantee would entail, rather than unifying in appreciation of the idea's significance per se. In *Guaranteed Income: The Right to Economic Security*, written just a decade later, Allan Sheahan reviewed the history of the idea in the process of himself reintroducing it.

But then what is the problem—why do people seem so resistant to the notion and to characterize it as so "over the top"? It cannot *really* be that the idea is too utopian, since historical developments have rendered the proposal if anything a sensible and logical-sounding potential reform; it cannot *really* be that guaranteed income means none of us will ever get out of bed to go to work or that it is alien to the United States, since guaranteed income both exists elsewhere and has been steadily reintroduced in Congress here. And it cannot *really* be its huge cost (since Moynihan, Sheahan and others have argued that it could be implemented quite affordably, especially if we shift funding away from the military, have progressive taxation and substitute guaranteed income for current welfare costs). Perhaps, then, the ironic core to problems with the notion has perversely to do not with its portended disadvantages but with its *advantages* and potential *pleasures*. Perhaps, then, the core of guaranteed income's seeming absurdity is that we are not accustomed to believing that people have a *right not*

only to survival but also to happiness. If so, then the truly disturbing kernel of the guaranteed income idea, and the explanation of its apparent radicalness, is just this: that it still strikes us as unimaginable that we could have policy ideas centered on providing human happiness rather unconditionally; we are terribly used to having to *work* for our survival even, as now, if this has come to mean that we must get used to working ourselves to death. And anything else, working ourselves to death being nothing if not familiar, somehow scares us.

It scares us, perhaps, because of some of the wonderful ramifications which guaranteed income might bring along with it. Clearly, with guaranteed income, there would be no welfare system because the distinction between workers and "idlers" would disappear. Services such as health care (including counseling and therapy), education and social work would expand and be paid for through general tax levies but, assuming a new perspective on "jobs" and the division of labor, would shift their emphasis from work toward solving problems, exploring possibilities, and finding new ethical and social meanings.

School curricula, for example, could concentrate on broadening students' cultural purview: music, athletics, art and science would assume a more central place in the curriculum and there would be a renewed emphasis on the aesthetic as well as the vocational aspects of traditional crafts. We suppose this would lead to a revival of what has become known as "leisure studies": psychologists and sociologists would study what people do with their time, no longer described in precisely the same terms as it was thirty years ago. Concomitantly, space and time themselves become objects both of knowledge and, in the more conventional science fiction sense, of personal and social exploration. Consequently, lifelong learning, travel, avocations, small business and artisanship take on new significance as they become possible for all people, not just the middle and upper classes. Some may choose to participate in the technoculture as a crucial component of the exercise of this right to *pleasure as well as work* that guaranteed in-

come helps to facilitate. Others may avoid the technological construction of social and personal meaning.

The important thing about guaranteed income, then, is that it would allow us *both to survive and to survive pleasurably*. It can facilitate and transform usual dichotomies between leisure and labor; needs and desires; work and play. And consequently, beyond such specious either/or distinctions, guaranteed income is both pragmatic *and* visionary; if implemented, it would symbolize the achievement of both a sensible reform *and* a radicalized sensibility. So, it is critically important that guaranteed income be one component of a number of basic measures proposed in this manifesto to deal with the human costs of technology under globalizing capitalism. In conjunction with calls for shortened workweeks, universal child care and single payer health care, guaranteed income is a necessary (if not sufficient) condition for improving our lives.

Conclusion: Post-Work Manifesto

The new world of post-work is a rupture with both the economic and cultural assumptions of work without end. What has been called utopian in the past is now a practical necessity. The world of post-work doesn't have to mean a world of massive poverty, drudgery and want but it can be a world of limitless individual and social potential where everyone is guaranteeed "the good life." Work that is personally absorbing and satisfying and expressing creativity and freedom is now possible if a movement is formed and a struggle conducted.

We argue here that the moment of post-work is entirely justified. It is time for a movement that struggles for increased wages with less work. We argue here that everyone must be guaranteed a decent standard of living as a minimum. Our proposals assume the goal of assuring the possibility of the full development of individual and social capacities.

We dare to imagine a world beyond scarcity and thus a world where the jobless future is not about misery and

desperation but a future in which time would be liberated and freedom made possible. To imagine is to entertain not only the possibility of a future, but to acknowledge that indeed the present has the potential to be shaped as we dream. To imagine means to dream, to move beyond the boundaries of what is routine and practical. Imagination is lodged not only in the individual creative dream, but in cultural movements that create new ways, new dreams enacted in social solidarity, hope and trust.

Too often this benign act of reflection, this spark of daring imagination, floods an individual with tension ranging from vague uneasiness to high anxiety. To imagine a different way is always a risk. But in the world where work is destroyed by global capital and computer-aided technologies, *not* to imagine an alternative is to take the greater risk. Not to imagine alternatives makes individuals and collectivities dependent on those in power without any possibility of escape. In this situation the Right endorses capital's hegemony while the Left only wants room to maneuver, to make little changes to maintain some social justice and a semblance of equality.

We disagree with both sides and propose a world where work is not without end. We propose a world of self-managed time where radical participatory democracy is possible. Our new technologies managed differently can lead not to more surveillance and less freedom but to a world of less required labor. Under these conditions we now have the time to shape our own lives: family, community and polity. For this to be achieved a different control system is needed for both production and distribution. The basic necessities of life would be determined by participatory democratic means, for we can no longer have individual and social requirements decided by corporate interests and the profit motive. Not just profitable housing but good housing for all. We would emphasize environmental considerations like clean air and water before the profit considerations of the marketplace. Education must be made available for all, not just for those who can afford to pay for it. In this newly imagined world we consider these as human rights. Rights are not the end of a struggle but the beginning demands, as

the very minimum. Ruptures created by the new technologies and global capitalism's hegemony demand that we imagine a world where what was once utopian is now practical. Our very survival requires that our demands are more than the reforms of the system. We demand a world where ordinary people are at the very center. We demand a world where radical, participatory democracy and thus universal freedom is at the heart of any new social movement.

Imagine a Jobless Future

The very premise of a nonwork future evokes a split second, gut-wrenching shock of the inconceivable. The conventional wisdom has elevated work to the status of a holy mission, even as labor productivity, generated by technological progress, makes possible a future without endless work. Western civilizations are fated by historical circumstance to be addicted to a culture of labor. Sometimes its hard to discern whether the initiating stressor for living on the borderline of "making ends meet" is fear of starvation from losing a job or fear of going to Hell and suffering eternal damnation. Such is the massive cultural guilt for nonwork. This strange amalgam of undermined personal security and worth in this society is due to both the physical fear of not being self-sufficient and not being worthy enough in the performance-driven culture of late capitalism.

The simple thought of a life not defined by paid work, where necessary labor is reduced to a few hours a week, strikes terror into the hearts of those who rule society as well as many who are ruled by them. To reflect on the alternative dream of unfettered free time is such a stomach-turning threat to what we suppose is the basis of our economic survival and material well-being that many of us can't tolerate the idea. Therefore, the prospect that our functional needs can be met and we can live our lives with self-defined pursuits is surpressed and hidden from public view except as a ridiculous joke.

We need to remind ourselves that humans existed before the development of the modern work ethic, which, at the earliest, dates from the eighteenth century. We need to question just how natural, normal and just the doctrine of

work without end really is. But more specifically just what is the reason for public and private silencing around discussions of the work ethic? What is the "secret" that has the force of a social "fact"—that paid work is a condition of human nature and that "one must work till one drops"?

Where are the trade unions, the Left, the radicals in all of this? Sadly, some radicals, even revolutionaries believe in work as a kind of salvation. Even Lenin praised Taylorism as a way to achieve socialist goals. Unfortunately, public silencing is at an all-time high and it is reinforced by the spreading dread and reluctance of even those in the political opposition to speak out.

But those who want a future of self-expression, more generative values, economic security and of human kindness rather than subordination, insecurity and brutality cannot afford to remain silent. At the dawn of the new millennium we say openly that humankind is on the threshold of freedom from spending life as an endless succession of days of work.

We do not hold that the future must or should be a replay of the recent past. The cold war is over. With it the millions of defense jobs and relatively high wages and salaries it produced are going fast. America no longer rules world markets for autos and steel. Media and cyberspace, still an American advantage, produce many fewer good jobs than did the older technologies. So, unless we want to say that only the productive among us deserve to live we need alternatives that can assure a life of plenty for everyone. There are no guarantees that the future will create strict equality for all, but we can create a democratic society capable of taking power from the global corporations who are designing a jobless future in which starvation and unemployment become, once more the "normal" state of humanity. Only an active, conscious and militant citizenry can find reasonable solutions to economic and social problems. We must recapture time from the bosses who would keep our collective shoulders to the wheel sentencing us to a kind of information cave where we can only see the shadows, not the substance. We must reject solutions that would recreate the eighteenth-century cities where workers scrambled for

the scraps left over from the excesses of global economics. Then and only then can we achieve the social and political freedom which remains the unfulfilled promise of the great democratic revolutions.

Towards a New Vision of the Future

Our first thrust is to speak the language of possibility and of change. The human and environmental costs of disorganized capitalism, of an unrestrained global free market are disastrous. We declare that the current poverty and unemployment on a vast scale are intolerable. Among other calumnies, disorganized capitalism, with its ethic of unlimited and unsustainable growth and exploitation, has created a veritable global epidemic of diseases. Cancer, TB, heart disease and AIDS, which are in the literal sense "social diseases," are connected to forms of class, race and gender oppression. But while the chaotic but steady destruction of our natural environments such as the ozone layer, rainforests and clean air and water may be understood in class terms, in the last instance unfettered capitalism threatens all life on the planet.

But the time is past when that category of power, "world leaders," can be relied upon to provide solutions. We must imagine a world of both radical participatory democracy and an ethic of public responsibility. The jobless future negates any possibility that the capitalist marketplace can end the current misery. The "jobless future" requires a new ethic of public responsibility which understands that there is work to be done and that we are all obliged to share it. This work has not been in the past because it has been too costly under this regime of capitalism. Thus, schools aren't built, housing isn't built, health care isn't guaranteed for everyone, the air isn't made clean, people aren't fed even though we already have the capabilities of accomplishing these human necessities. Only in a world where the lives of people come before market costs can we rebuild and guarantee as a right a good life to all. Of course a good life to all isn't possible without the maintenance of the ecology of the planet.

Basic battles must be fought. The struggle for a thirty-hour week and a six-hour day with no overtime and no de-

crease in income is primary for providing decent living standards but also for reviving the great dream of a grassroots democracy in which all of us share in decision-making at every level of public life. Shorter hours are required both to create new opportunities and for the personal health of the worker. Since survival for too many requires overtime this would mean a reduction in money wages but not necessarily in living standards. We offer a modest proposal to achieve this objective. Follow the example of many countries of western Europe: decommodify the costs of health care, housing and many public goods.

This is what we mean by decommodification. Instead of privatizing these services make them "universal rights" and finance their costs through public taxation. Dispense services on the basis of need, then consider cost. Would this proposal cost more for ordinary people earning the average wage? Not if we transferred a considerable portion of the defense budget to the social wage (that is, funds to meet basic social rather than private needs) and reinstituted a progressive tax system in which people who earn more would pay more. Corporations and wealthy individuals would no longer receive public welfare and take advantage of loopholes in the tax code which enable many to escape paying any taxes. Decommodification would enable all to have the "good life" not as a privilege or an accident of time and place but as a right. Decommodification then is not just removing central human necessities from the marketplace but means the removal of humans as workers from their own status as commodities.

Decommodification of many aspects of everyday life that are now subject to the laws of profit is the beginning of a broader struggle for a world in which peoples' lives are no longer dominated by jobs and trying to "make ends meet." Free of this burden they can now be citizens who *participate* in making the rules in their communities and in other political and civic arenas, not merely give their consent to the rules made by others. Broad, democratic participation requires free time once only available to the few but now possible for the first time for everyone. Now we can have a

definition of citizenship that is not centered on voting but on governance, on collectively managing our lives.

Since, as many have noted, the world is becoming a smaller place, we cannot confine our vision or our fight to the borders of any country. The emergence of transnational capitalism dominated by US-based corporations means that what happens here eventually can happen anywhere.

Like the great eight-hour-day struggles at the turn of the twentieth century, we envision an international movement for shorter hours, to establish and, in Europe, preserve guaranteed income, for expanded educational opportunities and other public services.

For a world beyond compulsory labor and where human freedom is the measure of social life we propose the following program:

1. Guaranteed Income: Everyone would be guaranteed a minimum annual income sufficient for a decent standard of living. This would include nutrition, housing, clothing, transportation and recreational requirements. Everyone would assume the responsibilities of producing and maintaining the community. Able-bodied women and men would share the tasks associated with a clean and healthy environment and one that affords its members amenities such as education, recreation and cultural development. If adequate income were guaranteed for all, the private sector would have to pay wages above the income guarantee to motivate workers in this sector. (After all, this was the original idea of minimum wage legislation: to raise the general living standard by raising the bottom. Even if most people earned more, the floor on the incomes was measured by a basic, adequate income level.) In order to reduce their costs corporations would be induced to further develop labor-saving technologies. Savings would be shared in the form of more public services and shorter hours.

There would be no welfare sector—with its cycle of dependency and degradation—because of the income guarantee. Services such as health care, education and social work would expand and be paid for through the

progressive income tax. As a result there would be a new perspective on jobs and the emphasis would shift from work done for the purchase of consumer goods to work done for problem solving, exploring possibilities and for finding new ethical, social and individual ways of life.

2. Radical Participatory Democracy: With the end of endless work, which binds our time to the demands of profit, we will finally have time to truly participate in the governance of our social world. We will finally have the time to imagine alternatives to the present and the possibility of a better future. With the progressive reduction of work time will come the possibility of all of the people to participate in democratic decision-making. One example: using e-mail and the Net for providing information in order to expand decision-making to wider constituencies. This is contingent on the availability of computers and training for all people. With this form of enhanced face-to-face communication we can bring to birth a truly democratic civil society in which all members could participate in the discourse on political, economic, cultural, environmental and recreational issues. Decisions would be made by a free association of individuals in popular assemblies. This would amount to the creation of a popular politics.

The liberation of time from endless work and the new power of ordinary people to participate daily in politics and community affairs is the precondition for the emancipation of the individual, who would gain the freedom of a self-managed life. But there is more than participation in civic affairs. The slogan for the eight-hour movement was "eight hours labor, eight hours rest and eight hours for what we will." "What we will" remains a goal for most of us. Our time seems crowded with imposed obligations. While some of these are both necessary and pleasurable, many are not. Cutting working hours would increase time to develop our capacities or simply to do what most pleases us, including things which provide private enjoyment without the impositions of external authority.

3. A New Labor Policy: We need to consider the pace of technological change and the effects of corporate reorganization that have shed tens of thousands of employees.

We have to gauge these developments in terms of the impact that they have on individuals and communities. Though we aren't against the development of technological innovations or forms of work reorganization which lighten our burdens, these should be open to public scrutiny, and planning should be open to public participation. Democratic decision-making in the workplace can have important outcomes for human survival at the individual, social and environmental levels. The costs of these new technological developments must be paid for by the corporations who have a responsibility to the public. These costs are measured by job and wage loss but also their effects on neighborhood and regional institutions and services and by potential environmental hazards associated with conducting business and abandoning production sites. A sustainable biosphere with stable ecosystems is as important to human survival as is a sustainable economy. In order to achieve a sustainable economy we foresee the need to reregulate many aspects of production, commerce and technological innovation by subjecting them to ecological and democratic criteria. In this respect, the bureaucratic regulatory agencies would not remain the court of last resort. As in AIDS policy—where those affected by the disease have played an active role in negotiating the size of the research budget, its priorities and policies affecting the introduction of new drugs—workers and their unions, community groups and individuals would have a substantial voice in various aspects of economic policy at both the enterprise level and regulatory agencies.

4. The Reduction of Working Hours: There has been no significant legal reduction in working hours in the United States since 1938. On the contrary, working hours have lengthened as many employers require overtime hours on penalty of discharge or inadequate income. The distribution of benefits of the new technologies has been one-sided. Only corporations and some professionals and entrepreneurs have benefitted. For most workers the new technologies have only created job insecurity and tens of thousands of workers have suffered job loss, wage loss and

part-time or temporary work. It is time that the population at large benefit from the progressive reduction of working hours. Thus we call for a six-hour day without a reduction in pay and for the abolition of overtime except under special conditions that, in any case, would not be compulsory. This will cause anxiety for many who have depended on overtime for their survival. The income guarantee and the decommodification of costs such as health care and education may alleviate problems associated with income losses for some. Equally important, we believe there can be no genuine improvement in general living standards until the standards enjoyed by the minority are shared by the vast majority. Unless the scourge of unemployment and underemployment is removed for all, the relative privileges which some have achieved will remain at risk.

5. Higher Education as a Form of Life: The new technologies require an increase in knowledge work. The education required to perform this work should be continuously available to all. At the same time the thrust towards multiculturalism and the emergence of new identities means that we must be educated for a global world. This requires a global curriculum that isn't only Eurocentric. This doesn't mean that we no longer read *Hamlet* and Greek philosophy but that we read Shakespeare as well as African folktales and Indian and Chinese philosophy. A global curriculum requires more time for education as it does for new developments in science and philosophy. For the first time in human history everyone may be able to pursue their own educational ends at any age and for the goal of individual development. When we have freed ourselves from work without end, education isn't required to be only vocationland. In the post-work world intellectual and aesthetic interests of students are primary. Students will enter and leave education according to their needs and not just the requirements of jobs.

6. There is Still Work to be Done: Despite labor-saving technologies, our roads, bridges, water systems, schools and parks need rebuilding and repair. We need to create an effective mass transit system in every urban commu-

nity and nationally which can gradually reduce the use of automobiles. We need to maintain and refurbish the environment and public spaces. We need to care medically and emotionally for our population. Cancer, heart disease, AIDS, and other diseases require both research and massive care facilities.

7. People do not live on bread alone: There have been periods in the twentieth century when an effort was made to publicly finance the arts in a fairly substantial way: the Depression and the 1960s. The New Deal's arts program was killed when some reactionary politicians discovered radicals among the program's employees. In the 1990s another generation of reactionaries have all but killed a much more modestly funded National Endowment for the Arts because it gave grants to dissenting artists, especially those who broke puritanical sexual codes. Creating visual, written and musical arts are an important part of the new public responsibility because, typically, the market does not support most people who produce culture, especially those who challenge us to think differently. We need a well-funded national program for artists and intellectuals who recognize their duty to speak to us freely and which opposes all forms of censorship masked as morality.

8. We favor a universal public service in which all tasks are shared including those tasks that are most unpleasant: In fact we suggest public service jobs be paid on the principle of reverse renumeration. This means paying more for jobs that are more unpleasant but enhance public goods, such as garbage collection, street cleaning, heavy industrial tasks, repetitive bureaucratic work, caring for children and the disabled. As the values of shared work are enhanced and new technologies are developed the amount of time required for these jobs will diminish. These are the requirements of public service in a world of participatory democracy and in which the individual has been liberated from work in a post-work world.

The fulfillment of any of these elements, let alone the whole program, will require a new alliance between the

labor movement and other social movements—feminism, black freedom, gay and lesbian and ecology movements. The struggle will have to be conducted on the shop floor, in local communities and in legislatures at all levels. We believe this manifesto is an organizing program for the revitalization of the labor movement. Intellectual as well as manual and clerical workers who have felt unions do not speak to their concerns may now find reason to join a new labor movement. If our analysis is accurate neither of the major parties are likely to sympathize with these objectives. The identification of many of these movements with the Democrats requires serious re-examination. We believe that only a politically and ideologically independent alliance of labor with the social movements can constitute an alternative to the prevailing political system, which has forged a consensus in the interest of transnational capital. Breaking from the consensus will not be easy. Some harbor illusions that the virtual single party system is supple enough to accommodate itself to radical change. In despair some dismiss any genuine alternative politics as hopelessly unrealistic. In our view what we have proposed here is eminently realistic, though impossible to realize without a sharp break with the past. In any case, given the hollowness of the dominant political culture there is almost nothing to lose.

∎ **Benefitting From Pragmatic Vision, Part I**
The Case for Guaranteed
Income in Principle

Lynn Chancer

"If man is inherently irresponsible and a bum, the
Guranteed Income is undoubtedly the most stupid
idea that anybody has yet managed to come up
with. If, on the other hand, you believe in the long
run that human beings can become responsible,
can rise to the responsibility of developing them-
selves in our society, then the Guaranteed Income
is the only thing, in my opinion, which will begin to
lead us into a free society."

—Robert Theobald, *The Guaranteed Income*, 1966[1]

"Guaranteed income would not only establish free-
dom as a reality rather than a slogan, it would also
establish a principle deeply rooted in Western reli-
gious and humanist tradition: man has the right to
live, regardless! This right to live, to have food,
shelter, medical care, education, etc., is an intrinsic
human right that cannot be restricted by any con-
dition, not even the one that he must be socially
'useful.' "

—Erich Fromm, "The Psychological Aspects
of the Guaranteed Income," in
The Guaranteed Income, 1966[2]

I An Historically Oriented Introduction

Try seriously proposing in the United States of the late
1990s that to institute a guaranteed income plan would be
an excellent idea. One is virtually ensured, if nothing else,
to be met by looks so surprised that one would think the lis-
tener had stumbled upon a lunatic, a fool, or both. But if

we start from the premise that such widespread incredulity *itself* is peculiar and begs explanation, then the subject of guaranteed income invites deeper scrutiny for this reason alone. This essay takes the apparent absurdity of the idea of guaranteed income in principle as a starting point for investigating contemporary ideas about poverty, class and work. What is it about this particular policy suggestion which is apt to strike many Americans as especially naive and utopian, as wrong-headed or perhaps even angering, especially at this moment in time?

Commencing with recent history, it may also be surprising to learn that the idea of guaranteed income has already been broached in recent decades on American soil. Therefore, the strangeness of the idea cannot entirely be attributed to its never having been encountered before; if guaranteed income sounds preposterous, this cannot be explained solely in terms of the individualistic character of political traditions in the United States. Instead, the humanistic enthusiasm as expressed (if in "male" oriented language) above by Robert Theobald, a British economist, and by Erich Fromm, a German psychoanalyst and social theorist, comprised only two of many influential voices according guaranteed income a legitimacy in the 1960s and 70s that is only incredible when contemplated retrospectively now. Interest spanned the political spectrum from right to left, and included economists, social workers, academics and presidents. According to Premilla Nadasen, contemporary accounts have been marked by a tendency to stress mostly the conflictual character of the 60s, thereby overlooking the striking degree of consensus which existed—if remarkable, again, only from a 1990s vantage point—about the need for some kind of income plan to eliminate burdens of poverty and economic insecurity of concern to all Americans.[3]

On the other hand, it is also important to emphasize that the brief history about to be reviewed should not be too blithely idealized: in retrospect, events may sound rosier and more progressive than they were perceived to be, and actually were, at the time. Looking backward reveals that certainly no flaming radical but conservative economist

Milton Friedman introduced the idea of a floor below which no American's income should be allowed to fall. Friedman unveiled a "negative income tax" proposal in his 1962 *Capitalism and Freedom*, published the same year when Michael Harrington's *The Other America* appeared and later influenced Lyndon Johnson to declare a "war on poverty." His hope was to find a cheaper and more efficient way of eliminating welfare. Similarly, while seeming relatively progressive in retrospect, Richard Nixon's Family Assistance Plan was defeated by Congress in 1972 partly because of strongly voiced concerns from welfare rights advocates that families might be left poorer after the program was instituted at even lower funding levels than existed before; the plan was also limited in its intended scope, eligible to families and not to the many individuals who also found themselves in need of economic assistance.

Just as important a caveat to emphasize in advance is that advocating a negative income tax does not simply equate with supporting guaranteed income: sometimes these terms have been used synonomously, while on other occasions they are employed to refer to separable ideas.[4] According to Alvin Schorr, three different perspectives on income maintenance have circulated in the U.S. context. One dates back to 1946, when Lewis Meriam proposed that a tax return establish eligibility for a basic income floor[5]; the second perspective, within which Friedman clearly should be classified, is that of the negative income tax.[6] Both the Meriam and Friedman perspectives share the characteristic of being means-tested proposals, *i.e.*, income support would only be provided to individuals in cases of demonstrated need. This is quite different from the intention infusing the third category Schorr identifies, namely, the hope of legislating a minimal universal income support payable to everyone simply because one is human: this notion has been referred to as the demogrant, and has attracted a quite different set of adherents from British social policy analyst "Lady" Juliet Rhys-Williams through Theobald, Edward Schwartz and later (as mentioned in his 1972 presidential campaign) even George McGovern.[7] Should a demogrant be legislated, it would be funded through a variety of possible means from a

reduced military budget to redistributive corporate taxes. It was even Theobald's hope that redistributive measures would not be necessary, and that eventually capitalism's productivity would create greater social wealth capable of funding this form of income entitlement[8].

These caveats are significant and will have to be addressed in the design of any future guaranteed income committed to avoiding the creation of newly severe problems in the course of resolving older ones. But I leave it to the forthcoming Part Two of this essay to discuss the case for guaranteed income in practice as well as in principle: it is crucial to draw upon the many writings and policy documents already written on the subject to specifically show the possibility of funding a guaranteed income plan intelligently and without unreasonable social dislocation. Still my primary focus for now is on what strikes me as a necessarily prerequisite step, a chronological *sine qua non*: changing the ideological predispositions which need to shift if any guaranteed income proposal is ever to see the light of day. For unless questions of basic moral and political belief are confronted, lack of sufficient determination—that is, a shortage of social will—tends to doom from the outset any policy proposals, unless extremely modest and piecemeal, which aim at eradicating poverty or are concerned about redressing extreme class inequities in the United States. To the extent such a shortage of will persists, it also necessarily influences shortages of resources and funding, these problems becoming more or less "real" depending upon how we have chosen to think or not think about the social world.

That there has already been an attitudinal shift is verified by the fact that, by the time of this writing in 1997, not only the validity of the idea of income supports in particular but of *entitlements in general* have been severely weakened and delegitimized in the United States. From this standpoint, and notwithstanding the analytically important distinctions that simultaneously persist between them, the various types of guaranteed income plans suggested from the 1940s until the present (including the particular interest the idea drew forth in the 1960s and 1970s) still share a

vital ideological element in common. All insist that some kind of income assurance must be institutionalized as a universal public entitlement. Even if the Friedman proposal was far too limited in intention and funding—indeed, too "negative"—a downward limit on income was nevertheless being conceived of as itself a universally applicable entitlement. This may be a key element as to why, from the vantage point of the 1990s, the Nixon proposal looks more visionary now than it did in its own time: in the late 1960s and early 1970s, the very notion of an entitlement had not yet been so severely undermined.

Thus, a brief historical overview is in order before concentrating upon this essay's own major goal: presenting a case for guaranteed income in principle a second time around in which I argue that the concept and reality of "entitlement" is needed even *more* in the 1990s than previously. Placed in historical perspective, then, it is not insignificant that a conservative economist like Milton Friedman was embracing in 1962 the very idea of an income floor below which no American's income should be allowed to fall. Again, for Friedman, the appeal of a minimum guaranteed income was not only that it would alleviate poverty, but also that it acted as a substitute through which an unwieldy and already unpopular welfare system could also be eliminated. If instituted, Friedman thought, a negative income tax could simply be administered by the IRS; checks would be mailed to recipients, just as "positive" taxes are ordinarily sent to the government by those who owe money in a given year.[9]

But even if only an embryonic notion of entitlement was involved, it is therefore significant that not only Friedman but a host of other economists in that decade were entertaining the idea. To the left of Friedman, Theobald was calling in *Free Men and Free Markets* (1963) for a guaranteed minimum income to be provided all Americans in the amount then suggested of $1,000 year for adults, $600 for children and $3,200 for a family of four. Theobald defined guaranted income as a ". . . guarantee to every citizen of the United States, and to every person who has resided in the United States for a period of five consecutive years, the

right to an income from the federal government sufficient to enable him to live with dignity."[10] Around the same time, as part of President Kennedy's Council of Economic Advisers, James Tobin and Robert Lampman were also discussing the notion.[11] At Harvard, John Kenneth Galbraith was hailing Friedman's idea as one of the few genuinely fresh ideas proffered by American economists since the New Deal.[12] By 1968, 1,300 economists at almost 150 institutions around the United States had signed a petition urging Congress to adopt a "national system of income guarantees and supplements."[13]

Yet it was not merely economists, conservative as well as liberal and left, who were struck by the entitlement-based idea of "income maintenance" to deal with poverty. In 1964, the National Association of Social Workers issued a position paper calling for "income as a matter of right," and at a uniformly adequate rate. In 1967, the National Social Welfare Assembly was advocating "minimum standards of assistance" regardless of age, family situation, or length of residence. Then, too, a slow but steady history of guaranteed income had commenced early in the decade inside political and legislative channels. In 1964, President Johnson named the first of three task forces to study income maintenance plans; the third, in 1966, endorsed the idea of a negative income tax on a limited basis and recommended the creation of a presidential commission to further study the problem.[14] Johnson also created the Office of Economic Opportunity which, under the stewardship of Sargent Shriver, published a plan stressing the need for income maintenance in 1966. The plan declared that the time had come ". . . when the Amerian people will accept a guaranteed minimum income at the poverty level as a right in a wealthy country."[15]

Even more unfamiliar from a contemporary perspective is that OEO funded a guaranteed income experiment in four New Jersey and Pennsylvania locations. The pilot program involved giving 1,300 families a guaranteed minimum at the same time a negative income tax was also tried; deductions were taken from people's additional earnings at rates low enough to retain work incentives.[16] The project was motivated by the goal of discovering if a serious political objec-

tion to guaranteed income on the part of the wider public was, or was not, well-founded: namely, the fear that if guaranteed income existed, either no one would want to work at all or recipients would reduce their labor participation so precipitously that the American economy would crumble. However, when the results of the experiment were reported at a conference held by the Brookings Institution, and detailed findings later published, it was found that no such massive withdrawal of labor force participation took place during the three years—1968 to 1971—the program was in operation. Contrary to public worry, some people decreased their hours but to only a small degree. Moreover, from the perspective of persistent racist stereotypes that still poison discussions of race and poverty to this day, even some positive effects were found for black men and black women.[17]

In 1969, a presidential body on which business leaders as well were active released the "Heineman Commission" report, named after the president of Northwest Industries who had headed the group. The report concluded that "only when the poor are assured a minimum state income" would fighting poverty ever become effective; not only did the Commission call for a job strategy but it admitted that "employment approaches alone cannot provide a satisfactory sole basis for a general economic security system and are not fundamental alternatives to income supplement proposals."[18]

But probably the most significant of these events, and their decade long culmination, occurred in August 1969 when Richard Nixon called for the creation of a Family Assistance Plan only eight months after his election. Nixon's plan would have guaranteed all families with children a minimum of $500 per adult and $300 per child or, as already noted, an extremely inadequate $1,600 for a two parent family of four. In its efforts to include the working poor, Nixon's proposed FAP *was* a form of guaranteed income although, as we have seen, a modified and specific version: it was a negative income tax. Over a course of three years' time, though, the Nixon plan was defeated by a variety of forces and for a panoply of reasons.

For one thing, many liberals felt FAP would disproportionately benefit people in the South and fail to adequately

assist the huge numbers of impoverished people living in Northern cities. For another, while poor people had few organized constituences representing its interests, those organizations that did exist were against the plan; even the apparent beneficiaries of FAP were unhappy with its terms. It was the National Welfare Rights Organization (NWRO) which played the aforementioned key role in bringing welfare mothers to Washington to testify against the Nixon proposal. But NWRO members nicknamed FAP a "family annihilation plan," and were bitterly opposed both to its too low funding levels ($5,500 was believed the requisite amount needed to eliminate poverty for a family of four, not $1,600) and to the work requirement clause Nixon had added as much from reasons of political expediency as conviction.[19] Indeed, as a result of the work requirement clause, one could argue that the 1969 proposal was in one sense a culmination of progress made over the decade and in another a foreshadow of impending defeat. The clause suggested that while entitlement programs are clearly not unknown in the American context, the concept of income support was by no means widely acceptable and familiar to the broader American public outside the realm of economists, intellectuals and an even bipartisan range of politicians. While guaranteed income was surely able to garner greater interest in the 1960s than is conceivable now, still, political difficulties encountered in the more liberalized decade confirm that underlying individualistic presuppositions are deeply rooted in the United States indeed.

In the face of such opposition, it is not surprising that left and liberal support rapidly faded. And, while some conservatives had clearly been interested in income maintenance over the course of the 60s, enough antagonism also persisted that many Republican politicians were only too glad to see FAP defeated. By the end of the decade, then, it was not common concerns about obliterating poverty but intensely held and biased sentiments which seemed to have won the day—at least this first time around. Without much in the way of counter-vailing notions to impede them, conservatives were freer to reiterate that Americans might not

really have wanted to pay the way of those who were sup-
posedly lazy and unwilling to work (and who happened to
be, of course, disproportionately minority) anyway.

Thus, by 1972, the surge of 60s interest in guaranteed
income had come and gone. Yes, the notion continued to be
discussed under the Carter administration; and, in the 80s,
guaranteed income was the focus of an occasional passion-
ate treatise.[20] Yet the fact that an important historical mo-
ment had passed is reflected in the opening sentence to a
book written to analyze how and why the Nixon plan went
wrong by (now) New York State Senator Daniel P. Moyni-
han, himself a long-time advocate of guaranteed income.
"In the course of the 91st Congress," Moynihan began un-
happily, "the United States *almost established* a guaranteed
income."[21] (My emphasis) What Moynihan could not ob-
serve was that the idea was to fail yet again in 1978, when
Jimmy Carter resuscitated and even expanded the more lim-
ited Nixon proposal through his Better Jobs and Income
Program (BJIP).

Even more sobering, though, is another conclusion that
Moynihan could not possibly have reached in 1973 on the
basis of the brief history just surveyed, but which seems de-
pressingly apparent in hindsight. For with the failure of
FAP, and later of BJIP, came not merely a blow to the extra-
ordinarily important idea which was at least being circu-
lated in the 60s and 70s that income floors were necessary
to protect against poverty and economic insecurity for all
Americans. But also, I would argue, with the defeat of these
efforts at legitimizing the very notion of entitlement, the
gradual defeat of welfare as we now "knew" it could be
more easily accomplished. Two developments—defeating
the idea of income maintenance as an entitlement by the
early 70s, and the rise of conservative ideologies which
managed so effectively over the course of the 1980s and
90s to stigmatize the poor—may have come together histor-
ically, like hand-and-glove, at a critical moment when the
misfortunes of one accrued to the benefit of the other.

Of course, like all partly contingent historical outcomes,
this one was not determined or fixed in advance. All that
can be said retroactively is that hating the poor, rather than

ending poverty, was a well-engrained cultural habit by 1996 when the defeat of welfare climaxed at the close of the first Clinton administration with little in the way of social conscience or collective guilt, let alone mass demonstrations, to prevent it. Nor was anything in place, as even many conservatives in the late 1960s would have believed necessary, to provide an institutionalized substitute well in advance. By the late 1990s, the figure of Richard Nixon appears perversely left-leaning in historical comparison.

But it is to the present and future that this essay is devoted, not only or predominantly to revitalizing the past. In shifting to the 1990s, two things must be noted simultaneously. Clearly, guaranteed income has been discredited along with other possible entitlements as conservatism slowly but surely became rigidified through the Reagan/ Bush years. At the same time, the 1960s ought not be romanticized to the point where the difficulties which existed then as well are forgotten. For our historical overview indicates both that guaranteed income is not a new idea and that objections to it are deeply rooted in long standing attitudes. Thus, history provides a necessary but incomplete start for better understanding how and why the idea of income maintenance has become discredited by now.

II From the 60s to the 90s: Guaranteed Income Revisited

The question must also be considered theoretically, then, not just historically: how did the relative significance of the notion of guaranteed income in the 1960s metamorphosize into apparent *in*significance? In hindsight, the defeat of guaranteed income by the early 1970s obviously signified a victory of stubborn biases over vision with regard to common beliefs about the sources of poverty and class inequities in the United States. It is difficult to see how later conservative efforts were not thereafter made easier when they directed attention away from structurally based critiques to the demonization of individuals—toward the making of a stigmatized "underclass," and onto obsessive concern about "pathologies" that allegedly characterize only the poor.[22]

But what is most ironic of all about the long-term cul-
tural ramifications of guaranteed income's earlier defeat in-
volves a point that differentiates our 1990s contemporary
context from that of the 1960s most dramatically of all.
Whereas it was mostly "the poor" and "working poor" who
needed income-based protection beforehand, today it ought
to be apparent that anxieties about the economy are far
more common and widespread cross-class.[23] For insecuri-
ties are democratizing, not dissipating, having become by
now well distributed among the working and middle classes
even as poverty, too, has grown. This was a major point of
an excellent series published in book form by *The New York
Times* entitled *The Downsizing of America*: jobs are being
lost and, when recreated, provide worse benefits and wages
than people had received before.[24] Moreover, even after
President Clinton was elected to a second term amidst polls
showing that many Americans were reassured that the
economy overall had improved, *The New York Times* was
still reporting on December 19, 1996 that 70% of Ameri-
cans felt vulnerable to layoffs (this being a greater percent-
age than those who actually voted).[25] Thus, even if the
unemployment rates are low as in the late 1990s, anxiety
levels seem to be stubbornly persistent.

At present, the average American is far more cognizant
than was likely to have been her or his 1960s or 70s coun-
terpart that being a banker or lawyer or academic Ph.D.
does not protect one from the sorts of layoffs and disloca-
tions which once appeared only to affect industrial workers.
Millions of avowedly middle class citizens are becoming
aware that their children's economic futures are not safe;
young people in their teens and 20s are themselves likely to
doubt that their income and lifestyle will ever reach the
same level once enjoyed by their parents. Middle managers
know that they are vulnerable, and doctors horrified at the
developing direction of managed care are beginning to dis-
cuss the need for unionizing among themselves. Nor can
municipal workers at federal, state or city levels avoid
recognition of their own historically escalated vulnerability;
college B.A. degrees are widely known to provide insuffi-
cient, if any, protection against "downsizing," "outsourcing,"

and other late capitalist processes associated with job displacement. That the union movement under the AFL-CIO stewardship of John Sweeney is gathering steam for the first time in decades is not accidental but also relates to a sense that economic insecurities are worsening, whether or not unemployment rates are bragged about to be low. Based on these developments, one might expect that by 1997, a notion like "guaranteed income" would *not* seem outlandish but sensible as a protection against the vagaries of a rapidly changing economy for a variety of Americans—for the working poor, the middle class, even upper middle class members as well as, quite obviously, to ensure those who are poor.

Let us return, then, to *this* essay's opening sentence to expand on what may have been a too hastily presented claim. The contention that guaranteed income strikes people as anomalous by the late 1990s is easily tested by informal observation, by broaching the topic to friends, associates or family members and then noting for oneself the tenor of discussions which ensue. Based on my own experience, at least, I have noted that adverse reactions extend across the political spectrum from right to left. Such reactions appear to be quite generally distributed, just as willingness to at least *entertain* the concept of guaranteed income was far more common across the board of people's political imaginations in the 1960s and 70s.

Examples should illuminate and concretize the claim. A dinner party to which I was invited by an old college friend only several months ago, for instance, was attended by an assortment of upper-middle-class professionals who usually vote moderate Republican or liberally Democratic; the guests were mostly in their 30s and 40s, their occupations ranging from newly-made law partners and investment bankers to well-to-do young artists and publishing executives. Here, suggesting guaranteed income was a fine idea soon led to heated argument, and quickly aligned the issue with current debates about welfare. One person expressed the same reservation about guaranteed income he felt toward welfare, airing a sentiment not only common but (as we saw) historically embedded: "Why should we support

people who are lazy and don't want to work?" But, more than anything, the group was shocked that anyone could be so "out of touch" with the allegedly self-evident character of our age to even think of guaranteed income as a sane or feasible alternative.

Of course, it is with this latter point—not with the stigmatization of persons on welfare, or with the belief that privatization can or will obliterate want and need—that many parties of much more left/liberal inclination are nonetheless likely to agree. At this side of the political spectrum, for instance, a colleague in political science who studies poverty programs in the 1960s and who despises the social insensitivity of the 90s, nevertheless concurred that I must have "lost my mind" after she heard I was writing an essay favorably disposed toward guaranteed income. How could I possibly think such a notion could garner any support in the climate of the 1990s, she exclaimed! Similarly, a friend who is a democratic socialist posited that it should be jobs and full employment that leftists in the United States ought these days to promote—surely not guaranteed income. When asked what happens to people if jobs are increasingly displaced by rapid technological changes, and if wages and benefits are so low that more and more people are finding it difficult to comfortably survive, this person insisted that turning to guaranteed income still made little sense as a practical matter. There will be minimal or no political support for such a proposal, he contended; at least working on other measures, from new job creation to decommodified health care or child care, holds out some hope of success in Reageanesque and economically conservative times like our own.

The bulk of this essay's remaining points are organized around an enumeration of, and responses to, such objections. But perhaps all of the ensuing arguments are best viewed in an updated context by first reconsidering whether those who are liberal or left-leaning in their views can really rest vindicated in the apparently "pragmatic" assessment that issues relatively more acceptable to the American political psyche—not, then, guaranteed income—are best able to garner support and success in the 1990s. Implicit here is

the assumption that a wiser and more efficacious strategy in the United States at present is to move gradually from one issue promoting of greater social humanity to more and more humane ones. If we start from one reform that can be "won," so the argument goes (and even if we must compromise tremendously on the contents of a given demand), people will slowly but surely move from willingness to enact one generous social policy measure toward willingness to enact a next.

But just the reverse argument can be made, and even more powerfully on the basis of historical evidence based— this time around—on the experiences of the 1980s and 90s. For the first presidential term of Bill Clinton seems to have been a classic object-lesson in exactly the opposite conclusion. Barely any gains seem to have recently accumulated from *not* promoting more ostensibly "radical" notions like guaranteed income, either. For it is not as though left/liberal pragmatists can point with satisfaction to universally available and single-payer health care systems by now achieved, stripped of the profit-driven medical dangers of privatization and built via incrementalist savvy. It is not as though unemployment and social security benefits are being extended rather than defended, or that universally available child care has advanced to a newly popularized position in mainstream 1990s American cultural/political "discourse" of the day. Instead, the reality around us appears far more accurately characterized as one wherein an almost complete lack of radical defiance expressed through strong ideological and social movement organization has made it all too easy to dismantle—with hardly, again, a whimper of opposition—whatever commitment to a European-style welfare state might previously have existed in the United States (if relatively weakly so, by comparison). Clearly, things have not moved in the direction of greater progressivism over the course of the cautious Reaganesque 1980s and 90s. Little seems better and much worse, a statement epitomized by the abandonment of welfare with nothing to replace it.

But how does this relate to our topic at hand—to presenting a case for guaranteed income a second time around? Let

us focus on a simple theoretical definition of guaranteed income. If we agree that guaranteed income is the right to adequate monetary support needed for basic survival, then a person's income will not be permitted by the state to fall below this historically assessed and variable level. Most importantly, this income would be guaranteed *simply because a person exists in a given society*. In other words, guaranteed income by this core definition is a social commitment held to regardless of work-related or other conditions being met; it is the antonym of current notions of "work-fare" (and, by this definition, again, not what Richard Nixon ended up proposing). Because envisioned here as a basic *right*, the sense of specialized stigma that has long adhered to welfare would be purposefully alien to guaranteed income *qua* generalized and generalizable entitlement. Indeed, from this, one could posit that guaranteed income in this sense symbolizes and embodies what all "entitlements" refer to at their ideological core. Other contemporary entitlement programs seem relatively bashful by comparison, limited insofar as they are inclined to stop short of full commitment to this belief that human beings have a right to survive *simply because we exist*.

Thus, to promote other social welfare programs, much more familiar and certainly not absurd sounding to the American ear, is still to make relatively more conditional (though, of course, also utterly worthwhile) claims. For instance, to argue in the 90s for health care, even of a universal kind, is still tantamount to calling for protection only *when a person is sick*; to advocate unemployment benefits is to agree that people need help for short periods but only *when out of work*; to defend the Social Security system is to understand problems of economic disability which arise but only *when one is old*. Perhaps, then, guaranteed income sounds so absurd because by this conception, and if actually enacted, it would mean that being left to starve or to experience chronic economic insecurities had become culturally unacceptable *no matter what*—including but going beyond the set of extenuating circumstances listed above. (Presuming, of course, that a particular society could afford the entitlement—a condition many observers, past and

present, believe to be fulfillable once the social will to enact the idea was procured itself.)

Thus, the common response of *ridiculing* such a notion in the 1990s, as noticed through even a cursory investigation, ought to gravely concern those who are of liberal or left persuasion whether or not interested or compelled by the notion of guaranteed income per se. For I suspect that a society in which the mere idea of guaranteed income has come to be greeted with astonishment or derision will also be one wherein the advantages of entitlements *per se* and *in general* are likely to stay difficult to promote, and even harder to defend. Thus, incredulity toward "guaranteed income" is not surprising but predictable during periods like our own when profound conservatism and selfishness, far more than collective generosity and sensitivity, link seemingly disparate policy reactions.

Nor do solely pragmatic liberal/left reactions have much cause to recommend cautiousness based on social movement precedent anyway. Looking back once more at the 1960s suggests that changes wrought in American cultural consciousness were hardly occasioned by gradual shifts made from less to more "radical" demands, but were due to the benefits of acting in *historical unison* with other protest groups also loudly active at the time. The relatively greater acceptability of guaranteed income in the 1960s did not arise in a vacuum, but was interconnected with the willingness of other groups committed to feminism, to gay rights, to ending the war, to socialism, to doing away with poverty—to speak on behalf of their own and sometimes each others' causes.

Thus, social movements seem to have thrived most powerfully and influentially when moved to *say what was meant*. It is arguably only when such directness is present that movements can be characterized as on the historical rise (just as being stuck in a defensive posture, as through much of the 1980s and 90s, correlates virtually by definition with a felt necessity to distill, shirk or refrain from saying that which is meant). After all, if committed (say) to women's rights and racial equality, there is not much else that can be said or demanded *short of that*; one's goal was and still is

just this: women's rights and racial equality. Consequently, there seems good reason to conclude that social movements swell as much on the basis of strongly expressed moral and inspirational appeals as they do from pragmatic cautiousness exercised—as is the crowning paradox of this Weltanschauung—from fear that, otherwise, a movement will dwindle and fail.

And, of course, an analogous argument can be made with regard to *class*, this critical dimension of the social world so difficult to politicize in the U.S. context and about which social movement organizations are by the late 1990s terribly weakened. Once more, a bottom line in this case persists whether one calls oneself a "democratic socialist" or a "radical democrat" or any other slightly adjusted post-Communist appellation.[26] For, indeed, there is not much getting around saying what one means insofar as some economic redistribution (whether progressive taxation, eliminating corporate-protected economic loopholes, or trimming military budgets) will be required if we are ever to do away with poverty and cross-class economic anxieties as we have come to know *these* too. From this flows a different though related thesis as to why guaranteed income strikes many people as so preposterous an idea in the late 1990s. To seriously contemplate guaranteed income's feasibility is also to highlight issues of economic stratification at exactly a time when class-conscious social critiques are more than ever discredited and in intellectual and political disarray.

Consequently, guaranteed income may be symbolically useful insofar, too, as its advantages and disadvantages cannot be debated—or the key question posed, exactly how would we pay for it?—*unless* attention turns toward, not away from, highly skewed and structured class inequalities. Whether or not enacted, then, it can be predicted in advance that political debates about guaranteed income are likely to be perceived as legitimate only when possibilities *do and are believed* to exist with regard to confronting inequities of class. Not surprisingly, relative prosperity and expansion is usually associated with the 1960s and 70s when guaranteed income was last broached, just as relative austerity and economic troubles are the dominant perceived

themes of the 1980s and 90s. And yet, as Kevin Phillips and a host of other social critics have noted, the rich became richer during the Reaganesque decades of the 1980s and 1990s while the poor were becoming poorer.[27] It is not as though social wealth is not available to be tapped more than at present, and not even that drastically, to facilitate the funding of entitlement programs (this essay's conclusion hints at specific proposals made by advocates of guaranteed income as to how concrete plans could be funded, although the second part of this essay will be devoted to this question in far greater depth). More progressive taxation plans could be legislated; the military's budget further reduced; the notion of "givebacks," applied in the 1980s and 90s only to labor, extended to corporations whose capital gains have been underwritten rather than taxed since Reagan.

This then implies, and again quite paradoxically, *that the issue of guaranteed income may come to appear most alien precisely at those times when such an entitlement is needed most.* Once more, one is led in the direction of a conclusion quite different from the seemingly more "pragmatic" liberal/left conventional wisdom. For it may be that the more an idea such as guaranteed income ceases to seem preposterous, the better chance *other* entitlement programs have also to be accorded legitimacy because the very notion of an entitlement would have become more acceptable. Ironically enough, then, ideological advocacy of a concept like guaranteed income may have *more* potential to unleash greater acceptance of universal child care, health care, or social security as its by-product, than if many liberals and leftists persist on what is now at best an only moderately successful and exceedingly defensive course.

For now, my argument is merely that to ignore these pragmatic matters altogether is just as irresponsible and mindless as the opposite tendency, *i.e.*, promulgating a politics so much inclined toward pragmatism that it suffers from loss of vision. But neither is the opposite desirable. A politics which errs on the side of vision to the cost of practicality is analogously doomed to failure amidst false dichotomies and either/or presumptions. Such a supposedly "visionary" politics would itself be threatened with becom-

ing lost, marginalized in the sort of radical-versus-reformist debates which have plagued and stymied the history of many class-based movements in the United States almost since their inception.

Thus, vis-à-vis the premise from which we have started—that the very strangeness of an idea at a given moment merits exploration—guaranteed income becomes a revealing case of the need for visionary practices and practical visions in American social policies conceived for the 21st century. Bearing this in mind, Part III turns specifically to presenting a "case" for guaranteed income by describing four related advantages—practical, moral/ethical, political, and psychic/libidinal—that would follow in principle upon the institution of a basic income maintenance plan. In so doing, I have emphasized why guaranteed income is even more germane to our present socioeconomic circumstances than it was several decades prior. Part IV is subtitled "claims and counter-claims" since it deals with the issue of common objections to guaranteed income. This segment of the essay attempts to anticipate responses that might be made to public objections and fears, while leaving it to others to elaborate at length on points raised only by way of general presentation here. In Part V, I conclude by returning to the challenging task of uniting the practical and the visionary so that guaranteed income seems not so much probably ridiculous but possibly realizable. Even—especially—in the United States of the late 1990s.

III Presenting a Case for Guaranteed Income and Its Advantages

If one agrees that there are benefits to promulgating practical visions of society, still a logical hesitation may come to mind: why guaranteed income? Are the benefits of this notion *only* that it is redolent of a broader concept of entitlement, or are there reasons to advocate this particular policy over full employment or other strategies focussed on jobs?

Clearly, the economic environment of the 1990s is one of fast-paced technological changes producing massive

insecurities amidst job displacement and job destruction. Whether one draws on documentation provided by *The New York Times* in depicting *The Downsizing of America*, or by Stanley Aronowitz and William DiFazio in *The Jobless Future*, or by William Julius Wilson in his account of neighborhood transformations in *When Jobs Disappear*, secure full-time jobs have been evaporating.[28] Moreover, for the majority of people who find re-employment among the large numbers of new positions also recently created, benefits and pay are frequently lower than in the jobs held before.[29] Compounding this loss of jobs are also much-heralded processes whereby capital shifts around the globe with greater fluidity than ever before; even in the United States, sociologists have long been noting that types and locations of new jobs are not coinciding with how and where they are most needed.[30]

Still, based on these factors, one might conclude that the most appropriate demand to make of government is not for income but for *job creation* and *full employment*: again, why guaranteed income? Yet there is no reason for jobs programs to be at odds with the insistence that guaranteed income also needs to be institutionalized as a protective entitlement. Instead, one could posit that the insecurity-generating features of late capitalist societies like our own ought make *both* demands critically important and best conceived as component parts of a broader policy package, including not only jobs and guaranteed income but shorter hours, which would be at once pragmatic and far-reaching in its programmatic specifications. Favoring jobs versus guaranteed income, then, ought itself be unacceptable when framed as though only an "either/or" set of alternative possibilities.

However, via my informal ethnographic foray into this subject, I have also been surprised to find that conversations do often proceed as though stuck in a zero/sum game, and as if only jobs *or* income can be advocated by the same person or group: why? Here, once more, a kind of psychological resistance to guaranteed income appears even among those who are liberal and left-leaning in political inclination. In Part IV, I will suggest that such "resistance" may result from the deeply embedded character of the work

ethic across American society regardless of political predisposition; proposals like guaranteed income, which promise in part to relieve that ethic's impossible imperatives, may for this reason initially produce threatened or hostile reactions.

Yet, regardless of such reactions, structural conditions in the contemporary economy suggest the importance of promoting both a guaranteed income plan and job creation— not guaranteed income *or* job creation—for several related reasons. These distinctive advantages likely to accompany the institution of a guaranteed income plan in the United States can be classified for analytic purposes into four types of benefits: 1) practical; 2) moral/ethical; 3) political; and 4) psychic/libidinal. I will briefly elaborate upon what is meant by each of these advantages in turn.

Practical Benefits of Guaranteed Income

This advantage can itself be broken down into "technological" and "social" benefits. Regarding the former, it cannot be overemphasized that a huge benefit of guaranteed income at present involves its explicitly anticipating, rather than denying, tendencies toward job displacement and economic uncertainty that are blatant by-products of a globalizing capitalism at the end of the twentieth century. Without some kind of better insurance in place than unemployment benefits that rapidly run out and are not universally available in any event, huge numbers of people in the United States continue to have reason to worry that layoffs may not quickly result—or result at all—in new jobs that offer adequate benefits and a livable income.

Nor is this argument negated by widespread references to low unemployment rates in the United States, taken to be signs of a vitally resilient rather than sagging American economy in the 1990s. In 1994, the official U.S. unemployment rate was 6.1%, according to Bureau of Labor Statistics.[31] Figures recently supplied for 1997 are even lower, in contrast to extremely high rates of double digit unemployment in Western Europe in the late 1990s.[32] Thus, an informed observer may think that there is also good reason to doubt that guaranteed income is actually needed at a practical level, certainly not in the United States,

and that instead the capitalist economy has cause for self-congratulation at present. But this skepticism can be answered in one, and preferably in both, of the following two ways. First, many social scientists agree that a 5-6% unemployment figure ought not be accepted at face value: unemployment rates in the United States are known to be notoriously underestimated, omitting those who have stopped looking for jobs or who are engaged in only inadequate paying part-time work. When these calculations are figured in, one estimate places the 1994 jobless rate not at 6.1% (or approximately 8 million people) but at double this rate or 12.5% (or approximately 15.9 million people). Combined with the fact that the number of people living below the official governmental definition of poverty suggested by the Office of Management and Budget (this being $14,763 for a family of four in 1993) has increased by 7.8 million since 1989 to over 39 million people, the situation hardly seems to call for political celebration.[33]

But let us say for argument's sake that unemployment rates are as low as misleadingly purported to be in the late 1990s. Alternatively, let us simply grant the proposition that the contemporary economy is capable of replacing jobs at a rate close to the number being lost because of the structural tendencies of capitalism toward rapid (and job *displacing*) technological innovation. Still, I would argue that a quite practical need for a basic form of income maintenance entitlement persists. For one fact on which agreement is nevertheless possible between those who believe that capitalism is permanently displacing jobs, and those who believe that capitalism is resiliently replacing them, is the following: technological innovation and therefore technological displacement are occurring at a strikingly rapid pace in the United States as well as worldwide. This quick *rate* of displacement means that social dislocation will also tend to correspondingly occur with rapidity, and in a highly anomic and often unpredictable fashion. There is no guarantee whatsoever that new jobs will properly "fit" the skills, or the economic or geographic requirements of people who need them, a fact which is quite accurately reflected in sustained public anxiety levels that have *not* entirely responded

to statistical reassurances. Thus, as William Julius Wilson writes poignantly about Chicago's South Side in *When Work Disappears* (1996), new job creation and low U.S. unemployment rates are meaninglessly abstract statistics to the many people who face simultaneously classed and racialized (compounded often, too, by gender) discrimination in a world seemingly without hope or opportunity. Where streets and stores once bustled with activity, Wilson writes, coping with social abandonment has all too often become a way of life.[34] Nor is Wilson's analysis only applicable to Chicago: not only in Western Europe countries like France and Spain but in New York City as well, unemployment rates are even officially acknowledged to be at double-digit levels of over 10%. How, then, could a basic income maintenance entitlement such as guaranteed income be practically unnecessary for the predicaments in which many people find themselves if they never had, or have lost, or feel afraid of losing, a decent job?

For these reasons, I would argue that an income support entitlement necessary to ensure individuals' survival amidst such structural displacement is an even more historically relevant notion in the 1990s than when initially proposed in the 1960s. No other social entitlement exists which is specifically directed to this practical need to both: a) relieve lack of income for those who are impoverished; and b) replace income loss when jobs are either not available, insufficiently replaced or disappearing.

But there is another practical advantage which might ensue in the aftermath of instituting a guaranteed income plan for all Americans: this is what I would call the practical effects of a "social" benefit. For it is difficult to believe that guaranteed income, if instituted, would not over time diminish the severity of myriad social problems to which income at first glance may appear unrelated. Yet, the provision of a reasonable income floor below which people could no longer fall would likely affect the kind of desperation which is responsible—if, certainly, only in part—for those crimes committed for small sums of money and out of anger at chronic social inequities. Of course, this is by no means a simplistic explanation of all crime. On the other

hand, it is just as silly to go to the opposite extreme and deny *any* relationship between class inequities and comparative rates of crime commission. One has only to consult Elliot Currie's *Confronting Crime: An American Challenge*, for instance, to be struck by the comparative fact that advanced industrial nations which channel greater proportions of their GNPs into social welfare programs have suffered from far less violent crime than is committed in the United States.[35]

Not only crime but other social problems such as homelessness, too, might be ameliorated if entire groups of people who currently find themselves economically dispossessed were instead treated as social citizens. Clearly, instituting basic income maintenance as an entitlement would alter the circumstances that make it common at present to find people homeless and reduced to begging in American cities that sometimes resemble a ruthlessly Dickensian London than a supposedly rich and "low unemployment rate" society. But there are also other advantages.

Moral and Ethical Advantages of Guaranteed Income

What I call a "moral and ethical" advantage dovetails with the benefits of what it means to advocate an entitlement *in general*. By providing sufficient income so that people do not need to expend energy worrying about basic survival, a huge source of ongoing human unhappiness and misery is diminished or eliminated. Like other entitlements, then, guaranteed income is at once helpful to others as well as to oneself; it does not require choosing between individual *or* social interests.

Nor is it wishy-washy or "touchy-feely" to discuss questions of social policy in such a way that issues of morality, ethics and human happiness are not isolated as though relevant only when broached under religious auspices. In their eagerness to correct for the rampant individualism of American culture, communitarian philosophies of the variety espoused by Amitai Etzioni or Michael Lerner are characterized by an excessive proclivity to subordinate individual interest to a "collective good." Still, the usual language of

political economy and economic policy ought to be incorporated with—rather than separated from—that of moral persuasion. How else will it ever become possible to convince people in the United States of the moral benefits, at once for oneself and others, at once selfishly and selflessly, of eliminating chronic anxieties caused by economic worries, insufficient health care or inadequate housing—and certainly, of course, by lack of enough income as is required to survive?

For indeed, it would be a different world were it no longer necessary to waste precious and scarce hours and days of one's life fearing the consequences of suddenly being out of work, laid off, unable to make even basic ends meet. If one has ever known friends or family members in such situations, it is difficult to underestimate the toll and pain of sleepless nights spent thinking about what one will do, and who will be there (anyone?) to turn to if all else seems to fail. This might apply, for example, to the hypothetical predicament of an older man or woman who has been laid off from a middle management position and now finds that even temporary unemployment benefits do not apply to him or her. Or to the circumstances of a middle-aged person who may have moved to a different state for a better job only to find that downsizing led to that job's elimination. What now, she or he is apt to worry, will I do, and will the next job give me enough to pay my car payments and my dental bills, and to keep the therapy appointments that person may need now more than ever?

Like other entitlements, then, guaranteed income fulfills the simple good of relieving a form of economic anxiety over which—unlike death or dying, or the unavoidable pain of unrequited love—we *can* exert a significant degree of control. But, *unlike* other entitlements, guaranteed income also has the potential to undermine a blatantly immoral social tendency to unfairly stigmatize others. Because conceived as a right to which everyone is entitled, a guaranteed income would make it harder to find grounds for bias against one social group or another (even though it would be extremely simplistic were this statement taken to suggest that an extraordinarily complex problem like bias would

simply vanish with the institutionalization of a guaranteed income).

Yet, this very advantage of guaranteed income can be turned on its head and viewed as its opposite because of a difficulty incumbent on promoting or trying to actualize the idea. For the demonization of "underclass" groups may have become so customary in American life that, indeed, psychological resistance will be stirred at the very notion of that stigma's removal. By now, speaking of this from a social psychological perspective, we may be deeply invested in "good guy" versus "bad guy" distinctions, no matter how morally and ethically damaging to others and ourselves. This suggests that yet another reason guaranteed income may appear so odd at present relates to a sociologically unconscious explanation persistent beneath the surface of admitted reactions. The very gaining of guaranteed income would simultaneously signify a loss, though not an explicitly conscious one; customary patterns of channeling resentful feelings and anger *en masse* might be shaken.[36] But, ironically, the task of overcoming this very problem might be assisted by a third beneficial by-product of guaranteed income were it to be instituted.

Political Advantage of Guaranteed Income

To the extent evidence gained through introspection is capable of producing generalizable insight, people are frequently angriest at others when unhappy themselves (and vice versa). Thus, to the extent we feel ourselves economically frightened and insecure, the desire to externalize anger and resentment is likely to increase. The converse may also hold true: namely, that policy suggestions aimed at providing greater personal security may also have political implications for large numbers of people coming to feel less dependent on external objects of anger to express their own resentments and fears.

This is where a third advantage of guaranteed income may be to potentially counteract this tendency, capable of occurring both at the level of individuals and of groups, for people to express anger outward when unhappy themselves. If indeed advanced capitalist societies are generating as

much economic anxieties and uncertainties as they are newly minting jobs, then the ability to express dissatisfaction about conditions of work seems *itself* necessary to ensure. But how can people be free to express dissatisfaction about their workplaces unless there is some organized institutional mechanism, such as a union, which facilitates this occurring? Without a union, conceived here ideally not as an isolated unit but existing inside a labor movement sufficiently strong to exert countervailing social force, how will people employed in a wide range of service and industrial occupations be able to withstand downsizing processes that limit the availability, quality and/or security of jobs under competitive globalizing conditions?

By this analysis, then, an income entitlement like guaranteed income seems necessary in order for people to be able to advocate on behalf of keeping, as well as creating, jobs that are satisfying and which provide good wages and benefits. Once again, the pitfalls of counterposing support for guaranteed income against advocacy of jobs—as though an either/or proposition wherein left/liberal types may find themselves objecting to the former and inclined toward the latter—is revealed to be a false and politically stifling dichotomy. For without a potent labor movement, it does not seem likely that majorities of people employed across a wide range of service and industrial occupations will have a chance at the simple happiness that arises simply from feeling secure. Yet, how exactly is labor to flourish if nothing like a guaranteed income exists to cushion individuals' typical and understandable worries: what will happen to myself and my family if taking part in a union drive, someone is likely to wonder, and if I have to go on strike for longer than I can afford to even if I have only limited union protection? When will only limited employment benefits start to run out?

But well over eighty percent of the American working population at present is still not covered by a union movement. What happens to those who are not employed in unionized workplaces, or who have been displaced by technological developments even if once belonging to a union? In such situations, still descriptive of most people's circumstances in the United States, guaranteed income also

assures that one need not rely solely on the labor movement to be protected from the vagaries of class. Simultaneously, one need not be dependent solely on the labor movement in order to feel secure enough to criticize class inequities, nor so driven toward working endless hours that time does not even exist to notice or reflect upon such matters. It is here that a fourth and last form of advantage might ensue from a guaranteed income plan, if instituted in the United States.

Psychic/Libidinal Benefits of Guaranteed Income

Clearly all of this section's points are closely entwined with one another. Thus, this last argument addresses precisely this last point: whether indeed one has any time to think. For "freedom," a value already familiar and understandably cherished in our cultural context, cannot fully exist unless accompanied by an understanding that expressing desires and needs, satisfactions and dissatisfactions, will not literally and/or figuratively threaten one's life. Elsewhere, I have characterized the *lack* of such basic freedom—freedom from fear of punitive reprisals and consequences—as comprising a central element of contemporary "sadomasochism in everyday life."[37]

By way of illustration, consider the following example. A major reason for most academics' stalwart belief in maintaining and protecting the "tenure" system in the United States is closely related to the argument I have been making in this essay on its whole: tenure *is* a guaranteed income; it *is* an income maintenance entitlement. As an entitlement, then, it ought not surprise us that tenure is relatively endangered in the 1990s when we have seen that the concept of entitlements in general became increasingly suspect: *qua* entitlement, tenure is increasingly out-of-sync with economic processes of downsizing and profit maximization. But it is precisely the beauty of tenure that it ensures against reprisals should one express an opinion about anything, whether for or against the existence of poverty, or for capitalism and against socialism, or even when debating the merits or demerits of guaranteed income itself. Tenure en-

sures that such expression cannot result in being summarily fired and losing one's livelihood. Otherwise, as is the premise on which the notion of "academic freedom" has long rested, professors would not feel able to say what they meant; they would worry that doing so would, as indeed it could, bring punitive reprisals from disapproval to dismissal as its immediate consequence.

And what reason is there to think that the same principle which seems simple and understandable when applied to universities and "academic" freedom does not apply societal-wide and to the very idea of freedom generally speaking? Why wouldn't an absence of a guaranteed income such as tenure enforce, and then reinforce, anyone's difficulties in saying what is felt and meant? In this respect, it is not at all surprising that social movements were relatively more direct in expressing impassioned convictions in a decade like the 1960s when people had more reason than now to believe good jobs might be waiting after one gave up full-time organizing or other forms of activism.

Thus, guaranteed income would bring along with it in principle the advantage of reducing the fear which accompany many people in multiple spheres of their lives, creating an apprehensiveness that might be partly assuaged simply by knowing that bottom line protections had come to be institutionalized as social commitments. Fortified by such knowledge, people might feel better able to *psychically relax*. And, thereafter, it becomes possible to approach not only hobbies and creative endeavors, but also jobs taken for extra money or because socially useful, on the basis of expected pleasures rather than guaranteed fears. This is what I mean when referring, in this fourth and last point, to "psychic/libidinal" benefits that would be likely to ensue in principle from the institutionalization of a guaranteed income. But from thinking about issues of pleasure, it also becomes possible to address the opposite consideration. How can a host of common objections to guaranteed income that have little or nothing to do with its benefits be answered, so that the idea can be dissociated from what are likely to be anticipated social pains?

III Claims and Counterclaims: Assuaging Common Fears

Not surprisingly, a number of the advantages just delineated can be used in the service of precisely an opposite set of conclusions. Even though their contents will be slightly different, these related arguments deserve to be answered because they express common objections and fears about guaranteed income.

Practical Objections

For a common attitude likely to result in objections to the idea of guaranteed income can be summarized as follows: if a guaranteed income existed, no one would be willing to work. In the late 1960s, as already seen, this dubiousness motivated a three-year long guaranteed income experiment that showed no such extreme conclusion to be warranted. But let us investigate this fear more carefully in terms of what appears to sustain its ongoing social psychological resonance. Clearly, the "rational" and mostly only quantitative evidence provided by the 1968-1971 OEO experiment, and published by well-regarded social scientists, was not sufficient to dispel the fear; just as clearly, such evidence did not keep guaranteed income from being politically rejected even in these earlier decades. For a skeptic is likely to argue from quite deeply emotional conviction that a guaranteed income would encourage laziness and indulgence: if people knew they would be supported when unemployed, why would anyone want to work? Isn't it obvious that people would stay home unless forced by sheer necessity to show up at most of our jobs? Now, the contention above—*i.e.*, that guaranteed income would help to *diminish* other social problems—is reversed, and the idea becomes interpreted as a potential cause of compounded collective troubles.

Not only would guaranteed income encourage people to stay home, such objections commonly hold, but this "entitlement" would discourage willingness to tolerate socially necessary but not high status or well paid labor. Were a guaranteed income plan to be institutionalized, who, for instance, would want to work for low wages at places like Mc-Donald's and Burger King? Who would sweep streets, or

work as janitors, or at menial low-paying jobs in government offices? In the weakest vion of this "practical" but now posed as *social harm* argument, guaranteed income is envisioned as encouraging even more widespread forms of "cheating" than existed under the welfare system. Taken to its extreme, and in its strongest version, this objection becomes even more dramatic: if anything like a guaranteed income existed, society itself might be in danger of coming to a standstill, and its ability to function effectively called into question.

Reacting sensitively to such deeply felt and culturally familiar attitudes may seem at first to pose a difficult challenge indeed. But two possibly persuasive reactions come to mind, the first of a relatively more theoretical bent whereas the second is pragmatically oriented. First, let us return to the fourth potential advantage of guaranteed income just described: its possibly "psychic/libidinal" benefits, suggesting not that people would simply cease working in the aftermath of an instituted guaranteed income but that just the opposite trend might unfold. With the institutionalization of guaranteed income as an entitlement ensuring basic survival, even under conditions of economic restructuring and displacement, people might be less rather than more likely to rebel from working.

For many people, the work which is undertaken *most* passionately, *most* doggedly—and in which we persist even through unpleasant and menial tasks such work often necessitates—corresponds to those efforts chosen freely from within, not imposed by fiat from outside. There is widespread recognition of pleasures and satisfactions to be found when starting one's own business, an entrepreneurial and individualistic joy which is deeply rooted in a specifically American cultural context. The artist or filmmaker or cook knows well the joys of creativity, of a disciplined dialectic between control and freedom in the course of unfolding a life's work. Then there is the person who feels hope as he or she works freely works out a plan—I will work here this summer, then there next fall—in order to realize one long-cherished dream or another.

One can thus posit, at first in principle, that people will be drawn *most*, not least, toward multiple contexts of "work"

that have not created profound resentments because forced into becoming a pressured life-and-death matter. Logically, there is nothing about a guaranteed income which stops people from pursuing the various occupations and interests that would still be found pleasurable, stimulating and necessary even after such an entitlement was instituted. Nor, for that matter, is there any reason that guaranteed income would have the slightest capacity to do away with people wanting to work for reasons that far surpass motivations based solely upon survival: desires for recognition fit in this category, surely, as do immensely general human cravings for acceptance, love and status.

And it makes little sense to think that just because a minimum income floor has become socially ensured, people will no longer wish to earn sums that total above this basic amount. No guaranteed income level instituted in the near future will be high enough to permit purchasing a host of luxuries toward which people are now sensuously attracted. Thus, certainly, some teenagers will still want to work summers at the local gas station or at McDonald's (or maybe Checker's, or Wendy's) to save money for a car, a better stereo system, and/or for college. And take the middle-aged person envisioned above, of any ethnicity or race or gender, who has lost the middle management position she or he held for ten years but now can at least rely upon a guaranteed income provision for basic sustenance. Of course, she or he is likely still to desire additional work so as to maintain small but looked forward to luxuries that were previously enjoyed and experienced. There is nothing about guaranteed income which would at all quell a given person's desire to eat out at a fancy restaurant now and then, or to travel where and when possible, or to splurge on buying one's child a gift. Put simply, then, not all that much would change except that people across varied strata would no longer have to fear simply for their survival. We would still work for a panoply of reasons but not, as would be historical progress indeed, merely to exist.

Thus, there does not seem much cause for fear based on either an extreme version of this common and "practically" oriented objection (i.e., that guaranteed income would pro-

duce a cessation of working after which society might fall apart) nor on a less extreme version (*i.e.*, that no one would ever work again at McDonald's). But what may reassure the skeptic even more than an argument in theory is a more concretely empirical point that can and should be annexed. Why haven't other countries, such as Sweden or Canada where entitlement programs have long flourished and provided greater security from fundamental human anxieties, fallen apart?

Whether referring to Canada or France, Norway or West Germany, the level of ongoing state-ensured benefits regularly provided are remarkably generous in these countries compared to dwindling U.S. public welfare programs and the discrediting of the notion of entitlement *per se*. Moreover, intense public protests are quickly lodged in France or Sweden when even a portion of entitlement benefits are threatened with extinction. Since many other advanced industrial nations comparable to ours have long lived with far more generous unemployment benefits—ones which already provide a sense of security close to the function I am arguing guaranteed income in the United States would need to fill—why haven't these societies manifested signs of creeping catastrophe?

Of course, this is not to deny that European countries are experiencing economic difficulties in times of international competition; debates about citizenship rights, and about the maintenance of state-funded benefits, are increasingly common as Western Europe faces economic pressures imposed as much from without as within. Yet there is little evidence of an outcry about huge numbers of people refusing to go to work, or about laziness allegedly "caused" because generous benefits have long been available. Clearly, then, historical precedents and empirical examples exist to provide reassurance *in advance*—if, that is, the heart of common objections to the idea of guaranteed income was that after its institution no one would be willing to work.

Indeed, it is interesting to speculate about whether the very same experiment I proposed at the beginning of this essay—tracking of reactions expressed upon broaching a

topic like guaranteed income—would produce different and/or similar reactions in France or Sweden to those typically encountered at social gatherings here. Well-established traditions of providing generous benefits to citizens would likely render the idea far less preposterous sounding. In terms of culturally specific differences, many Europeans may envision this first fear about guaranteed income—that it would lead to cessation of and mass exodus from work—to be a characteristically American obsession. But it should simultaneously be noted that while such cultural differences continue to be immense, racist and xenophobic ideologies and suspicious attitudes toward immigrant groups are increasingly affecting European countries, too, particularly in a context where unemployment rates are even higher and competitive international pressures are at present keenly felt.

With this, a second common objection to guaranteed income may bring us closer to the heart of the matter in an especially though by no means exclusively U.S. context.

The Basis, or Lack Thereof, of Moral/Moralistic Objections

This second common fear and objection to guaranteed income can be characterized as follows: if a guaranteed income existed, the value of work would be undermined as a moral and ethical good in and of itself. Once again, the kind of argument made in Part II *in favor of* guaranteed income on moral grounds—that it would reduce chronic psychic and social anxieties, freeing people to find happiness and pleasure in the aftermath of such an enormous and fundamental relief—takes shape here in virtually the reverse form. Accordingly, guaranteed income would not be a social "good" but ethically worrisome insofar as devaluing work. Instead, work itself ought to be cherished as fulfilling a healthy and basic need. Again, this objection is often one with which people of both left/liberal and more right-ward leaning persuasions can commonly sympathize. On the basis of such objections, a person of left/liberal persuasion may even become slightly annoyed at the idea of guaranteed income. What we need now, she or he may likely say, is

jobs; there is dignity and respect to be found in and from labor; work provides human beings with important satisfactions and with a structure to our lives.

In response, though, the question again arises as to why and how such beliefs about the value of public labor become objections to—rather than additional and supplementary beliefs *in favor* of—guaranteed income. For, to repeat, there is absolutely nothing necessarily contradictory in believing *both* a) that people obtain great satisfaction from socially recognized and paid labor; *and* b) that the character of the globalizing capitalist economy render jobs technologically obsolescent or increasingly unprofitable as a structural tendency, requiring protections against the vicissitudes of social and individual life. Why ought not, or cannot, both beliefs be held and form the basis of public policies simultaneously?

But perhaps it is precisely the fact that these two ideas—jobs and income—come to *appear* as though "either/or" alternatives which is most revealing of all. For why and how does labor become an "objection" to, or even cause for annoyance about, the notion of guaranteed income? If one goes back to Weber's classic *Protestant Ethic and the Spirit of Capitalism*, written to explore the roots of modern capitalism, it is hardly accidental to find the adages of Benjamin Franklin liberally quoted in this classical work of sociology; it cannot be coincidental that the primary example used to describe the burgeoning capitalist spirit is the United States. Weber's argument was that capitalism is sustained by a cultural ethos as much rooted in deeply embedded anxieties about fundamental questions of life and death as in narrow imperatives economistically conceived. Thus, for the purpose of answering the objection about "immorality" commonly directed against guaranteed income, Weber's treatise suggests that one must look beyond apparency—beyond what "valuing labor" appears to signify—to understand the roots of contemporary capitalistic energy. Rather than viewing a "work ethic" in the American context as self-explanatory, then, Weber saw it as a problem of *surplus energy*—i.e., that early Calvinists felt, compulsively and to excess, forced to work if salvation beyond this life was to be

attained. It may have been a religious drive for the early Protestant, Weber asserts, but for those later trapped by the legacy of already established compulsions, questions of origin cease to be relevant or recalled. What does remain is a drive to which people become attached in and of itself, a will to work and an investment in labor that may become relentless and unforgiving, steering people away from the value of relaxed pleasures in *this* life and accustoming us to feelings of austerity, insecurity and even pain.

Couldn't the depth of such a belief, of an ethic there is no reason to expect will discriminate in its vestigial effects on those who are left or right, rich or poor, bring us closer at a more profound level to understanding why policy questions about income "versus" jobs are often framed as though necessarily contradictory propositions? Were guaranteed incomes to be provided in the contemporary United States to all who need it, then a surplus Protestantism would not so blatantly persist; we would not still be trapped in an "iron," or possibly by now a cybernetic, cage. Yet, when one is used to having to expend excess energy to feed a driving motivation, this very emotional state can become familiar and perhaps even comforting. Even prospects of relief may seem threatening when we are so accustomed to working, working more, working even more once again. From this, too, flows one possible explanation for why—relatively speaking—European debates about citizenship are much less concentrated on questions of supposed individual *laziness* than simply on nationalistic feeling: the debate centers around general bias, not the specific fear that indolent people will not work if basic benefits continued to cushion their existences. One need not overly romanticize cultural differences to admit that a different relation to social aesthetics is implied when many Western Europeans are accustomed to certain cherished pleasures: to perhaps the possibility of a leisurely two-hour break from work in the middle of one's day if one is accustomed to sensual enjoyments—of food, of sights, of sounds—as a regular part of everyday life.

Yet if such basic mind-and-bodily contentment is harder to come by and instead a driven tendency toward constant

work predominates, it is not surprising if many people feel angered amidst such unhappiness. To a surplus and seemingly excessive degree, resentment may be felt toward "others," toward anyone who appears to be not so driven by this invested-in work ethic (and even if, as in myths about welfare, these appearances are false and become greatly exaggerated through biases). Given that such sentiments have characterized collective debate about welfare in the 1990s United States, little wonder that the thought of guaranteed income strikes many people as objectionable during such an historical juncture! Anger is then likely to be expressed through typically asked questions such as "why should I work to fund others who are lazy and do not wish to work?" This sense of resentment feeds into policy ramifications which then, ironically enough, are potentially destructive for everyone in a society wherein economic and social insecurities affect not only those presently receiving benefits but are actually quite democratically relevant to all.

But something rings disingenous as we now turn to answering this second common objection to guaranteed income in principle: that it would, if instituted in practice, threaten the moral value of work. Here, then, is the germ of a counter-claim I would propose. If a given society was *really* one in which work was morally and ethically valued, it might follow that such a society would enthusiastically *advocate* rather than angrily *oppose* the notion of a basic income entitlement such as a guaranteed income. But perhaps the insistent attitudinal determination with which we vaunt the values of work in the 1990s—becoming, by extension, practically obsessed by the alleged "laziness" of those who are disproportionately poor, minority, or perhaps single mothers—unconsciously indicates, as Shakespeare wrote, a society in which people are "protesting too much." For to proclaim the cultural value of work, on the one hand, while responding to ideas like guaranteed income as though utterly preposterous, on the other, may indicate that deep down one suspects that work is not really so terrific after all. How could this be otherwise, *i.e.*, that the flip side of work-obsession is not, albeit unconsciously, work-hatred?

This is because, if one explores its subtler implications, the dominant work ethic in the United States is founded on the presumption that people will not work unless forced to do so by sheer life-and-death necessity. Does this imply a belief in the value of work or, beneath the surface of this loudly asserted attitude, possibly just the opposite? Though, of course, looking back at even one counter-example—that of the 1960s—should caution against forgetting that there are other cultural traditions in American history which have also left powerful vestigial influences, and are capable of contributing to altering and possibly even reversing present trends. But the very vehemence of contemporary reactions against guaranteed income—for why not simply entertain the idea if it could reasonably be funded without becoming especially surprised, scandalized and sometimes hostile?— suggests that somehow *we may not ourselves be very happy about the idea of laboring.*

If perhaps feeling compelled to work and not very thrilled to face such possibly unpleasant coercion ourselves, people may be apt to project this dissatisfaction onto others as a mode of dissipating inner anxieties and tensions: I am willing to work albeit unhappily and insecurely, people may feel, why aren't you? Onto others we may project the anger, the resentment, the lack of control which we are experiencing in our own situation. In so doing, however, a vicious circle comes into play: the irony deserves repeating that in denying benefits to others, we also forego the benefits of a social generosity to which we would otherwise be entitled ourselves.

But could this trend begin to reverse, it might become possible for people to redirect angry feelings toward *socioeconomic structures* and *systemic tendencies* rather than at pathologized individuals. And then, finally, those conservative efforts that have been so extraordinarily successful since the repeated defeat of income maintenance proposals in the 1960s and 70s might encounter far more difficulty when encouraging people to angrily imagine how *others* should somehow be individually able to control social circumstances that have left us feeling quite out of control ourselves.

In sum, then, it may be that many people are not now so much attached to the value of work but are engaged in what Freud called a "reaction formation" though here one which operates as a collective and not merely an individual defense mechanism against ongoing socioeconomic feelings of uncertainty that are actually experienced *en masse*. Thus, the seemingly conscious and explicit meaning of this second major objection to guaranteed income—to wit, that we ought to support jobs rather than income—may signify just the opposite of its apparent meaning. And, if such unconscious dimensions of social life really do exist in addition to conscious ones, they cannot simply be swept under the rug. Unless such unconscious meanings and the strong feelings to which they relate are acknowledged desires to hold onto the work ethic and to stigmatize others, with or without reason, are likely to be recycled again and again. And, thus, this case for guaranteed income at first in principle rests upon asserting that questions of cultural motivation at conscious and unconscious levels cannot cannot simply be separated from "policy" considerations as though the implications of one was simply irrelevant to the consequences of the other.

But if this analysis is at all apt, what are we to do? How do we begin to get around this dilemma now updated to the 1990s, a moment when the technological wizardry of late capitalism and its job-displacing capacities make Weber's diagnosis about feelings of attachment to the work ethic seem even more relevant today than at periods before?

V Coming Full Circle:
Envisioning Guaranteed Income in Practice

But it *is* possible to redirect angers differently than we are now used to doing. Our conscious abilities to think and to reason, as well as to love and to feel, provide chances for explicitly and quite consciously reversing the direction in which American society has been stubbornly and destructively heading for everyone, not only the poor, who are rendered insecure within it. If instituting a guaranteed income would diminish anxieties and create the possibility of

greater social security, then slowly but surely the trajectory of events might change through dialogue with others, by first imagining and then acting upon a vision of how life could be otherwise. In this sense, we come back full circle to the importance of guaranteed income as a cultural lynchpin, boding at once symbolic and quite material significance.

But if people are to take the idea of guaranteed income seriously, we must also return to pragmatic questions of cost. Let us assume that the intentionally multi-dimensional argument I have been making in favor of guaranteed income has been to some extent persuasive. Still, a question that will need to be addressed relates to funding. From where would money come to fund such a proposal? It is beyond the scope of the first part of this two-part project to elaborate in depth upon an answer in Part I: it will be the purpose of Part II in its entirety to present a case for guaranteed income in practice. For now, though, it is necessary to hint at a few feasible sources of funding so that we do not leave the idea of guaranteed income seeming as though it is merely a principle, and seemingly utopian. On the contrary, numerous sources of funding exist that could reasonably be tapped with a careful eye toward not causing undue social hardship. For instance, one source of possible funding exists in the form of reductions in military spending. Some analysts estimate that close to 50% of the current military budget of $265 billion could be reduced since much of that budget was predicated upon Cold War assumptions rendered obsolete upon the demise of the Soviet Union. If so, then the military budget alone could provide a large proportion of the funding needed to start a basic income maintenance program. But even if we assume that the 50% military budget cut is too extreme, a still significant portion seems now unnecessary and to be inflated (military expenditures were 50% of the fiscal 1998 discretionary budget in the United States). According to the Cato Institute Handbook, the military budget could be sensibly reduced from $243 to $154 billion, a savings of $89 billion which might become part of the funding needed to start a basic income maintenance program.[38] The Center for Defense In-

formation publishes *The Defense Monitor*, which noted in its April/May 1996 issue that "The United States can safely and sensibly reduce its annual budget to about $200 billion and continue to maintain the strongest military forces in the world."[39]

Thus, some observers close to the military itself agree that anywhere from $60 to $80 billion could be obtained from military cutbacks even before one even raises the question of progressive taxation at all. A second clear possibility for funding would come from a variety of corporate tax loopholes—from what is currently dubbed "corporate welfare," estimated by some at well over $100 billion. But rather than suggesting what would certainly be an abrupt step of eliminating these loopholes altogether, one could at present more realistically impose what several Clinton economists have written about in the *Journal of Financial Services Research*—namely, the need for a stock transfer tax. Economists Joseph Stieglitz and Larry Summers have both argued that such a tax would raise about $30 to $60 billion[40]; clearly, there is reason to believe that this tax could be imposed without severely dislocating consequences. Such sources of funding, too, could obviously be used for the funding of a basic income maintenance entitlement: in and of themselves, these two items alone potentially produce betwen $90 and $140 billion of newly freed funding. Moreover, to all of this must be added a point made in 1962 by Milton Friedman and later echoed to his left again by Theresa Funiciello in her own case for guaranteed income as proffered in *The Tyranny of Kindness*[41]: one must deduct from the total cost of guaranteed income plans whatever monies would have been spent otherwise on welfare administration costs, diminishing the amount which would need to be funded for a basic program to be initiated because its administration would likely occur far more simply through an agency like the IRS.

But when one turns to taxation, the case grows even stronger. It is by now widely accepted by economists, political scientists and sociologists that the 1980s and 1990s brought an historic shift of wealth to the upper fifth of American society, analogously impoverishing the bottom

two fifths.[42] Yet, the United States remains one of the lower taxed nations in the world. Under Presidents Reagan and Bush, our highest tax rates on wealthy persons were lowered to 28%, whereas these rates in Western Europe are 40% and in Scandinavia close to 50%. One does not even have to propose a radical redistributive tax scheme to understand that changes aimed at moving back toward pre-Reagan/Bush distributions could produce large sums of funding for state-backed programs like guaranteed income, health care, better education and housing, and job creation. Thus, if one combines military cuts with proposals aimed at raising tax rates on the wealthiest 1/5 of Americans by even a few percentage points, basic income maintenance need no longer seem absurdly "utopian" from a pragmatic standpoint. Rather, not only the elimination of poverty but the elimination of basic economic insecurity for those who are working and middle class as well as poor is rendered distinctly within the realm of the possible. One need not exchange the visionary for the pragmatic, therefore, nor the practical for the visionary.

With this, some concluding points are in order. The very fact that Milton Friedman and Erich Fromm shared a common belief in guaranteed income—while on most other political, social and intellectual issues they would certainly have been prone to disagree—should also be taken as a cautionary reason for pause. For, as I also wish at last to emphasize, guaranteed income is not a panacea for all social problems facing Americans into the 21st century. Should the idea be viewed narrowly and in isolation, the proposal can be perversely privatizing: it would end up according with, rather than challengly, the strongly individualistic propensities which have tended far too characteristically to abandon people to their own devices. The establishment of a basic income maintenance program in the United States would not eliminate, nor does it provide any reason to oppose, simultaneously critical needs for other entitlements to be established: nothing about presenting a case for guaranteed income reduces needs for decent housing, for good health care to become available for all, for universally available child care to be provided, and for jobs to be amply

recreated when and where needed and should they be displaced. By this perspective, guaranteed income is best conceived as part of a larger package of changes. This package would include guaranteed income *in addition to, not instead of*, advocacy on behalf of such desperately needed better health care, housing, education and job creation. Moreover, with regard to job creation, pouring money into the hands of those who are in the bottom quintiles of U.S. society is bound to aid in job creation by spurring consumer demand. Nor should propounding the virtues of guaranteed income be taken to mean that thereby one is somehow against the idea of better and more jobs being created, or that one has somehow overlooked the many advantages for human beings of structured work situations and deserved pride in paid labor. Again, the trade-off need not be presented as though either/or: in fact, it *is not* an "either/or" dichotomy unless we persist in conceiving it as such.

For in the end, the subject of guaranteed income is not only about matters of funding and *political economy* but also about matters of ideological belief and *psychic economy*. Whether guaranteed income can be imagined as a basic entitlement is inseparable from whether attitudes toward entitlements in general can shift from the depressing direction taken in the Reagan/Bush/Clinton era toward a willingness to believe that both individual and social security are worth attaining. For this reason, transferring guaranteed income from the realm of the preposterous to the conceivable is a task well worth envisioning not only in principle but in practice, not only in the present but as it paves the way toward a more hopeful future.

Notes

1. Robert Theobald, *The Guaranteed Income* (Garden City, New York: Doubleday & Co., 1966), p. 1.

2. Erich Fromm, "The Psychological Aspects of the Guarenteed Income" in *The Guaranteed Income*, ed. Robert Theobald (Garden City, New York: Doubleday and Company, 1966), pp. 175–177.

3. See Premilla Nadasen, "Conservative Politicians and Welfare Policy, 1960–1975," paper presented at the American Historical Association, January 3, 1997, p. 2.

4. For instance, in *Guaranteed Income: The Right to Economic Security* (Van Nuys, California: GAIN Publications, 1983), Sheahen talks about the two ideas as though inseparable. On the other hand, the discussion of guaranteed income in Juliet Rhys-Williams, *Family Allowances and Social Security: Lady Williams' Scheme* (London: Liberal Publications Department, 1944) and in Theobald, op cit., are discussions which advocate a demogrant 1945) that would not be means-tested. The two are related though also distinct notions.

5. See Lewis Meriam's *Relief and Social Security* (Washington, D.C.: The Brookings Institution, 1946).

6. See Alvin L. Schorr, *Poor Kids* (New York: Basic Books, 1966), pp. 130–131.

7. See both Schorr, op cit. and Juliet Rhys-Williams, *Family Allowances and Social Security: Lady Rhys-Williams' Scheme* (London: Liberal Publication Department, 1944).

8. See Theobald, op cit.

9. See Milton Friedman, *Capitalism and Freedom* (Chicago: University of Chicago Press, 1962).

10. See Robert Theobald's discussion in *Free Men and Free Markets* (New York: C.M. Potter, 1963).

11. Nadasen, *op cit.*

12. See Vincent J. Burke & Vee Burke, *Nixon's Good Deed Welfare Reform* (New York, 1974), which quotes Galbraith.

13. See James T. Patterson, *America's Struggle Against Poverty 1900–1985* (Cambridge, Mass.: Harvard University Press, 1986), p. 188.

14. *Ibid.*, p. 189.

15. *Ibid.*, p. 189.

16. See Joseph A. Pechman and P. Michael Timpane, editors, *Work Incentives and Income Guaranteed: The New Jersey Negative Income Tax Experiment* (Washington, D.C.: The Brook-

ings Institution, 1975), especially the overview of the labor supply results written by Albert Rees and Harold W. Watts.

17. *Ibid.*, pp. 81, 86 and 87.

18. Patterson, *op cit.*, pp. 189–190.

19. Patterson, *op cit.*, pp. 192–193.

20. See Sheahan, op cit.

21. Daniel P. Moynihan, *The Politics of a Guaranteed Income: The Nixon Administration and the Family Assistance Plan* (New York: Random House, 1973), p. 3.

22. Ruth Sidel, *Keeping Women and Children Last* (New York: Penguin, 1996) and Herbert Gans, *The War Against the Poor: The Underclass and Anti-Poverty Policy* (New York: Basic Books, 1995).

23. See, for example, *The Downsizing of America* (New York: New York Times Books, 1996) and Stanley Aronowitz and William DiFazio, *The Jobless Future: Sci-Tech and the Dogma of Work* (Minneapolis, MN: The University of Minnesota Press, 1994), especially the Introduction and Chapter 11 of the latter work.

24. *The Downsizing of America* (New York: New York Times Books, 1996).

25. Ibid.

26. All the while it should also be noted that some "post" terminology is needed to distance oneself from the decidedly anti-democratic legacies unfortunately bequeathed by many past Communist societies. This legacy rendered it even more difficult in the American context to illuminate the importance of class.

27. Kevin Phillips, *The Politics of Rich and Poor: Wealth and the American Electorate in the Reagan Aftermath* (New York: Random House, 1990).

28. Stanley Aronowitz and William DiFazio, *The Jobless Future: Sci-Tech and the Dogma of Work* (Minneapolic, MN: The University of Minnesota Press, 1994) and William Julius Wilson, *When Work Disappears: The World of the New Urban Poor* (New York: Knopf, 1996).

29. See The Post Work Manifesto in this volume.

30. See, for instance, William Julius Wilson's now classic presentation of this argument in *The Truly Disadvantaged*.

31. See David Dembo and Ward Morehouse of the Council on International and Public Affairs' report entitled, "The Underbelly of the U.S. Economy: Joblessness and the Pauperization of Work in America" (New York: The Apex Press, 1995), pp. 5 and 13.

32. According to Bureau of Labor statistics for June 1997, the U.S. unemployment rate was 5.0%. This compares strikingly with official unemployment figures for Europe: for Spain, according to the Banco de Espana, the rate was just under 22% in 1997; in Germany, according to the *Weekly Business Review*, it was 11% in 1997; and for France, according to The *New York Times* (see article by Roger Cohen, The *New York Times*, July 22, 1997 I, 3:1), it was 13%.

33. Dembo and Morehouse, *op cit.*, pp. 5–6.

34. See the first two chapters, in particular, of William Julius Wilson's *When Work Disappears: The World of the New Urban Poor* (New York: Knopf, 1996).

35. See Elliot Currie's chapters on inequality and welfare in *Confronting Crime: An American Challenge* (New York: Pantheon Books, 1985).

36. For an interesting account of socially unconscious resentments as they make their way into attitudes toward crime and criminals, see Martha Grace Duncan's *Romantic Outlaws, Beloved Prisons: The Unconscious Meanings of Crime and Punishment* (New York: New York University Press, 1996).

37. See Lynn S. Chancer, *Sadomasochism in Everyday Life* (New Brunswick, New Jersey: Rutgers University Press, 1992).

38. See "The 1998 Defense Budget," a segment of the Cato Institute's Handbook for Congress (sent to the author upon calling the Cato Institute in Washington, D.C.)

39. See page 1 of the April/May 1996 issue of *The Defense Monitor*, published by the Center for Defense Information, Washington, D.C.

40. Joseph Stieglitz and Larry Summers, *Journal of Financial Services.*

41. See the discussion of guaranteed income in Theresa Funiciello, *Tyranny of Kindness: Dismantling the Welfare System to End Poverty in America* (New York: Atlantic Monthly Press, 1993).

42. Among the sources mentioned in this essay which confirm this claim are Gans, op cit., Sidel, op cit. and Phillips, op cit.

3 ■ A Justification of the Right to Welfare

Michael Lewis

Introduction

The Social Security Act of 1935 authorized a public assistance program which has come to be known as Aid to Families with Dependent Children (AFDC or welfare). The AFDC program primarily served impoverished women and their children. AFDC was a grants-in-aid program. This means that states and the federal government shared the costs of the program. The federal government agreed to pay some specified proportion of a state's AFDC costs if and only if the state agreed to dispense benefits in accordance with federal rules. For present purposes, the rule which was most important is what I call the "entitlement rule."

The entitlement rule stipulated that, in order to receive federal funding, states had to dispense AFDC benefits, as a statutory right, to anyone needy enough to qualify for them. In other words, the federal government created a financial incentive for states to grant their residents a right to welfare. This is no longer the case.

In August of 1996, President Clinton signed into law a piece of legislation which abolished the AFDC program. The law replaces AFDC with a program called the Temporary Assistance for Needy Families (TANF) program. TANF is still a program which combines federal and state funding. And the federal government still provides financial support

to states only on the condition that they dispense program benefits according to federal rules. The entitlement rule, however, is not one of them. The text of the law explicitly tells us that no family or individual should be regarded as having a right to TANF benefits (U.S. Congress, 1996). Since TANF benefits provide people with the means of subsistence, the law is telling us that no one should be regarded as having a right to such means.

In my view, the enactment of the TANF program was wrongheaded. The rest of this chapter addresses why I think this is the case.

The Concept of Right

The concept of "right" is one which has been the subject of a great deal of philosophical discussion. In an important essay on the subject, philosopher Brenda Almond (1994) explicates the various types of rights which are said to exist.

One kind of right is right as the power to engage in some type of action. For example, in capitalist societies such as the U.S., property owners are granted the right to distribute their property at will. Another type of right is right as a liberty, which is to say the right not to be imposed upon by a potentially burdensome requirement. For example, in the U.S., someone accused of a crime has the right to remain silent so he/she will not incriminate him/herself. Thirdly, there is a right as an immunity, which is to say a right to be protected from the actions of another. For example, in many so called advanced industrialized countries workers are granted the right to join unions, which, in theory, guarantees them immunity from the actions of employers who might try to forbid this. Lastly, Almond discusses rights as claims, which she views as correlatives of duties. Claim rights refer to justified demands made upon particular actors who are obligated to meet such demands.

The former entitlement to AFDC appears to have been an instance of this last type of right. To say that AFDC in the U.S. was an entitlement is to say that individuals whose incomes and assets were below a certain level could have justifiably demanded that they be provided with welfare

benefits and that the government had an obligation to provide them with such benefits.

Not only has philosophical discussion about rights addressed the issue of the various types of rights, but also of concern has been a metaphysical question regarding the ontological status of rights. By ontological status of rights, I mean the question of the nature of the existence of rights. Some "natural law" thinkers, such as Locke, have taken the view that rights exist independently of the social and legal norms of human communities. Others, sometimes known as legal positivists, have argued that the only kinds of rights that exist are those directly linked to the legal norms of given communities (see McBride 1994 for a discussion of this debate).

The former status of AFDC as an entitlement was certainly sanctioned by U.S legal norms. It is difficult to know, though, whether the legally sanctioned right to welfare corresponded with a right to welfare which exist independently of the social/legal norms of some human community. For present purposes, this problem need not be resolved. In contrast to a number of Democratic and Republican leaders, I am going to argue that the U.S. government should grant public assistance benefits as an entitlement, regardless of whether or not this corresponds with some natural right to such assistance.

Why There Should Be a Right to Public Assistance

As far as we know, all societies require a significant number of their adult members to consistently engage in some form of productive activity. This is so because the productive activity (e.g., the production of food, shelter, health services, etc.) consistently engaged in by the members of a given society is what allows that society to sustain itself. Thus, societies (or, more accurately, those who constitute them), if they are to be sustained, have an interest in assuring that their adult members are provided with the resources necessary to allow them to consistently engage in productive activity.

Currently in the U.S., much productive activity is market-based. By this, I mean that much productive activity takes place on the basis of exchanges between buyers and sellers of different goods and services. For present purposes, one of the more important exchanges which occur in the U.S. marketplace is that between the buyer and seller of labor. Much of the production of the goods and services we depend on for sustenance results from employers making purchases in the market for human labor. In order for those who sell their labor (whether it be manual, technical, or knowledge based) to consistently do so, it is necessary that they be provided with certain basic goods and services, which include food and shelter. A person without food and shelter cannot consistently sell his or her labor or, in other words, cannot consistently engage in market-based productive activity. Now if we want to sustain our society, if this sustenance depends in part on there being a significant number of adult members of our society consistently engaged in market-based productive activity, and if the attainment of this significant number, in turn, depends on those constituting it being provided with basic goods and services such as food and shelter, then we should assure that a significant number of adults be provided with these basic goods and services.

How many adults constitute a significant number when it comes to the number of adults needed to produce the goods and services which sustain us? This question is difficult to answer because the number of adults needed to produce the goods and services necessary to sustain us is historically variable. Mechanization, automation, and other technological developments generate the conditions which make it possible for us to produce the same amount of or more goods and services with less labor input. Thus, it is difficult to come up with a specific number of adults who should be provided with the basic goods and services which would allow them to engage in community-sustaining market work. Even if it were possible to come up with such a number, it would not be a good strategy for a society or community dependent on market work for its sustenance to provide basic goods and services only to this number of adults. The

better strategy would be to provide all able-bodied adults with the goods/services required to meet their basic needs. A simply hypothetical should illustrate why this is the case.

Suppose we knew that 100 adults were needed to produce the goods and services needed to sustain us. Due to the vagaries of existence (people get injured, die, become too old to work, etc.), those among this 100 would be unable to engage in market work forever. If our community were to continue, other adults would be needed to substitute (e.g., engage in market work) for members of our "starting 100." The fact that our starting 100 would not be able to engage in market work forever is the reason it would be a good strategy to prepare all of our adults for market work, even though only 100 would be needed at a time.

One could argue, on the basis of the position I have taken up to this point, that our community should provide for the basic needs of adults but not of children. This could be argued because I have stated that, under present economic arrangements, only *adults* are needed to engage in market work. This argument would not have much force, though. Adults do not live forever. The way to sustain the number of adults needed for productive activity is to assure that children grow up to be adults capable of engaging in such activity. And this is done by meeting the basic food and shelter needs of children. Thus, if our community is to be sustained over the long run, we should provide for the basic needs of children as well as adults.

There is another question which could be raised about my argument. It might be suggested that my reason for taking the position that we should provide for the basic needs of adults and children in our community is a reprehensible one. I have argued that providing for the basic needs of the members of our community allows them to be able to take part in the productive activity which sustains it. Doesn't this mean that those too physically and intellectually impaired to ever engage in productive activity should not have their basic needs provided for by our community? And isn't this a morally indefensible position to take? My answer to this is that such a position would be a morally indefensible one, but that it is not the position I am taking.

In arguing that we should provide for the basic needs of our community's members because such provision allows them to engage in the productive activity which sustains us, I am not arguing that the capacity to engage in productive activity is what is morally significant. What is morally significant is the sustenance of those who constitute our community. In other words, I take the viability of the members of our community to be a good which is worth promoting. To neglect to meet the basic needs, when we have the resources to do so, of those too physically or intellectually impaired to be productive is to threaten the viability of these more vulnerable members of our community. Because I take the viability of the members of our community to be a good worth promoting, I think our community's unproductive, physically and intellectually impaired members should be accorded a right to public assistance just as our less physically and intellectually challenged members should be.

One could challenge my position that the viability of the members of our community should be promoted. He or she might suggest that this position is arbitrary. It might be argued that my view is simply a personal preference which cannot by objectively justified. "Objectively justified," in the present context, refers to justification by appeal to standards independent of the socially created norms of some community.

My imaginary challenger might be correct. There may be no objective standard by which my preference for the promotion of the viability of the members of our community can be justified. In this paper, I am presenting an argument why, in the U.S., public assistance should be provided as an entitlement. Given that this is the case, my inability to appeal to an objective standard to support my position may not be a grave liability. Perhaps there are U.S. cultural standards, which can justify my position.

It is frequently said (rightfully so, I think) that the U.S. Constitution does not contain any principle that clearly states that those residing in the U.S. should be granted a right to public assistance. Section 8 of Article I of the Constitution does say the following, though:

the Congress shall have power to lay and collect taxes, duties, imposts, and excises, to pay the debts and provide for the common defense and *general welfare* of the United States . . . (my italics).

When the term "general welfare" is used in current political discourse, this is done to refer to the well-being of all those who make up the U.S. community. If this conception of general welfare is granted, the Constitutional principle cited above can be read as authorizing a federal governmental obligation to provide for the well-being of all U.S. citizens. Subsistence is a necessary condition for well-being. Thus, the cited Constitutional principle can be read as authorizing a federal governmental obligation to assure access to the means of subsistence for all U.S. citizens. This obligation provides U.S. citizens with a correlative right to demand that the state assure access to such means.

There is another notion which is a component of the U.S. cultural system which could ground my preference for the promotion of the viability of the members of our community. This is the notion of "freedom" or "liberty." Our Declaration of Independence tells us that all humans are endowed with the right to liberty. Again, I am not concerned with whether this right exist independently of our social creation of it. What I want to suggest is that if we take this right seriously, we would be behaving consistently with such a position if we utilized the resources of the public sector to provide for the meeting of the basic needs of our community's members. As Rawls tells us (1971), a right to liberty is not worth much if one does not have access to the resources which allows one to exercise this right. People without access to food, and shelter end up dying. As far as we know, dead people cannot exercise a right to liberty.

Libertarians who are also strict advocates of private property rights are likely to be deeply troubled by this part of my argument (see, for example, Nozick 1974). A governmental assistance program would be financed by taxes. If people are required to pay taxes against their will to support this program, this amounts to a violation of their right to private property and their right to liberty. Thus, "in the name of

liberty" my proposal relies on the curtailment of it. This is an important criticism which I feel an obligation to respond to.

Property rights libertarians take the position that private property rights exist prior to the social/legal norms of given communities; they *are not* viewed as the creations of communities. These rights grant people an entitlement to use and dispose of the "fruits of their labor" as *they see* fit not as others see fit.

This doesn't seem to me to be a compelling view. The position that our property rights exist prior to the norms created by human communities is an example of what social scientists refer to as a positive statement. Positive statements are judgements about what is or is not the case. In order to assess the accuracy of such statements, we must appeal to some aspect of the "real" world. If we cannot appeal to the norms of human communities to examine the accuracy of the libertarian claim, to what or whom can we appeal?

Earlier property rights libertarians, such as John Locke, (1983) offered an answer to this question. As he saw it, God created us and endowed us with a right to, among other things, property in the fruits of our labor. Due to the difficulty of proving that God exist, let alone that she or he endowed us with private property rights, this is a less than convincing answer to our question.

Instead of assuming that we have property rights prior to the existence of the norms of communities, it seems more reasonable to assume that such rights are created by a given community's social/legal norms. In the U.S., for example, our property rights have been created by laws such as those proscribing theft, trespassing, breaking and entering, armed robbery, etc. Notice how these laws simultaneously place limits on our freedom. They all curtail our liberty to use the possessions of others as we see fit. What might justify such curtailment of individual liberty?

Human societies, if they are to persist, must create incentives which motivate people to engage in the productive activities necessary for sustenance. Arguably, the creation of property rights serves as incentives of this nature (this is not to say, however, that the creation of private property rights

is the *only* possible way to create such incentives). People might be more inclined to engage in productive activities which sustain the members of their society if the norms of their society allow them exclusive use and disposal rights regarding the fruits of their labor. Viewed in this way the creation of private property rights and the curtailment of liberty this entails are not ends in themselves but means to the end of societal sustenance.

My proposal for granting people a right to public assistance is essentially a proposal for granting U.S. citizens a property right in the form of an income guarantee. If implemented, it would curtail the liberty of those who would prefer not to have their tax dollars support such a program. It is my view that the liberty of such persons should be curtailed, just as the liberty of thieves and armed robbers should be. This is because the curtailment of liberty in all these cases serves to promote the good of sustaining the members of our community.

I have argued that the public sector should assume responsibility for assuring access to the resources which allow the basic needs of all members of our community to be met. The question still remains, though, how exactly should this be done.

Why the Federal Government Should Be the Provider

One might think that my proposal could be met if the federal government simply mandated that all states must provide assistance to the needy but played no other role in the provision of benefits (e.g., provided no funding for program benefits). Yet this approach to public assistance provision would be inadvisable. A brief discussion of the former structure of the AFDC program will show why this is the case.

Although AFDC was an entitlement program, states were allowed to decide how much money was to be provided to recipients who resided within their borders. In no state in the nation did welfare bring a recipient's income to the official federal poverty threshold. In the majority of states,

welfare benefit levels were below these states' own determi-
nations of the minimum incomes needed in them for fami-
lies to meet their basic needs (Center on Social Welfare
Policy and Law, 1996).

The above facts suggest that it would be ill advised to
grant states a primary role in setting the terms of the provi-
sion of public assistance. We simply cannot depend on
states to provide appropriate levels of these crucial benefits.
The federal government should, therefore, not only man-
date that states provide assistance as an entitlement, but it
should also mandate that recipients be provided a deter-
mined amount which would allow them to meet their basic
needs.

Some might argue that the position stated at the end of
the last paragraph is one which supports the placing of a
huge burden on our states. It could be argued that some
states are very poor and simply would not be able to afford
the provision of a benefit level deemed, by the federal gov-
ernment, to be the appropriate one.

This argument is one which should be taken seriously. It
is true that some states are poorer than others. Admittedly,
it might be the case that some states would have difficulty
providing a grant at a specified level set by the federal gov-
ernment.

One way to deal with this problem would be to have the
federal government set a standard benefit level and assist
states in paying the costs of the provision of this benefit.
Washington could devise a formula which would allow
poorer states to have a higher proportion of their public as-
sistance costs paid for by the federal government than bet-
ter off states.

The problem with this approach is that it would be likely
to leave a lot of state officials feeling that it is unfair. Bet-
ter off states with higher proportions of needy people than
poorer states would be likely to argue that the formula to
determine the federal share of state public assistance costs
should be based on the percentage of indigent persons
within a state, not the per capita income of a state (the typ-
ical measure of a state's economic status). Officials in

poorer states with relatively low proportions of needy people would, of course, resist the use of such a formula.

To prevent such battles, the federal government should not only mandate that assistance be provided as an entitlement; it should pay for the benefits as well. The position I have taken here seems to be justified by the earlier cited section of the U.S. Constitution. Not only does this section suggest that the general welfare should be provided for, but it also suggests that the resources of the *federal* government should be used to do so. It tells us that, "*Congress* shall collect taxes to provide for the general welfare" (my italics).

The most efficient way for the federal government to provide assistance as an entitlement is by implementing a guaranteed income plan. It should simply assure that no family's income falls below the minimum level necessary to meet the food and shelter needs of family members. For reasons discussed in earlier parts of the chapter, such benefits should be granted whether or not recipients work outside the home (I have left out health care because I think this should be provided through a universal health program). At this point, readers conversant with economic theory probably have some serious questions about my argument. How would a guaranteed income program be paid for? Wouldn't such a program create a severe work disincentive? Etc? These are important questions, but a consideration of them will have to be postponed. My intention in this paper was not to focus on the economics of public assistance but to provide a normative justification for the granting of an entitlement to such assistance.

References

Almond, Brenda. "Rights." In Singer, Peter ed. *A Companion to Ethics*. Massachusetts: Basil Blackwell Ltd, 1993.

Center on Social Welfare Policy and Law. *Living at the Bottom*. New York: Center on Social Welfare Policy and Law, 1996.

Locke, John. *The Second Treatise on Government*. Indiana: Hackett, 1983.

McBride, William L. *Social and Political Philosophy*. New York: Paragon House, 1994.

Nozick, Robert. *Anarchy, State, and Utopia*. New York: Basic Books, 1974.

Rawls, John. *A Theory of Justice*. Massachusetts: Harvard University Press, 1971.

4 ▍ Why There Is No Movement of the Poor

William DiFazio

May 5, 1992: "I don't want to die in the streets. Hossein, don't let me die in the streets." An eighteen-year-old black teenager, but no longer a kid. His life only hard times. His parents threw him out two years ago. His mother's boyfriend didn't like him. He has been on the streets ever since. His hands are all red and swollen. His face leathery. Two years on the streets and he looks old and sick.

Hossein says, "I won't let you die, you shouldn't be on the streets. You should be in school. You should have a life." I listen to this. Hossein knows that I know that even with all the resources of the Bread and Life Program, St. John the Baptist Church and Public Assistance, it might not be enough. He may not be able to prevent his death on the streets.

I go to work. Serving food on the line. I see Beverly and ask her how Sasha is. "Oh she's better. Yeah she's finally over the tuberculosis. She even came in to eat last week. But the doctors want her to have more bed rest because she has a cold in her lungs. Bill, if you saw her you wouldn't know her."

I worked three years with Sasha before she got sick. Beverly continues, "She's half the size, you wouldn't know her."

It's only a few days after the Rodney King verdict and the Los Angeles riots. As a sociologist I am ready for the dra-

142 ■ William DiFazio

matic and angry responses of these poor people to this cat-
astrophe.

Dramatic responses do not come. Instead I get quiet res-
ignation. "Sure people all over BedStuy were outraged that
the police, that they weren't found guilty, but what did you
expect. This is nothing new for us." People tell me incidents
in downtown Brooklyn, at the A&S department store they
say a woman was killed. It was all hushed up. A woman re-
sponds, "Yeah it was terrible in my neighborhood, my neigh-
borhood is always terrible [she laughs cynically]. That's
normal in my neighborhood."

As a sociologist, I was ready to dramatize poverty, and
thus unintentionally romanticize it. But poverty is neither
romantic nor dramatic. It is ordinary. In our free market
system there are always a few winners but most lose, and
poverty just increases. With permanently declining job op-
portunities and lower wages for the jobs that remain, plus
cuts in public funding (27.9% in aid for single mothers with
children alone from 1979 to 1989)[1] the poor keep losing
ground. There are no social movements, and no govern-
ment programs to change this. In fact it just gets worse;
President Clinton has sided with conservatives on welfare
and entitlements have ended. Democrats and Republicans
have agreed that workfare is the full employment program
for the United States. "Jobs for All," but at a rate which
means indentured servitude for the poor. The politicians all
speak the same language, that jobs will reduce poverty, but
there aren't enough jobs, the new technologies are job-
destroying, and 50 percent of the new jobs that have been
created pay poverty-level wages. To end poverty, jobs would
have to pay above poverty-level wages. They don't; instead
we have the end of welfare replaced by workfare, the poor
are forced to work for their public assistance just guaran-
teeing their continued poverty. Poverty grows throughout
the United States. The hopelessness of the poor has be-
come ordinary.

Cornel West states that, "What happened in Los Angeles
was neither a race riot nor a class rebellion."[2] He's right.
Why are there no alternative movements, no new vocabu-

lary shifts in opposition to the language of limitations that dominates poverty policy? There are myriad programs and thousands of poverty advocates and professionals but they exist in competition with each other for a shrinking poverty pie. Many even do good work like Hossein and Sr. Bernadette at St. John's Bread and Life, which feeds 1,200 people per day lunch and breakfast. But good works and even a few innovative programs doesn't make a movement. Movements would posit an alternative to the current immiseration, that would mobilize the population to work for the elimination of poverty. Currently the only alternative is the conservative vision of Newt Gingrich and Charles Murray and their faith in free market capitalism to end welfare. There is no alternative language of possibility.

Here I will argue that three conditions work against a social movement of the poor; first the postmodern condition, second the problem of advocacy, and third the jobless future. Together these three conditions make the possibility of a poor people's movement difficult but not impossible.

The Postmodern and the Last Master Narrative

Michel Foucault told us that he is not a postmodernist, but his critique of modernism, and his analysis of power has had a profound effect on postmodern and poststructuralist social theory. For Foucault, "The omnipresence of power: not because it has the privilege of consolidating everything under its invincible unity, but because it is produced from one moment to the next, at every point, or rather in every relation from one point to another. Power is everywhere not because it embraces everything but because it comes from everywhere."[3]

Further, "Where there is power there is resistance, and yet, or rather consequently, this resistance is never in a position of exteriority in relation to power."[4]

Foucault theorizes about the micro-level of power in opposition to the tyranny of all totalizing discourses, the grand narratives of history of Marx, Freud, the sciences of man. Thus he opposes Marxism as a project that explains history

as an inevitable contest between classes ending with the defeat of the bourgeoisie. Power is not to be understood in terms of these grand schemes of history culminating in the myth of scientific truth. Power is not to be understood as being continuous and the result of history but as a break that constitutes individuals and knowledge. Struggles here occur at the level of micro-politics, at the capillary level, "the point where power reaches into every grain of individuals, touches their bodies and inserts itself into their actions and attitudes, their discourses, learning processes and everyday lives."[5]

Foucault's notion of power equalizes instead of creating hierarchies. Power is everywhere, it is equal, circulating, multiple, constituting discourses, fomenting micro-struggles. This allows for the surfacing of an insurrection of subjugated knowledge, "the historical contents that have been buried and disguised in a functionalist coherence or formal systematization."[6] Disqualified knowledges display themselves, and individuals are constructed by the power of these discourses. Many struggles come to the surface; a whole "politics of identity" is constituted everywhere from gays and lesbians to Bosnians, Serbs and Croatians. Here knowledge is power, the power to define others. The struggles for identity at the micro-level are constituted as liberatory but as they succeed they are institutionalized and they become panoptic and produce a world of domination, judgement, surveillance and discipline.

Here I seem to have a description of the world of poverty, all kinds of micro-struggles of advocates, professionals, the homeless, the hungry, the HIV positive, poor women, for benefits, programs, which as they become successful become panoptic. Foucault describes a situation that has real relevance for understanding poverty, but he cannot offer an alternative analysis, or a vocabulary that can nourish a movement to change all of this misery. The micro-struggles help to define a situation, even provide some innovations, but for an ending of poverty these micro-struggles must unify. Unification is necessary for power as a force that moves the world. This is not happening. Foucault is right and as long as he is right the misery will increase.

Thus micro-politics is all that is possible at this postmodern moment. The old grand narratives offer no alternatives, and micro-politics is a reformist alternative, thus we live in an endless present in which there is no possibility of reinventing the world. This is not to deny that this is a world where the voices of marginalized groups have emerged. Women's voices, lesbian and gay voices, African American voices, postcolonial voices. This multiplicity of voices is now heard but rarely does it move beyond the speaking. In a world in which the emancipatory project of modernism is exhausted, its voice is reduced to the language of domination and oppression. At the same time, postmodernist new social movements rarely move beyond deconstructing possible emancipatory alternatives. The political representation of the postmodern is piecemeal reform.

Jean-Francois Lyotard's[7] postmodern condition reinforces this reformist present. He constructs a computerized world in which knowledge is a crucial commodity. Though categories such as class, race, gender are not possible. They lack complexity and are incompetent because they reduce the world to totalizing discourses. This world of knowledge and data banks is not for every one. The poor are exempt and left to simple narrative explanations and excluded from the complex language games of postmodern science. Of course, Lyotard wants to grant equal access to all, but in terms of the conditions of the poor in the United States, where schooling is inadequate and school failure normal for them, Black and Latino poor suffer even more in the school system. For me, Lyotard is right, scientific language games are games of exclusion in terms of race, gender, class and poverty and these categories are excluded from his analysis. In the postmodern condition the poor are denied the opportunity to function and they are removed from the data bases that constitute power. Instead of the possibility of agency for the poor we have a scientific pluralism, which excludes them. We have poverty advocates and professional poverty experts computing the poor. The poor have lost their voice to those advocates and professionals who can play the language games of power. In Lyotard's scientific textualization the poor have been unintentionally

deconstructed as agents. Unintentionally because they are not part of his theoretical gaze. They are absent in his discourse, as are class agents, women agents, racial agents, gay and lesbian agents.

With the rejection of totality we have a series of fragmented presents; we only have difference but we do not have a way out of the present increasing immiseration. There is no alternative to the ubiquitous present, no riots, no movement, only poverty professionals and advocates structuring the lives of the poor.

Of course micro-struggles are real, as are their limits. I am part of those limits. I am a professional social scientist and poverty advocate. I am on the Board of Directors for St. John's Bread and Life Program, Neighbors Together, New York City Coalition Against Hunger and the steering committee of the Sameboat Coalition. I also lobby for these groups and participate in the three-minute democracy of public hearings. There is a continuous and concerted effort to lobby the New York City Council in opposition to the endlessly proposed cuts to education and poverty programs by the Republican Mayor Rudy Giuliani. Recently, Council member after council member told us that they were against these cuts; one member told us "that you have to understand that Giuliani is a nightmare . . . we are on your side." Though we are a group primarily oriented to hunger issues we lobbied for more services to the hungry, which includes all of the poor; thus for soup kitchens we lobbied to add $4 million dollars to the Emergency Food Assistance Program (EFAP), and for those in danger of losing their housing we demanded $2 million to the eviction prevention program and legal services for poor and an outreach program to educate the poor on what is available to them. The City Council crumbled and approved the budget. It is a disaster for the poor.

While poverty and education programs were cut in general, we were relatively successful and got about half of what we wanted for EFAP. Here is an example of the limits of micro-politics, where many interest groups struggle against each other for a "shrinking pie" of benefits. We don't really struggle for a larger pie or an alternative to this

insidious structure. The rules of the game are determined beyond the world of the advocates, in the backrooms of government, where the political meets capital—that's the real power. The micro-struggles at best can fight for reforms. Nothing more is possible outside of a social movement that would change the rules of the game. The postmodern condition is a reformist moment in a time that requires great change. Thus, the micro-struggles of the poor take a Foucaultian turn; they cheat, rob and steal. Crime becomes a major form of resistance, and in relation to this resistance domination, judgement, surveillance increase.

Seemingly, Ernesto Laclau and Chantel Mouffe offer an alternative, a postmodern politics of radical democracy. They write in *Hegemony and Socialist Strategy: Towards a Radical Democratic Politics*[8] that the Marxist conception of class has "exhausted its productivity." The class struggle model is untenable and the consciousness of the proletariat is historically unsubstantiated. What is necessary is the creation of a political imaginary that is not founded on an a priori, class-based agent but on the pluralistic principles of a radically liberated democracy. Not that a class movement is not important but it is only a component of a movement for radical democracy. Class as the basis for a movement was too narrow. Radical democracy opens the possibility for a broad spectrum of social movements. Laclau and Mouffe's "thesis is that it is only from the moment when the democratic discourse becomes available to articulate the different forms of resistance to subordination that the conditions will exist to make possible the struggle against different types of inequality."[9]

These struggles are subjectless and occur outside the social body. Agency that requires a subject like Marx's universalistic agent, the proletariat, is "essentialistic," for Laclau and Mouffe. Marxists reduced all oppression to inequities in the capitalist production process. It is only by constituting subordination in new discursive formations of radical democracy that they can begin to do a nonessentialistic politics against all forms of oppression. Thus "from the point of view of the determining of the fundamental antagonism, the basic obstacle as we have seen, has been classism: that

is to say, the idea that the working-class represents the privileged agent in which the fundamental impulse of change resides."[10] They came to this conclusion through a survey of Soviet and non-Soviet Marxism. For them class is a term steeped in orthodox determinism: it is incapable of sustaining solidarity. In the postmodern world, the political is increasingly autonomous and pluralist. Laclau and Mouffe privilege the political and cultural over the economic. Since they simply and wrongly view class as an economic category and not a cultural category, their analysis is a continuous attack on class. The poor are implicated here because they are a class group as well.

I agree in part with Laclau and Mouffe's claim that class mapping is insufficient. But though they take on the history of Marxism, they never take on Marx. As a result, they reduce and thus distort the notion of class, flattening it to an economic category almost in the tradition of Parsonian sociology. They miss the social and cultural components that were crucial to Marx's analysis of class, which made struggle possible. Thus they reinforce the economistic analysis of class of which they are critical. In continuing with this line of thought, they substitute a Marxist essentialism of the working class as the a priori agent for an essentialism of a particular discursive formation—the principle of radical democracy. Whether Marx, Marxist, or Laclau and Mouffe, all are trying to reduce social theory to its essential space for impact on actions. They all resemble physicists looking for a unified field theory. Laclau and Mouffe's political imaginary views the discourse of socialism as a limited voice because of its claim to be the single, universal voice. Instead they offer radical democracy, which they claim is prior to the limited socialist vision. They fail to see their own essentialism. They write:

> The discourse of radical democracy is no longer the discourse of the universal; the epistemological niche from which "universal" classes and subjects spoke has been eradicated, and it has been replaced by a polyphony of voices, each of which constructs its own

irreducible discursive identity. This point is decisive: there is no radical and plural democracy without renouncing the discourse of the universal and its implicit assumptions of a privileged point of access to the "truth" which can be reached only by a limited number of subjects.[11]

In resisting the Marxist privileging of the agency of a single subject, their analysis denies any agency to the proletariat and by implication the poor as well. Laclau and Mouffe allow the working-class struggle as a discursive formation but this struggle takes the form of a transformation that will occur without any human agents. As a result, their argument denies the autonomy of the plurality of the oppressed groups they are defending. They deny the subjectivity of groups that have only recently displayed their subjectivity, whether they are women struggling for equal rights, Lesbians in the Lesbian Avengers, or the Brazilian working class. This is particularly important for the poor who remain outside of the power of discourse. What they have unintentionally posited is a new vanguardism of "intellectual and moral leadership." With their claim that domination and oppression do not exist until a discursive formation labels them as such, the actual experience of ordinary people is negated, for none more than the poor. Nor can these people struggle to formulate their own discursive formations. If true this explains why there are no poor people's movements, and thus radical discourse seems to exist independently of their lives. For a truly radical democracy to exist it would have to create the conditions of active participation for all based on the guarantee of a middle-class standard of living for everyone. This is the basis for a new class project. A project that understands the demands of women, gays and racial minorities and also the centrality of knowledge-based, high-tech production regimes. Here class is not to be understood as a reified category but as a project that is formed in a movement. Class then isn't to be excluded but is central to the formation of an alternative to the current piecemeal reform.

I agree the grand narratives no longer work, but there is nothing to take their place, certainly not micro-politics or radical democracy. But even with all of the discourse against the grand histoire, the master narrative, the signs and spaces of the postmodern world are flooded by an unspoken signifier—global capital. Computer-aided, postmodern capitalism is the signifier of this world and its last master narrative.

Computer-aided capitalism meets the postmodern at the point of flexible, just-in-time, post-fordist production regimes. These production regimes have been made possible because of the new knowledge-based computer technologies. They are dependent on the computer in the same way that fordist, mass production regimes were dependent on the mechanical technologies of industrial capitalism. The postmodern is the cultural sensibility that enframes the commodity production of computer-aided capitalism. This new form of capitalism enables the commodification of knowledge in endless and instantaneous simulations. It reduces all signifieds to its free market script. It has annihilated space and time. Space is transformed into controllable cyberspace, where Wall Street and banks become unnecessary as physical places and only exist in the ever increasing power of the World Wide Web. Time is compressed to automatic turnover in an endless excess of profit. This immediate capitalism no longer has to legitimate itself because there aren't any competing grand narratives in this world where history is now obsolete.

Computer-aided capitalism under the guise of a petit histoire of flexible, fluid, personal and decentered individual entrepreneurialism is global and multicultural in the sense of a truly hegemonic domination. Capitalism in its modernist stage was oppressive but it needed a strong nation state to facilitate accumulation and social programs to pacify its citizens for capital's excesses. Social Security, AFDC, unemployment benefits, helped legitimate nationally based corporate capital. But in computer-aided capitalism which knows no space, such as a nation state, its only allegiance is to excessive profits. The state has been made hollow—and privatization fulfills everyone's expectations

and satisfies all needs. The free market in a hyper form, beyond anything Adam Smith imagined, creates profit at every itch and scratch. Public space implodes, and with it politics is reduced to a side show for capitalism's expansion beyond space and time. The hollow state is concerned with balancing budgets and eliminating taxes; this is how the public good is now defined.

First on the agenda of the hollow state are the entitlements of the poor. The advocates fight back, not through social movements but through attempts to rebuild the modernist functions of the nation state, a nostalgia for "the New Deal" and "the Great Society." They try to maintain local programs that the hollow state must cut to balance the budget. Some of these battles are won, reforms are won. But the state in its postmodern form is hollow and its tendency is toward deregulation and privatization; that is the accumulation function for computer-aided capitalism. In this the poor are its greatest victims; but the lives of working-class and middle-class people are also being sacrificed. The middle class is angry, aware of their wage stagnation and job insecurity. Tax cuts have become the simple solution. The poor are silent.

The irony of this postmodern world is that everything has been deconstructed but computer-aided capitalism. The mistake of all this postmodern politics is that it ignores the hegemony of computer-aided capitalism and takes this reformist moment of history and universalizes it. Foucault, Lyotard, Laclau and Mouffe have all created their own grand narrative of multiplicity, difference and contingency. At this point in the present they are right, but we must not forget that this is but a moment. Even the hegemony of computer-aided capitalism is a moment. But ordinary people, as subjects of their own lives, do reflect on, create and produce their own cultural worlds, their own communities of resistance, their own alternatives to this moment of increasing immiseration. They must do this both materially and discursively. Even in this world where there seems to be no alternative to the world of global, computer-aided capitalism, there is the possibility of an alternative narrative, radical democracy based on a guaranteed income.

The Problem of Advocacy

The dialectic of Sr. Bernadette:

> If there are any here who thought they joined this congregation only to preach the gospel to the poor but not to comfort them, only to support their spiritual needs but not their material ones, to them I say this. We should assist the poor in every way and do it both by ourselves and by enlisting the help of others." Vincent de Paul[12]

> A sphere that does not stand partially opposed to the consequences, but totally opposed to the premises of the German political system; a sphere, finally that cannot emancipate itself without emancipating itself from all other spheres of society, thereby emancipating them; a sphere in short, that is the complete loss of humanity and can only redeem itself through the total redemption of humanity. This dissolution of society existing as a particular class is the proletariat." Karl Marx[13]

In November of 1988 the day before George Bush would be elected president, the soup kitchen, then on Willoughby Street, was very crowded. At 12:30 we ran out of food one half hour before closing. There were still people on line waiting to be fed. Sr. Bernadette, knowing that we hadn't any food left and would be unable to feed the people outside waiting, "lost it." This very competent woman, who prepared food for over one thousand people per day, started to scream. She knew what a disaster Reaganomics had been for the poor. It was obvious to her that the continuous cuts in spending had increased the everyday misery of the people in the soup kitchen. Now that Bush was about to be elected, these policies would be continued. Earlier she had gone table-to-table to tell people to vote for Dukakis. Now, she had had enough and she screamed: "Four more years of Reagan, four more years. How will we survive?"

The dialectic of Sr. Bernadette is expressed in the above situation; it expresses the contradictions of social welfare

in a free market capitalist society. Thus at the same time that Sr. Bernadette knows that the need in Bedford Stuyvesant and the surrounding areas of Brooklyn is immense and that the food and other services which are provided are needed to reduce people's misery; she also knows that St. John's Bread and Life Program is a band-aid. It only serves a small fraction of the need in the neighborhood. She also knows that all of the soup kitchens, food pantries and other services run by the state or the non-profits do not begin to satisfy the needs of the poor people of New York City. Specifically, in terms of poverty, we deal only with the consequences and rarely with the premises of this condition. Sr. Bernadette knows that feeding more than one thousand people per day takes all of her time and energy and that in spending her time providing food and social services she spends very little time in helping to mobilize the poor politically. That if the poor do not become political their condition will only become worse. The soup kitchen doesn't provide political alternatives; they only feed people and help them to get and keep their benefits. Thus Sr. Bernadette's frustrated refrain of "four more years of Reagan" is both an expression and her understanding of the contradiction of the limits of what can be done through charity and entitlements; but at the same time of why people line up, then on Willoughby Street and now eight years later on Hart Street. She understands that poor people's failure to mobilize and construct an alternative to their condition has led to an ever worsening condition. Benefits continued to be reduced, the poor are increasingly stigmatized, and now even the government has deserted them and a Democratic president, President Clinton, has signed the Welfare Reform Act that terminated entitlements. Now, the fate of the poor has been reduced to block grants, term limits and workfare. Immiseration increases and more people are forced to use the services of soup kitchens and food pantries. But as funding is cut, Hossein Sadaat and the Board of Directors of the kitchen must figure out creative ways to fund the program. Even less time is spent on poverty politics. As more people come to the door, more

food and services are required. This is an endless cycle of funding cutbacks, increases in people using our services and our need to raise more money.

Theresa Funicello's important work *Tyranny of Kindness*[14] correctly understands the contradiction but comes to the wrong conclusion. She understands that charities and social welfare agencies often serve to maintain the immiseration of the poor. Money that should be going directly to the poor through a guaranteed income instead spawns soup kitchens, shelters and non-profit poverty bureaucracies. These agencies provide jobs for middle-class advocates who misuse and waste both government monies and private donations. "The charities old and new, food distributors, shelter providers and the rest are ill suited to care for poor people—especially families with children. They are driven by the logic of self perpetuation, which almost without fail leads to a relentless pursuit of government contracts and donated dollars."[15]

The problem with Funicello's argument is that she blames the charities and the social welfare agencies for the condition when the problem is really the result of a much larger system. For her, corruption is the problem; she then in her own way reproduces individual behavior as the problem, that is, the behavior of the advocates. Not that their behavior is completely innocent but she misses the larger interests that benefit from the artificial reproduction of poverty. She misses the part played by both global capitalism and by the new technologies with their massive destruction of jobs through automation and computerized displacement. She is willing to blame the state, but fails to see how diminished it is. Her analysis highlights both the state and the non-profits but it mystifies the place of national and global capital.

Funicello uses a common-sense notion of bureaucracy as corrupt and inefficient. This is an insufficient critique. She doesn't take into consideration the fiscal pressures that force service providers and advocacy groups to adopt a corporate model. Though she does understand that increasingly scarce resources and the everyday requirements of running an agency under the conditions of dependency on

large contributors (whether dependent on the state or private foundations), restricts their flexibility. The real problem of bureaucracy is that agencies are forced to adopt a corporate model, and thus they function like any bureaucratic organization. The organizational requirements make both having an alternative vision and doing politics very difficult. Thus when I participate in an advocacy group that is planning a demonstration at the Stock Exchange, we must do a cost benefits analysis of the political outcomes. Is a good demonstration one that gets a lot of publicity and is this beneficial despite the possibility that some corporate funds will be lost because a funder doesn't agree with our political position? I have often attended advocacy groups when they are discussing political actions and often these advocates worry about a successful demonstration having a negative impact on fund raising. Advocacy groups are dependent on external funding for their survival, and political activism can seriously hurt their ability to raise money from the government and the private sector. This is especially true now that the state has hollowed out and provides less funds, and now that we are increasingly dependent on "the kindness of strangers."

Many non-profits have tax exempt status under section 501(C)3 of the Internal Revenue Code. This section on one hand provides favored tax treatment for non-profits but on the other hand prevents them from engaging in partisan politics. They are unable to endorse political candidates, or do political campaigning and electioneering. They are reduced to limited lobbying, voter registration without partisan politics and education. These limit the types of political activities that advocacy agencies can participate in.[16] Movement building activities require partisan politics; 501(C)3 has made this impossible. Newt Gingrich and the other Republicans produced the very partisan "Contract With America"[17], which has successfully ended entitlement programs and moved much of the country to the right. This includes the president's own position. Their thrust of having the non-profits serve as the "new safety net," is a task that the non-profits recognize as impossible. "The critical question is, will donations increase enough to fill the void left by the

federal cutbacks? The evidence strongly indicates that they will not. The real increase in donations was only 0.5 percent overall in 1993. . . . Other estimates range as low as 1 to 2 percent. Even if donation levels were to rise substantially, only a modest share of the gain would likely be channeled to assist the most disadvantaged groups. Higher giving rates typically benefit higher education, culture, and the arts more than social services."[18]

How can advocates find the time for politics? It's very difficult when they are maintaining the agency, providing services, maintaining the physical structure of the facility, raising funds, writing grants, client problems, board problems, neighborhood problems. These activities take up almost all of the time of, in general poorly paid administrators, staff and volunteers. Political activity becomes a secondary activity to the daily business necessary for the survival of the agency. In this situation political work is often carried on as a defensive action. It's what you are forced to do when the federal, state or city budget is cut again. You organize a group to go to city hall or Albany to tell politicians the misery that these cuts will cost the people of Bedford-Stuyvesant or Brownsville, Brooklyn. Advocacy groups are forced into doing piecemeal politics, after the fact, and into trying to maintain the hollow state's insufficient welfare system. Advocates and some poor people will lobby, go to public hearings where they will wait for hours and then testify for three minutes, while the politicians walk in and out of the hearing room. All of these activities take time; organizing takes time, and the first priority of any advocate is devoting time to the survival of the agency.

The budget cuts continue; more and more people need the services that the agency provides. Thus advocates are in a permanent problem-solving mode as crisis after crisis must be confronted and resolved. On one hand the agency is trying to provide more services as government is providing fewer benefits; fund raising becomes the single most important activity and administrators must consider that political involvement might alienate big corporate donors. On

the other hand, poor people are also losing their benefits, which means that the number of people who need these services are increasing daily.

At the same time there are the internal problems that all institutions have. There are power struggles between board members for control of the organization. There are differences between the Administrators on the size and scope of the mission, and the Board of Directors always agree on the need to get involved in poverty politics. Organizations flounder on these internal strains.

Between the bureaucratic structure of advocacy institutions, the continuous problem solving mode of operation, fund raising and tax exempt status, political activity becomes minimized in the face of the everyday work of the agency. The advocates' meager vision is going back to the old welfare state. They haven't forgotten that it was insufficient and oppressive to poor people but it was better than "the end of welfare as we know it." This isn't an alternative vision of how to end poverty. The politics of advocacy, without a vision of how to end poverty and unable to mobilize a mass poor people's movement, are reduced to budget battles. These struggles have failed and at great expense, the increased immiseration of poor people. The conservatives have won, they control the debate on welfare. They believe the utopian vision of the capitalist marketplace can eliminate poverty. They have made this utopian vision seem practical and they have transformed the politics of welfare in the United States.

Ending poverty requires, first, that the poor must be mobilized, that is, helped to organize themselves politically and second, that poor people and advocates must join together and take the time to democratically develop an alternative vision of a world without poverty. Here I am in agreement with Theresa Funicello that a guaranteed annual income is worth fighting for. Currently these activities are done in a piecemeal fashion, at best. Currently advocates are stuck in their bureaucracies, raising funds and doing politics at the level of budget battles. They do good work but they are stuck in the dialectic of Sr. Bernadette.

The Jobless Future:
Fewer Jobs at Livable Wages

In August 1996 President Clinton signed the new Welfare Reform Act. This legislation cut food stamps, imposed block grants for a new program, the Temporary Assistance for Needy Families (TANF), that has replaced Aid for Families with Dependent Children (AFDC), thus ending entitlement programs for the poor. Now all able-bodied men and women must work for their meager benefits. We now have "workfare" in the jobless present. This legislation also has eliminated Supplemental Security Income (SSI) and Foodstamps for non-citizen legal immigrants. This is the conclusion of twenty-five years of the continuous assault on aid to poor people.

President Clinton is proud of the reduction of the welfare roles during his first term. This is not the result of a reduction in poverty but the result of new bureaucratic surveillance procedures. "The United States child poverty rate is 20.8 percent—three times the average of other industrial countries. But the welfare bill that became law in 1996 is likely to push an additional 2.6 million people—including 1.1 million children—into poverty."[19]

At St. John's Bread and Life Soup Kitchen the changes that have been implemented at the state and local levels have already taken their toll. In November 1996, as I talk to people at the full tables in the soup kitchen I hear tales of misery and desperation. A thirty-eight-year-old African American woman who has lost her benefits tells me what she now does to get housing. "My friend helps me, I live some of the time with him. I eat here whenever I can."

I ask her, is it getting harder to make ends meet? "Yes it is. I can't survive, I need medical assistance and I'll do anything. I have to ask people to stay at their house. I have to do favors. I provide sexual favors [she points at her friend]. He only lets me stay with him for sex."

A forty-nine-year-old African American man who doesn't have any benefits tells me, "I live between a rock and a hard place. I'm homeless, but I have a basement that they let me sleep in for taking care of it. I don't have my own home. . . . It's truly a shame that I can't get a job. . . . I have an Asso-

ciates Degree in Accounting. . . . I was working at a beverage place that reclaims bottles and cans. It took me less than a minute to fill the boxes. I pride myself at my speed at work. They're paying me $3 an hour. Working ten hours a day, how could I live? Then they laid me off because they weren't busy. It's pitiful out there."

Poor people losing their welfare benefits, looking for jobs that will allow them a decent life. Willing to work on "workfare programs" if those programs could get them jobs with an income that would allow them to afford an apartment and to support their families. These programs don't provide for that opportunity. As they lose their benefits, they work what they call "odds-and-ends jobs." These are jobs that are low paid, temporary and often degrading. They are at the bottom and they know it. But they are part of the general, global tendency of fewer jobs at livable wages.

Economists and policy makers are pessimistic about the computer revolution creating an equal revolution in economic growth. Representative of this position is a recent article in *The New York Times* by Louis Uchitelle. "The output resulting from the computer revolution of the last twenty-five years has been disappointing. Computers have, of course contributed to productivity and economic growth. But the contribution has failed to register in government statistics as the kind of robust catalyst that made the 1950's and 1960's such prosperous years."[20]

But economists, with their inflexible models,[21] haven't really understood the rupture that the computer revolution is. It transforms the world of corporate and financial capital. Economists cannot understand this for the same reasons they failed to understand Karl Marx's critique of political economy. They were so afraid of the revolutionary implications of his theory that they failed to understand what he was saying about their discipline. His critique is that political economics is insufficient because it fails to understand itself as a social form, within a social context. For Marx capitalism was a whole society. In the same light, through Bill Gates' eyes, the computer revolution isn't about economists' narrow notions of productivity but about the transformation of a whole society. Like Karl Marx, Bill Gates has made the

same discovery, albeit from different political positions, that the transformation is at the level of totality and has transformed daily life, including the daily life of work and business. Gates thus says that in an everyday life "mediated" by computers and the Internet, "The global information market will combine all the various ways human goods and services and ideas are exchanged . . . your workplace and your idea of what it means to be 'educated' will be transformed almost beyond recognition. Your sense of identity, of who you are and where you belong, may open up considerably. In short just about everything will be done differently."[22]

This new technology isn't innocent, it is directed by the interests of global capital. It increases productivity, thus allowing fewer workers to do both the physical and more importantly the knowledge tasks.

The logic of computer-aided capitalism, which was partly illustrated in the section on postmodernism, is exemplified by ICAD. The computer revolution is a new development in the replacement of men and women by machines. This technology can direct automated systems of production in the fabrication of everything from automobiles to computers but this technology functions at the level of knowledge production as well. Thus, ICAD is a "knowledge based engineering system . . . developed by Concentra, a U.S. software company. . . . [U]sing ICAD as the main aircraft development tool should make it possible to complete the conceptual design in about half the time, employ half the number of engineers and test twice as many options," says Jeff Jupp, director of engineering at BAe Airbus (British Aerospace).[23]

The global logic of computer-aided capitalism is fewer workers and greater productivity, not only in manual work but in knowledge work as well. In *The Jobless Future*, Stanley Aronowitz and I argued that the computer revolution leads to what we called quantum measures. "[T]he tendency of most investment is labor saving in comparison to the part played by machinery in production, then the jobs created will be reduced relative to the unit of investment capital . . . the number of workers—intellectual as well as manual—is reduced by quantum measures in computer-mediated labor."[24]

Whether we are talking about airplane engineers or people at the soup kitchen, this is a problem. In the past more productivity created more jobs but now greater productivity puts workers into increasing competition with each other and here jobs, wages and job security are too often sacrificed. This is particularly important for the poor, who are largely excluded from any possibility of participating in the high-tech economy. This is a global process and as it's reported in the ILO report, World Employment 1995, ". . . the rapid diffusion of ICT [information and communication technologies] has led, and is likely to continue . . . a substantial 'exclusion' of large parts of the labor force, either unskilled or wrongly skilled and incapable of retraining. This bias in demand for labor has only emerged over the last ten or fifteen years, but is likely to be more pronounced in the rest of the 1990's. In this sense, therefore, it is new technology that is the basic cause of the problems faced by unskilled workers in industrialized countries."[25]

In the U.S.A., since 1973 family income has increased at the growth rate of 0.6 percent per year to $47,221, but this is mostly the result of women entering the workforce and of two-income families. The current tendency is for economists to income-average and thus to evenly distribute the 46% of the income of the top income fifth throughout the population. This statistical redistribution has accomplished the appearance of increased equality through statistical manipulation, without accomplishing real equality of income. Despite these statistical manipulations, in the years from 1973 to 1993, ". . . the distribution of family incomes became much more unequal as the share of total family income going to the bottom fifth of families fell from 6 percent to 4 percent and the share going to the top income fifth increased from 41 to 46 percent."[26]

To this should be added the work done by Chris Tilly on the contingent labor force, and in particular the expansion of the involuntary part-time worker who wants a full-time job. "Throughout 1993, an average of 6.1 million Americans, or 5.5 percent of those at work, were working part-time involuntarily—a number comparable to the annual average of 6.5 million who were unemployed."[27]

Bad jobs with low wages that are often temporary and part-time have increased in all sectors of the economy, including college-trained professionals. In this context postindustrial transformations decrease the production of new jobs in all sectors, this situation hurts the poor disproportionately.

> The sharp declines in employment are no longer restricted to old line manufacturing firms or old blue collar workers. Plant closings, layoffs, and paycuts have swept high technology industries as well. In just the first six months of 1985 . . . employment in the computer and semiconductor industries—the core of the new technology shed more than twenty thousand jobs.

> The BLS (Bureau of Labor Statistics) reported that between 1981 and 1986 more than 780,000 managers lost their jobs as a result of plant closings and permanent layoffs. And the pace has increased even as the economy entered its fourth year of recovery. In the drive to make the ranks of management "leaner and meaner," nearly 600,000 middle and upper level executives lost their jobs between 1984 and 1986. Such companies as AT&T, United Technologies, Union Carbide, and Ford are leading the "management massacre."[28]

In the computer-aided postindustrial society, growth in productivity doesn't mean job creation. Economic growth does not "trickle" through the whole society. The new forms of organization and new technologies from high-tech expert systems to robotics displace the productive forces of the old industrial society. Postindustrial efficiencies create declines in the production of jobs, especially for the poor.

> The decline of the old productive forces means that the economy cannot provide the millions of unskilled, entry level jobs that are needed to absorb the available labor power. The result is that millions of people, particularly inner-city minority residents, become a surplus population with little prospect for even minimal economic se-

curity. But now, with employment declining in many traditional sectors of the economy, "structural unemployment" threatens many industrial workers of all races.[29]

In the current context, with the decline of secure jobs at livable wages, the problem of advocacy and the postmodern condition, the development of social movements has become difficult but not impossible. This explains why there currently isn't a poor people's movement in the United States. Of course there are many organizations of advocates and poor people fighting against budget cuts, homelessness, and hunger, but these groups are fragmentary and usually defensive in their actions. Ultimately, because they have failed to develop an alternative vision they have tacitly accepted the conditions of the conservative discourse on poverty. They fight over welfare policy, budget cuts and jobs. They have bought into both parties' solution to poverty, that is, more jobs are needed. But jobs are not the solution nor is full employment. Workfare is the full employment program of the minions of Newt Gingrich. An alternative vision would understand the logic of quantum measures and the jobless future. The advocates would understand that they should concern themselves with incomes. Only income solutions will significantly raise the standard of living of poor people. In a computer-aided capitalist society in which the new technologies are labor destroying, only solutions whose central focus is on income can possibly work. Even the massive rebuilding of the decaying American infrastructure, which would create jobs, would be insufficient to lift the masses of poor and near poor out of the heavy burdens of poverty. These jobs would have to pay wages which would enable workers to have decent food, housing, education, medical care, etc.

The rebuilding of the infrastructure is needed and would increase American competitiveness in the global marketplace. But the current federal deficits are in the range of more than $150 billion a year. Both parties, because of these deficits have ruled out the extensive federal spending that is required. Massive public works have been ruled out by a permanent austerity economy.[30]

Even if such work were funded and created a sufficient amount of decent paying jobs, there would have to be a guaranteed annual income. All workers who were displaced by new technologies and forms of organization that made their work obsolete would have to be guaranteed wages at their current levels. They would have to be guaranteed through the time that would be required for them to be reeducated and until they could be hired at a new job. This is the type of income based solution that would be required to guarantee a good life to all. This is not imaginable in the current free market vocabulary of both Democrats and Republicans.

Income solutions to poverty would require a major policy shift. Only a social movement with the vision to redefine the relation of work to income to morality could accomplish this goal. This is also not imaginable at this point in American history.

The advocate based leadership of most poverty organizations at this postmodern moment hasn't been able to do the work that is necessary to create a poor people's movement. The practical concerns of daily survival have been their focus at the expense of a movement to end poverty. Instead, the conservative vision of ending welfare entitlements, increasing the misery and hopelessness of the poor have been successful. But the problem of advocacy, the jobless future and the postmodern tendency to reform is a moment in history that can be transcended by the mobilization of the poor. This mobilization can only occur if it makes sense to the masses of poor people. They are silent, beaten and cynical at this moment in their history. To overcome this a movement is needed that "seizes" the imagination of these poor people. The movement that can make this possibility a reality is the movement for a truly participatory radical democracy based on a guaranteed income.

Notes

1. Wallace C. Peterson, *Silent Depression* (New York: W.W. Norton & Company, 1994) p.75.

2. Cornel West, *Race Matters* (Boston: Beacon Press, 1993) p. 1.

3. Michel Foucault, *The History of Sexuality* (New York: Random House, 1978) p. 93.

4. Ibid. p. 95.

5. Michel Foucault, *Power/Knowledge* (New York: Pantheon Books, 1980) p. 39.

6. Ibid. p. 81.

7. Jean-Francois Lyotard, *The Postmodern Condition: A Report on Knowledge* (Minneapolis: University of Minnesota Press, 1984).

8. Ernesto Laclau and Chantal Mouffe, *Hegemony & Socialist Strategy: Towards A Radical Democratic Politics* (London: Verso, 1985).

9. Ibid. p. 154.

10. Ibid. p. 177.

11. Ibid. p. 191–192.

12. Vincent de Paul, ed. Pierre Coste, *Saint Vincent de Paul: Correspondence, Entretiens, Documents* Vol. 12, p. 87, quoted from, Thomas McKenna, *Praying with Vincent de Paul* (Winona, Minnesota: Saint Mary's Press 1994) p. 63–64.

13. Karl Marx, *Critique of Hegel's Philosophy of Right* (London: Cambridge University Press, 1970) pp. 141–142.

14. Theresa Funicello, *Tyranny of Kindness* (New York: Atlantic Monthly Press, 1993).

15. Ibid. p. 252.

16. Peter Swords, "Advocacy Without Fear" (New York: paper for Nonprofit Coordinating Committee of New York, Fund for the City of New York, 1996).

17. Rep. Newt Gingrich, Rep. Dick Armey and the House Republicans to Change the Nation, *Contract With America* (New York: Times Books, 1994).

18. Julian Wolpert, *What Charity Can and Cannot Do: A Twentieth Century Fund Report* (New York: The Twentieth Century Fund, 1996) p. 26.

19. Lynette Engelhardt, "The 1996 Welfare Law," paper for Bread for the World (Silver Spring, Maryland: Bread For the World, November 1996) p. 1.

20. Louis Uchitelle, "What Has the Computer Done For Us Lately?" *New York Times* December 8, 1996, Section 4, p. 1.

21. Bill Gates, *The Road Ahead* Second Edition (New York: Penguin Books, 1996).

22. Ibid. pp. 6–7.

23. Diane Palframan, "Design System Takes Wing," *Financial Times* September 12, 1996, p. 10.

24. Stanley Aronowitz and William DiFazio, *The Jobless Future: Sci-Tech and the Dogma of Work* (Minneapolis: University of Minnesota Press, 1994) p. 299.

25. ILO Report, *World Employment 1995* (Geneva: International Labor Office, 1995) p. 52.

26. U.S. Department of Labor, *Report on the American Workforce* (Washington, D.C.: U.S. Department of Labor, 1995) p. 51.

27. Chris Tilly, *Half A Job: Bad and Good Part-Time Jobs in a Changing Labor Market* (Philadelphia: Temple University Press, 1996) p. 3.

28. Bennett Harrison and Barry Bluestone, *The Great U-Turn: Corporate Restructuring and the Polarizing of America* (New York: Basic Books, 1990) pp. 37–38.

29. Fred Block, *Revising State Theory: Essays in Politics and Postindustrialism* (Philadelphia: Temple University Press, 1987) p. 110.

30. Eric Lichten, *Class, Power & Austerity* (South Hadley, Massachusetts: Bergin & Garvey Publishers, 1986).

5 ▌ From Chaplin to Dilbert
The Origins of
Computer Concepts

Joan Greenbaum

Beyond the Workplace
Probably the most well-known film character of the industrial period is the role played by Charlie Chaplin in the silent film *Modern Times*. Here he personified modern man set adrift by the rapid pacing of the mechanized assembly-line. The dominant first world nations of the industrial period have now entered a post-industrial era, which in many ways contrasts sharply with those industrial characteristics that divided labor and attempted to control it through the sequential flow of automation. Charlie Chaplin's character and his warnings linger with us, but the message of those warnings needs to change with a better understanding of the way economic objectives influence information system design. Post-modern "man" is no longer caught in the cogs of the unending assembly-line or excessively routinized office work, but instead is being confronted with work that is being made more intense by policies of reorganization and information technology. Perhaps the *Dilbert* cartoons of Scott Adams are replacing the character played by Charlie Chaplin in *Modern Times* as a symbol of how people are lost in their work environment. Like Chaplin, Dilbert needs to be taken seriously. For while it appears that new intensified work structures and new technology could mean that the old concepts of work and jobs will change, work will

certainly not wither away. Indeed the concepts behind the design of computer information systems are intended to intensify work so that work can be done anywhere and at any time: a redivision of labor effecting who, where, and when is done, but not necessarily resulting in less work.

Media pronouncements about the Internet and new multi-media computer programs make it sound like the Internet and its commercial drive, the World Wide Web, are great new technologies just waiting to take us into the entertainment world of the twenty-first century. This type of attention is part and parcel of the blitz that has highlighted each massive piece of what appears to be technologically-led societal change, from the introduction of railroads, to the spread of electrical networks, through personal computer use and now networked computing. The Internet, like its immediate computer-related predecessor, Personal Computers (PCs), have been targeted as great new technologies for entertaining the world's population, since information technology is, according to the media image of the computer industry, to be used to make "life easier" and reduce labor. In *Brave New Workplace*, for example, Robert Howard (1985) described IBM's early marketing ploy for introducing PCs. The ad campaign used Charlie Chaplin's character dancing his way to leisure, as personal computers were to be a tool for truly modern times.

While it is a generally acknowledged principle that computer system design is socially constructed, the specifics about the goals, values, and assumptions that underlie design principles are rarely discussed. Indeed, computer scientists writing about their own work are as likely as others to make it seem as though new ideas emerge full-blown and just suddenly appear to work. Yet there are an almost endless series of stories about technologies that have been virtually "sitting on the shelf" until public use and business interest have brought them out. The Internet for example was developed in the late 1960s as a U.S. military network used by defense contractors and universities. The protocols, or basic agreed-upon standards, for interchanging information from one place to another were the root of its technical success, yet its use as a mass means of communication did

not take hold until a number of economic and social factors changed in the 1980s. A similar story can be told about personal computers, which were technically sound in the late 1970s, but not seen as useful for business until the late 1980s; a shorter time period from design through acceptance but one which, as we will see, illustrates how management had to reorganize work before personal computers could be adapted to office use, and how in some ways organizations had to be pushed by people who had been using computers at home.

This chapter addresses the need to better understand the computer system design concepts which are currently influencing the shape of information systems and Web-based applications. These design concepts, while addressing entertainment and so-called leisure, are concretely based on dividing labor and using computer systems in management-like functions as mechanisms of coordination and communication. Analysis presented here outlines the ways that computer systems design reflects social and economic goals and in some cases conflicting practices. In addition it highlights the circumstances under which computer systems have been constrained by prior technical developments as well as limited by the organization of labor that produced earlier computer systems.

Two major social and economic changes that are now reflected in system design grow out of 1) the separation of work from place and 2) the delinking of labor from labor contracts. This chapter will operationalize what these social and economic changes mean for information systems design and describe how both of these changes have come together under the design concept of *communication*— for this concept influences post-industrial capitalism as strongly as the concept of automation did in the industrial period. In essence this means that communication as a design concept for computer systems provides for ways of embedding managerial control and coordination in hardware and software packages. But this design concept also brings about possibilities for new contradictions between technical design, management objectives and the way people use things in practice.

The Coming of the Age of Communication

In the computer field, as in the general media, the term "communication" has taken on a wide range of meanings from basic ones like telecommunications, indicating the importance of distant message exchange, to all forms of sending messages including fax, e-mail, phones and portable devices. While the idea that we are living in an "age of information" caught popular attention in the beginning of the post-industrial period, it is only recently that the catch-word "communication" has been tagged on as a critical element in linking dispersed people in the so-called information age. *Communication* as a design concept, like its predecessor *automation*, represents a change in design focus that is based on changes in social and economic practices.

In the early period of computer system development, from the late 1950s through the 1980s, the design of mainframe computer systems was based on the concept of automation, which grew out of factory-based division of labor. Businesses and government agencies were primarily organized this way and computer system design reflected this. But in the 1980s competition within capitalism took new forms (as discussed elsewhere in this volume), causing computer systems designed under the ideas of automation to no longer fit workplace organization, nor the needs of capital (Greenbaum, 1995).

As will be illustrated in this chapter, the switch from automation as the driving concept to that of communication did not come easily. In the 1980s, for example, the dominate computer systems still mimicked centralized management beliefs by creating computer systems such as Management Information Systems (MIS), decision-support systems, inventory control systems, and accounting programs. In offices today these have been supplemented, and in smaller companies almost eclipsed by, applications in the form of integrated software packages such as Microsoft's Office Suite and Lotus Notes: programs that facilitate a wide range of office functions such as word processing, data base processing, spreadsheets and now increasing emphasis on e-mail, fax and calendar scheduling programs—

the nitty-gritty of using computers to communicate information across a landscape of redivided labor.

Economic shifts were becoming visible in computer system specifications by the late 1980s, when companies began to call for information systems that could handle *communication* functions and *distributed* work (see Greenbaum 1996). These changes in technical requirements reflected the economic change toward flexibility of scale and place as well as distributed workplaces. These in turn were evidenced by organizational changes which stemmed from the separation of work from place and the delinking of labor contracts from employment, resulting in an increasing reliance on *temporary agreements* rather than employment contracts—a fact born out by both the increasing unemployment rates in the U.S. and Europe and by the noticeable impact of part-time, freelance and leased work relations.[1]

By the 1980s the post-industrial economic and political landscape was shifting out of the workplace and away from the fixed time and place arrangements of industrial relations. Thus shifting the design focus for computer systems from systems that automated flows of products produced under one roof to systems that needed to consider workers and information spread out over time and space.

Older forms of division of labor like those Frederick Taylor advocated broke specific jobs down into rationalized and divided labor, which information system design later used as a base for "automating" these tasks into a flow of procedures and data. But management theory and information system design can now be technically and organizationally based on the concept of reintegrating tasks and jobs and using design strategies of coordination and communication to integrate individual jobs and redivide labor over time and space. The results fit the prevailing post-industrial economic objectives of flexibility and distributed workplaces meaning that work can be separated from place and be moved to locations where the labor market has appropriate skills and can be hired for lower wages. It also means that temporary work agreements become more attractive to employers instead of the industrial practice of

filling central workplaces with jobs based on employment contracts.

It is perhaps as easy to oversimplify these developments from an economically determinist perspective as it is to do so from a technological one. The shift in design emphasis in the current period needs to be viewed as one that grows out of contradictory developments both within and between capitalist growth needs and the organization of technical design work. In short, the constraints of each type of development are based on contradictions in prior periods and thus can be influenced politically when the mechanisms of technical design are made visible.

Building on the Old

Communication as a principle of information system design like that of factory-styled automation is suited to fit into economic and managerial objectives. Yet the ability of systems developers to construct such systems is, of course, limited by the usability of existing technology and the way such systems actually fit in with the organization of work. During a period of economic transition such as the 1970s and 80s there are further contradictions between economic objectives and the ability of management to deliver work organization and technology to meet them. In such cases the design of technical systems often runs in counter directions to management objectives, for design and work organization are built up from existing economic, organizational and technical systems.

In order to better understand the interplay of management theory and technical design criteria, it is useful to examine three types of organizational control that are the building blocks of newer management strategies as well as part of computer software specifications. These are:

- corporate managerial control: in the early computer period bureaucratic control was the dominate form of getting workers to internalize company rules (see Edwards, 1979); this has shifted to a management philosophy of professionalism, but is still based on having

workers internalize rules whether they work in a single workplace or as consultants from home.

- division of labor: mainframe computer systems were designed to fit in with the rationalized division of labor described so well by Braverman (1974); current systems are based on integrating parts of the formerly divided jobs, yet are built on the originally rationalized pieces of jobs and programs (Greenbaum, 1995).
- computer system design concepts and procedures for developing computer systems: mirrored corporate practices of control and division of labor in the mainframe era and continue to do so today.

These three types of organizational control continue to serve the divide-and-conquer needs of capital; they just do so by building new concepts on top of old structures. In the case of computer system design they have been instrumental in helping to design information technology that separates work from the place where it is done, and severs the contractual binds with workers, especially the labor conditions they operate under.

The 1970s
In the 1970s, organizational policies of bureaucracy and extensive division of labor were the basis for the design of mainframe computer systems which were programmed for routine and repetitive processing. The "idealized" form of computer system design was of course modelled after factory automation, where parts were processed in a sequential and linear fashion and where rules and controls were centralized in the computer department. This type of automation was applied to service sector organizations like banks, insurance firms and government agencies that had to handle large volumes of transactions and were economically large enough to afford the expense of ordering and maintaining computer systems.

A key characteristic of this factory model of automation was that work had to have been rationalized and data standardized, *before* programming could be attempted. According to management theory of the time, this meant that

control over data, procedures and indeed, computers, was to be centralized. Standard bureaucratic management practices were also applied to system development projects. Procedures for systems analysis fit in with this rationalistic perspective since they reflected both their engineering roots in Operations Research during World War II and managerial procedures in isolating problems and separating tasks (Greenbaum, 1979). The emphasis was, as it still is, on managing quantitative data so that management could review the numbers and accountants could record them in order to control costs.

The combination of routinizing tasks and standardizing data led in this period to computer systems that specialized in processing routine transactions, such as simple tests for accepting or rejecting insurance claims, processing payrolls at regular intervals and accessing flight reservations by destination—routinization of data and procedures that are still with us today, even though computer system development and computers have changed a great deal. Most business and government systems in the 1970s were based on the sequential flow concept of processing keypunch cards, even though manufacturers such as RCA and GE had produced hardware and software for "time-sharing" data, which meant that different departments within an organization could access information from the mainframe at the same time. For upper management, sequential flow fit existing systems of bureaucratic control of the workforce and of the data, thus decisions were slow to come in trying out newer "time-sharing" ideas.

The production of software during this period also followed the bureaucratic model of divided labor: systems analysts were hired to write specifications, programmers to code the instructions and operators to run the programs (see Greenbaum, 1975, Kraft, 1977). This principle of rationalization of work fit in with management beliefs that costs could be best controlled by dividing and therefore controlling labor. In the young computer industry at that time, controlling software production costs was then viewed as a primary problem, since hardware was on the way to becoming more reliable.

This follows Friedman's (1989) analysis of computer system development, which highlights a period of hardware constraints, followed by a period where software constraints dominated and then into a period in the 1980s where defining the needs of users became the central problem.[2] These constraints in the development of computer systems were of course reflected in the automation model of designing computer systems and thus further compounded by its reliance on bureaucratic managerial control and on extensive division of labor. During the 1970s and into the early 1980s these series of intertwined limits began to unravel as contradictions arose in how management control systems were to adapt to faster paced economic changes, and in how dinosaur-like business computer systems, which were designed to process routine and repetitive data in one organization, could be adapted to work that was less routine and done in smaller companies and smaller and geographically divided workplaces, as well as across different organizations.

The 1980s

According to most management accounts, the factory image of automation in the 1970s didn't result in faster document production or enhanced office productivity (Bowen, 1986). In fact, while it produced sharp divisions between back and front office jobs and thus between salaries, the outcome of the 1970s was rapidly growing office employment (Greenbaum, 1995).

In practice, the 1980s was a period of transition for management in adapting previous strategies to much more rapidly changing economic conditions (Greenbaum, 1996). Characteristic of this transition was the hold-over of design principles from the industrial period, exemplified by terms like "office automation" and the "paperless office," which were rooted in the idea that office systems should be designed to fit the automation paradigm including an emphasis on the "flow" of information in computers rather than in paper documents (Office of Technology Assessment, 1985). Bureaucratic work organization and stand-alone PC technology were not in step with what upper management

thought it wanted to accomplish. In 1986 *Fortune* magazine ran a cover story claiming that:

> U.S. business has spent hundreds of billions of dollars on them [office computers], but white-collar productivity is no higher than it was in the late Sixties. Getting results usually entails changing the way work is done and that takes time. (Bowen, 1986 p. 20)

Some of the technical and organizational contradictions emerging during this period were:

- conflict between technical designs and organizational decision-making, which could be seen in the gap between the use of decentralized PCs and centralized managerial control;
- differences between technical designs and division of labor as reflected in the reliance on single-user systems such as PCs amid increasing management emphasis on group-based project work which meant sharing data and files; and
- the lack of fit between the concept of office automation and its corollary—sequential flow of products or information, and more integrated group-based work.

In addition, the existing division of labor didn't fit emerging patterns where some professional workers like managers were expected to do some administrative work, such as word processing, and administrative workers like secretaries were expected to do more professional tasks, such as data base administration.

Indeed in this period of flux there were many instances where computer application use came before businesses were ready to adapt to change. Personal computers, for example, were at first sold in the late 1970s as hobbyist machines, but then quickly caught on as home equipment when programs like Visicalc, an early spreadsheet, and Wordstar, a word processing program, were found to be useful. These early PCs (or microcomputers) and the first software packages were not designed by large companies and

did not grow out of the bureaucratic models of divided labor or controlling costs. The example of electronic mail (e-mail) indicates another case where personal use preceded organizational adaptation. By the late 1980s e-mail, which used the protocols of the Internet, was in use among academics and computer people, and Eudora, which was later to become the most used e-mail software, was being passed around free to new users. To this day, e-mail, the basis of the emphasis on communication software, is reluctantly adopted by many organizations, who often restrict its use and build "fire walls" or protective software around messages coming in and going out.

When IBM began orienting Personal Computers to a business market in the mid 1980s, organizations were not set up to use them, an issue which was addressed in an Office of Technology Assessment report that argued that shifts in power were occurring as new forms of work organization were tried out. The report cited that "These shifts in power depended less on the characteristics of the technology than on the characteristics of the organization and its management strategy" (Office of Technology Assessment, 1985), something that reflected from a different perspective, the issues that *Fortune* magazine and other business journals were highlighting.

The idea that early personal computer hardware and software was "designed in garages" is part of today's popular mythology. Some of the early success did come from individuals and small firms, in part because large bureaucratic firms showed little interest. Such success stories carry with them the message that new designs will continue to come from these small, independent workplaces. But as the legend of Microsoft now illustrates, the bulk of computer software *in use* is designed and sold by large companies or organizations that get bought out by larger units.

This trend has two characteristics reflected in design of computer systems: 1) integrated software packages such as Microsoft Office are built on a base of previously successful pieces of software like Word for wordprocessing, and 2) new "suites" and applications are designed to coordinate integrated pieces of work. This second point takes many

forms but is clearly seen in the emphasis on communications networks, such as Novell, the early leader of local networks, and the widespread use of Graphical User Interfaces (GUIs) stemming from Apple MacIntosh's user-friendly operating system[3] to the general standard of Microsoft's Windows program in 1995. Network software, user-friendly interfaces and integrated application packages reflect the interests of organizations to bind divided office labor back together, and simultaneously spread the results of this labor out over geographically dispersed areas of separate outsourced units. These technical design criteria also reflect the fact that computers are used by workers in a wide range of jobs: workers who are less skeptical and more demanding in what they want computer systems to do.

Two main computer professional groups had their origins in the 1980s. The first Computer-Human Interaction (CHI) was formed in the early 1980s to bring professorial designers together to find solutions to the problems of "user constraints," namely how software could be designed for individual users sitting in front of personal computers (see Grudin, 1991). By the second half of the 1980s the problems of user constraints had extended beyond a single-user focus, as it was becoming clear that more work was done in groups and that management was finding it difficult to coordinate separate users. Not insignificantly workers had difficulties trying to work together when different programs didn't work on different personal computers or documents couldn't be printed. Thus the second large professional organization, Computer Support for Cooperative Work (CSCW) brought together designers whose research or application interests focused on how computer systems could actually fit the way work was dispersed among work sites.

The Cooperative Work focus provided a research and development frame to examine and develop systems for the way workers and organizations actually sent information from place to place. In doing so the design concepts constructively helped computer systems retrofit or adapt to the way work was carried out. But CSCW research was also setting the stage for better adapting to the demands of top management to be able to re-divide work and send the

pieces of project-based work to least cost worksites (Greenbaum, 1996).

One set of examples of the communication focus are systems loosely called groupware which include programs for holding "virtual" meetings, calendar software for scheduling meetings that may occur in different places, collaborative writing software for different people writing documents together in different places, and of course programs for sharing and updating files. These types of programs form the backbone of systems of communication, where each supports the separation of work from place and the delinking of labor from contractual terms, since the schedules, plans and information sharing assume that work is not necessarily done under one roof by workers employed by one firm.

The 1990s

Much has been written about the outsourcing of work, and the linking together of redivided labor through reliance on fax, mobile phones, e-mail, Internet and computer support tools. And as discussed in the introduction to this chapter, most of it makes it seem like it is the "invention" of these pieces of technology that drives the changes. Yet it can be seen that in the 1970s corporate bureaucratic control and its reliance on extensive division of labor in many ways held back or perhaps slowed down development of new ideas in hardware and software. Similarly in the 1980s personal computers were almost the "wrong" technology for organizations to be using since they were based on a design concept relying on single users rather than integrated and coordinated work.

Sometimes management objectives get out of synch with available technology, such as the need for reliable network software and hardware at the end of the 1980s, when so much of computer system design was still based on cobbling together systems that had been designed for single users. At other times available technology is waiting for use and perceived needs to catch up, as in the case of Internet protocols being available long before management of large organizations saw commercial potential in such a technical network.

I would argue that it is not particularly useful at this point to try to separate out the technical factors which are currently influencing management practices or the worker induced changes that are leading to new technical breakthroughs. All are closely intertwined and would require further research. What is most critical from the standpoint of influencing change is the understanding that design of technical systems like computer hardware and software is influenced by design principles that in turn reflect and support the reasons that upper level management orders or introduces systems. And those reasons of course have to do with controlling labor costs and coordinating redivided labor. The Microsoft corporation is a prime example of this, for it has a relatively small "core" number of employees who are paid comparatively small salaries but offered stock options. This core is supported by many outsourced projects and work done by temporary employees who are leased to the company to develop specified products. In doing this the company uses its own products to knit pieces of work together, as well as trying out new design tools to support work done in different places and at different salary levels.

One thing is clear about the latter half of the 1990s and that is that the groundwork is in place to bring computer system design concepts together with strategic management beliefs about redividing labor. But the availability of computer products like Lotus Notes and Microsoft Office, and the support of platforms like Windows and MacIntosh, and the background of Internet protocols and network software like Novel and Windows NT, together with the post-industrial reorganization of work and management, bring about a new series of contradictions.

In the early period computer development hardware and software constraints posed closely intertwined technical and organizational problems: it was difficult to conceive of developing hardware for organizations other than large bureaucratic structures, and thus this concept drove mainframe design for sequential, automation-based hardware and software. In the 1980s, when the emphasis was on developing user-friendly systems, it can be argued that it was both the technical and organizational constraints of design-

ing for uses that impeded new developments. New constraints are evolving in the area of "communication." The design concept of communication both supports and possibly impedes the needs of capital for rapid expansion across borders of jobs, occupations, organizations, and countries.

A case in point can be taken from the use of the Lotus Notes program. This package is currently being marketed in the U.S. as the "solution" to company problems such as coordinating sales in Asia with support services in the U.S. Studies suggest that in fact the software does what it claims to do and serves the communication functions that it was designed to support (see Orlikowski, 1992). But in addition it supports groups of professional workers in carrying out their own work, which under the new "entrepreneurial" and freelance emphasis of the current period, means that workers goals are not necessarily the same as the organizations to which they sell their services. Consider as well the wide range of "fire wall" and security programs that are being marketed as ways to keep people out of e-mail contact or away from sites on the World Wide Web.

The design concept of communication, like that of automation, may be running into conflict with the objectives of companies to compete in post-industrial capitalism, for it could be opening up possibilities for more bottom up communication and thus slowing down or interfering with management controlled objectives. In short, its not the technical innovations or limits that necessarily drive change but the ways that organizations and labor interact with them. Changing the design concepts behind computer system development and tackling these as part and parcel of a political agenda is as critical as fighting for shorter working hours and improved working conditions. Chaplin's *Modern Times* character was caught in the automated assembly-line. Scott Adams' Dilbert character is caught in a new web; perhaps the so-called World Wide Web of work being spread over time and place electronically. Although the Web and interactive technologies are being marketed as mechanisms of entertainment, the design of computer systems that support capital's need for least-cost labor, wherever it might be found, is a serious business.

Notes

1. In the U.S. the Bureau of Labor Statistics instituted new categories in 1995 for counting underemployed and involuntary part-time workers. When these categories are added to the press-cited low unemployment percent of between 5–6%, the official unemployment figures come to between 10 and 11%. This is comparable with many West European countries and counters the claim that "free market" styled deregulation would lower Europe's unemployment rates.

2. This three-stage model of computer system constraints grew out of the work of the ICON project (International Computer Occupations Network) which I was a member of and which conducted comparative studies of the computer industry in a number of countries in the early 1980s.

3. This type of Graphical User Interface followed one called the Xerox Star which was available a few years earlier. The lack of success for this first user-friendly interface is attributed both to marketing failures by Xerox and to the fact that organizations buying software didn't see the need for a range of people such as professionals and managers to use computers.

References

Aronowitz, Stanley, 1988, *Science as Power*, Minneapolis: University of Minnesota.

Bowen, William, 1986, "The Puny Payoff from Office Computers," *Fortune*, May 26.

Bannon, Liam, 1991, "From Human Factors to Human Actors" in J. Greenbaum & M. Kyng, *Design at Work*, Hillsdale, N.J.: Erlbaum Associates.

Braverman, Harry, 1974, *Labor and Monopoly Capital: The Degradation of Work in the Twentieth Century*, N.Y.: Monthly Review Press.]

Edwards, Richard, 1979, *Contested Terrain: The Transformation*

of the Workplace in the Twentieth Century, N.Y.: Basic Books.

Friedman, Andrew, 1989, *Computer Systems Development: History, Organization and Implementation*, N.Y.: Wiley.

Greenbaum, Joan, 1979, *In the Name of Efficiency*, Philadelphia; Temple University Press.

Greenbaum, Joan & Morten Kyng (eds), 1991, *Design at Work: Cooperative Design of Computer Systems*, Hillsdale, N.J.: Erlbaum Associates.

Greenbaum, Joan, 1995, *Windows on the Workplace—Computers, Jobs and the Organization of Office Work in the Late Twentieth Century*, N.Y.: Monthly Review Press, Cornerstone Books.

Greenbaum, Joan, 1996, "Back to Labor," CSCW Proceedings, ACM, No. 1996.

Grudin, Jonathan, 1991, "Interactive systems: Bridging the Gaps Between Developers and Users," *IEEE Computer* 24 (4) pp. 59–69, April.

Head, Simon, 1996, "The New, Ruthless Economy," *New York Review of Books*, 29 Feb.

Herzenberg, Stephen, John Alic & Howard Wial, 1996, *Better Jobs for More People: A New Deal for the Service Economy*, Washington, D.C.: Twentieth Century Fund.

Howard, Robert, 1985, *Brave New Workplace* N.Y.: Viking.

Kraft, Phillip, 1977, *Programmers and Managers*, New York: Springer-Verlag.

Kuttner, Robert, 1966, "Are the Rich Getting Richer?" *Business Week*, 22 March.

Marx, Karl, *Capital*, Vol. I (1967; 1867) N.Y.: International Publishers.

Orlikowski, Wanda, 1992 "Learning from Notes: Organizational Issues in Groupware Implementation" in R. Baecker, et al., *Human-Computer Interaction*, 2nd ed. California: Morgan Kaufman Publishers.

Peters, Tom, 1982, *In Search of Excellence*, N.Y.: Knopf.

Office of Technology Assessment, 1985 *Automating America's Offices*, Washington, D.C.: U.S. Congress. U.S. Government Printing Office.

U.S. Department of Labor, Bureau of Labor Statistics, see Table 39, *Household Annual Averages*, yearly. See also *Employment and Earnings*, Jan. 97.

6 ▊ Schooling to Work

Lois Weiner

My essay about changes in education caused by the "wages of cybernation" takes as its intellectual starting point an observation explained by other contributors to this book: popular wisdom about the changes technology has prompted in both manufacturing and white collar occupations is misguided and politically dangerous. One assumption that has been particularly harmful to schooling is the notion that if the American workforce were more highly-skilled, adept at analytical thinking and problem-solving, the economy would be more competitive internationally, generating jobs equally well-paying as those being lost. This picture of technology's effects on the economy and work has been used to defend an agenda for educational change in the next century that includes developing national standards for curriculum, student achievement, and teacher certification, and Europeanizing the school-to-career transition. The key to achieving the goals in this package of educational reform is eliminating the factory model of schooling and its pedagogy of skill-and-drill. Both, it is argued, are outmoded because new, higher standards of academic achievement are required by a technologically transformed work place.

The research done by Joan Greenbaum and Harley Shaiken is particularly useful in understanding how the

narrow, politically conservative focus on technology's trans-
formation of work has blurred the broader portrait of multi-
national corporations developing and using technology to
gain greater control over the workplace, maximizing profit
by minimizing workers' pay, benefits, and rights. This larger
picture, which connects the loss of manufacturing jobs to
changes in the political economy of capitalism globally, sug-
gests a more complicated explanation for liberal capitalism's
eagerness to jettison the factory model for schooling and
hold students to "world-class" standards of achievement. In
this essay I will suggest another explanation for American
capitalism's effort to replace the "school-as-factory" with
different models, and place this initiative in the context of
efforts to eliminate public education as we have known it
for a century. I will then apply my ideas about the origins of
this crisis to suggest the framework for a progressive agenda
for school reform.

Why the Current Crisis Is Different

Unlike previous "crises" of confidence in American pub-
lic education (e.g. "Why Johnny can't read"), this crisis is an
ideological turning point in the way American society views
schooling. A measure of the degree of public confusion and
loss of faith in public education is the recent finding that
most Americans whose children attend public school say
they would send their children to private school if they
could afford it.[1] This sentiment partially reflects the general
disenchantment (fueled and steered by the Right) with the
public sector providing social services, but it also represents
a development unique to education.

Historically American public education has fulfilled two
essential but contradictory functions for liberal capitalism.
Understanding both is essential for making sense of the de-
mands made on schools and of schooling's structure. Public
education in this country has two contradictory functions,
both essential in a liberal capitalist society with a merito-
cratic ideology. As numerous studies of ability groupings or
"tracks" in secondary schools show, schools reproduce so-
cial stratifications,[2] but they also propound the values of

liberal democratic society, one of the most important being education's role in equalizing economic opportunity. As Carnoy and Levin explain,

> Though schools do reproduce unequal class relations, the fact that they do so imperfectly merely reflects the social conflict that characterizes the capitalist society they serve. . . . The relationship between education and work is dialectical—composed of a perpetual tension between two dynamics, the imperatives of capitalism and those of a democracy in all its forms. As both a product and a shaper of social discord, the school is necessarily caught up in the larger conflicts inherent in a capitalist economy and a liberal capitalist state.[3]

The history of the creation of urban school systems illustrates how our present system of public education has come to satisfy both functions simultaneously. Although education is the legal responsibility of individual states and is funded by property taxes levied by individual districts, virtually all school systems have a near-identical structure, as do the schools within them. This institutional uniformity was methodically planned and enacted by school reformers eager to organize a system of public education that could ameliorate the economic, social, and political strains produced by massive immigration at the turn of the century.[4]

This "one best system" of education, created in the cities and exported to rural and suburban communities over the first decades of the twentieth century, organized schooling, on a corporate model. In this design for schooling which persists today, power relations are hierarchical, authority is invested in a bureaucracy, and schools are intentionally insulated from parental and community pressures, ostensibly to keep politics out of educational decision-making. The ethos of the factory is embedded in the organizational structure of the classroom, school, and school system: Students are the product; teachers are the workers; a corporate board oversees the superintendent's actions as CEO.

However, because of education's twin ideological purposes, the "one best system" did not simply or simplistically

reproduce the factory. School success had to be, or seem to be, equally accessible to all groups making up the rapidly expanding and highly diverse student population—everyone who was white, that is. The institutional solution to the problem of treating all (white) students fairly was to create a school system that treated all students the same. Procedures were standardized and regulations made inflexible. While this response addressed the *political* demand made on schools to rationalize school success and thereby explain social stratification, it created an inescapable *pedagogical* problem, as Carl Kaestle explains.

> The dilemma of standardized impartiality and quality control through systematization is that the decision-making processes are taken out of the hands of the person who deals directly with the system's clients— the children—and therefore tends to depersonalize the relationship. The teacher becomes more a part of the apparatus and less able to be flexible. Also, to the extent that the system intentionally masks the identity of the student to ensure impartiality, the student loses part of his individuality.[5]

To understand how "the one best system" withstood attack from both sides of the political spectrum for a century, it's essential to recognize that students whose culture and family background meshed with the cognitive demands of an impersonal school environment used education to improve their social standing. As David Tyack explains in his comparison of the school experiences of Southern Italian and Eastern European Jewish immigrants in the early 1900s, academic success depended on the fit between the cognitive structures and value patterns students brought to schooling and "the one best system's" rigid and hierarchical structure. He observes that

> beneath superfical differences between ethnic groups lay a kind of deep structure of family and community values, roles and behavior that may have coincided or clashed with the expectations and demands of urban

public education. Such deep structures may reflect differences of class, religion, urban or rural residence, national traditions, methods of child-raising, and other powerful influences. They involve both cognitive structures and value patterns.[6]

The ability of some individuals from certain ethnic groups to acquire academic credentials that improved their social and economic status bolstered the meritocratic claims and ideology of liberal capitalism. Thus, for close to a century the ideological consensus underlying American public education and its institutional expression in "the one best system" were firmly rooted. This accord lasted until the civil rights movement successfully challenged the legality and morality of segregated schooling and the idea of "separate but equal," which was a virtually unquestioned aspect of public education.

In their struggle to gain full legal equality, and with it access to education's credentialing power, African-Americans called into question the arrangements that created "one best system." First, the battle to integrate schooling revealed the fundamental hypocrisy of "the one best system's" claim to have provided equal opportunity for all Americans to use education as a means of economic advancement. Moreover, many of the remedies intended to redress decades of segregated schooling necessarily challenged the assumption that standardized treatment was inherently fair. For example, special allocations of resources for schools serving poor, minority children implied a different definition of equality, one that allowed for students' particular circumstances. In order to provide an education that resulted in equal opportunity, schooling had to take into account the legacy of racism and legally sanctioned discrimination; impartiality and standardization of treatment did not and could not provide all students with an equal chance for school success.[7]

This redefinition of equality undercut the key pedagogical premise of "the one best system," namely that when students are educated impersonally, without reference to individual differences, the system is fulfilling its responsibility

to give all students an equal chance to succeed in school—
and in turn, the job market. Another cornerstone of the
"one best system" was weakened when disempowered mi-
nority parents struggled to influence curriculum and in-
struction. They explicitly attacked the structural and
ideological barriers that isolated and insulated schools from
parent and community influence.

Viewed in terms of their structural effect on capitalism,
the reforms prompted by the civil rights movement democ-
ratized access to schooling, modifying its role in reproducing
social inequality and a differentially stratified workforce. In
his thoughtful analysis of educational policy and the crisis of
the welfare state, Shapiro explains how the 60's reforms
began "to undermine the relationship of education to the . . .
reproduction of middle-class advantage," threatening the
ability of the middle class to "transmit the advantages of the
division of labor to its offspring through its superior cultural
inheritance" or its cultural capital.[8] But as they democra-
tized access, these reforms swelled school bureaucracies.
They added new regulations, programs, and administrative
personnel onto the existing structure of "the one best sys-
tem" in school districts that accepted—as virtually all did—
new federal and state money linked to programs serving poor
children.[9] Urban school bureaucracies, already dysfunc-
tional, as Rogers' landmark study of the New York City Board
of Education revealed,[10] became even sicker.

While many parents who devoted themselves to integrat-
ing schools and improving their local schools did not focus
on pedagogical change—and did not automatically sup-
port it, as several highly publicized, ill-fated experiments
showed—the bottom-up nature of their struggle under-
mined the emphasis on authority and conformity that in-
here in a hierarchical, bureaucratic system of education.
The agitation of civil rights activists contested the ideologi-
cal justification for isolating parents and communities from
schools; it opened the door to changes in teaching that
stressed "subjectivity, diversity, and self-expression."[11]

As this brief historical sketch shows, both "the one best
system" and the political consensus that forged it were weak-
ened thirty years before the far Right captured the Republi-

can party and a Congressional majority. Indeed, support for public education's democratic purposes was eroded in the early 1980s by an alliance between corporate liberals and conservatives to promote two new tasks for public education. Publication of *A Nation at Risk* and a host of supporting reports by quasi-official commissions composed of government and corporate officials sparked a campaign for education to assume two new responsibilities. It was charged with reviving the economy and making it competitive internationally in order to sustain high-wage employment, as well as providing American workers with the skills they are said to need to earn a living wage in the new world economy.

Education has incurred these new tasks on top of its failed mission to make good on society's pledge of equal opportunity, and this conjuncture of demands has heightened expectations for schooling while illuminating the intractability of its structural defects. Thus two contradictory agendas are generating a powerful momentum for school reform. In addition, the bipartisan consensus that Americans have to accept a declining standard of living implies that in the present economy, American society cannot fulfill its promise of using education to equalize opportunity. Americans are confused about defending a system of public education whose democratic purposes are valued, yet which as a system seems to be seriously flawed. Citizens are apprehensive that a democratically controlled public school system is impossible to achieve because our economic problems and the political and social divisions in society seem intractable.

In short, the present crisis in public education is an ideological watershed in which Americans are questioning whether capitalism can co-exist with an egalitarian mission for schools and the society's democratic ideals.

Elimination of Factories—and the Factory Model of Schooling

The current attack on the factory model of schooling occurs as industrial manufacturing is steadily disappearing from this country. In this context education is increasingly

unable to rationalize inequality because of the increasing lack of synchronization between employment and education. The political emphasis on altering the "school-as-a-factory" is an effort to address the frightening demise of the "factory-as-a-source-of-employment."

An assumption that education can revive the economy underlies much of the current discussion about the need for educational reform. Education is viewed as a key vehicle for making the economy competitive internationally and in the process creating jobs that pay a living wage. However, as Stanley Aronowitz and William DiFazio observe, the progressive destruction of high-quality, well-paid, permanent jobs is not remediable with educational reform. The process is due to long-term tendencies in both manufacturing and the service sectors that will not be significantly arrested, even during periods of economic growth.[12] Evidence presented in this book and elsewhere seems to me completely persuasive that capitalism's use of technology to transform work cannot be altered by education. Computerization has sparked a transformation in capital and labor at least as significant as the alterations in work produced by the industrial revolution.

The analogy to the industrial revolution[13] is critical for understanding why Levin and Kelley are wrong when they maintain that "Education is just one factor, albeit an important one, in an overall melange of conditions that determines productivity and economic competitiveness, as well as the levels of crime, public assistance, political participation, health, and so on" (p. 107).[14]

Not only can education not "do it alone," as Levin and Kelley argue, education can't "do it" at all, even as one of many policy instruments, because capitalism's current use of technology to transform employment is no more amenable to reform through changes in education than it was during the industrial revolution. Insofar as educational reform is understood to be an arena to contest capitalism's ideological grip, school reform can help alter capitalism's use of technology and in this regard be an indirect vehicle for economic reform. But this is quite different from pro-

posing a direct link between school reform and economic growth.

From the time the school-as-factory was proposed, radical educators and militant trade unionists opposed the idea, arguing for a humanistic view of education. Ironically, the current rationale for eliminating the factory model of schooling resembles the arguments raised in its defense a hundred years ago. While progressive educators have found the new appeal to abolish the school-as-factory attractive because of their humanistic ideals, many have swallowed its underlying argument: To reinvigorate the economy, schools need to raise the level of achievement of American students.

The educational establishment has, with few exceptions, accepted this reasoning, as it did the economic rationale for creating schools that resembled factories. But while researchers and education officials debate how best to raise students' achievement levels, federal and state governments are reducing education budgets. Schools that already suffer from chronic underfunding are being forced to absorb devastating cuts in aid. The simultaneity of these developments, of initiatives to hold students to new, higher-level, "world-class standards" and the financial strangulation of public schools, reveals the real meaning of reforms to eliminate the factory model of schooling. Students who achieve the higher standards will have demonstrated that they deserve access to compete for a diminishing pool of well-paying jobs. Other students—the majority—will be placed out of the running for jobs that will allow them to earn more than subsistence wages. Demanding higher levels of achievement without providing support to teachers and students to meet them will result in fewer students acquiring the educational credentials that ration economic mobility and rationalize increased social and economic stratification.

Perhaps the most ominous aspect of this scenario is that the most powerful opposition to the reforms associated with eliminating the school-as-factory has come from the far Right. Its political ascendancy has clouded the future of

governmentally supported initiatives to create national standards for curriculum and teaching. By focusing public attention on the moral and biological deficiencies of the poor, the Right has shifted debate about the reasons for inequality, and neatly dispensed with education's role in rationalizing disparities in wealth and power. Hence the new Republican majority has little need for public education because it is not needed in the far Right's ideological justification for inequality.

Supporting Education's Democratic Purposes

With the collapse of progressive social movements and the labor movement's surrender and disorientation, the "perpetual tension between . . . the imperatives of capitalism and those of democracy," referred to earlier, has become slack indeed. This political situation calls for an agenda for school reform that protects and advances education's democratic purposes, counterposing a democratic vision of education's uses against capitalism's urge to fashion schooling in its own image.

When social movements press schools to live up to their democratic purposes, the struggles alter the relationship of social forces, exciting forces that can weaken capitalism's social and political hegemony. This process weakens capitalism's ability to dictate how technology will be used at work, and a strengthened resistance to capital's ability to define the conditions of labor creates opportunities to expand on schooling's non-economic purposes. Thus educational reform can help alter economic conditions by inspiring and reinforcing broader political resistance to the status quo.

Educational reform's circumscribed, indirect role in altering economic conditions should not be confused with the other task it has historically been assigned in American society: giving students the skills they need to compete for jobs that pay a living wage. Supporting this second mission of schooling is critical to challenging capitalism's definition of education's purpose, because it democratizes access to schooling's economic rewards. While education cannot give

every citizen a job, that is, it cannot abolish labor market tyrannies, it can democratize the competition for a diminishing number of jobs.[15]

Michelle Fine's study of the reasons poor, minority students leave high school before graduating demonstrates why a progressive agenda for school reform should argue for school reform as a vehicle for addressing social inequality.[16] But her research also illuminates the interconnectedness of students' attitudes about school success and the conditions in students' families and neighborhoods. The Latino and African-American adolescents she interviewed were ambivalent about the value of an education; while they recognized that there were few jobs available to them, they realized that without a diploma their chances for employment were even more limited.

Levin and Kelley's formulation about education's inability to "do it alone," which misdirects our attention when applied to reviving the economy, makes sense in understanding the limits of school reform in creating more equal access to job opportunities. Many conditions outside its walls influence a school's ability to educate children, so school reform requires the same "range of complementary conditions" Levin and Kelley identify, mistakenly, as preconditions for education's usefulness in economic revival. A movement to make schools serve all students equally well necessarily takes up the range of social problems that keep children from learning.

Two Guiding Principles

I think two inseparable principles emerge from my analysis so far about school reform. Both are essential to reinvigorating the struggle for schooling's democratic purposes and should be thought of as inseparable. First, educational reform should encourage the fullest participation in decisions about schooling by the people most directly affected by them. Second, reforms should further schooling's role as a vehicle for social and economic mobility. These two principles operate together to make schooling more democratic by shifting power to parents and communities, unless

policies diminish education's ability to promote social and economic equality.

Applying the first principle means encouraging initiatives that challenge the structure and pedagogy reified in "the one best system." The Right is correct in arguing that the bureaucratic control exercised by the federal, state, and local government is destructive. The standardized procedures that are supposed to ensure fairness depersonalize education, distorting a process that has little meaning when it is not personal. However, the second principle demands a different type of government intervention in schooling, for instance increased federal funding for schools to equalize expenditures between wealthy and poor districts, what the authors of *Choosing Equality* refer to as "progressive federalism."

The debate over proposals to decentralize control of schooling shows how these two principles should be applied. Vouchers and charter schools will probably destroy "the one best system," but they also absolve education of its responsibility to promote equality. Progressive school reform calls for education to make good on the promise of fairness and equality of treatment that were an essential aspect of the consensus that created the system of public education, and the school bureaucracies. The Right waves away concerns about fairness and equity with an incantation about the power of the marketplace, but educators committed to democracy need to take care that reforms that dismantle "the one best system" also address the bureaucracies' responsibility to ensure fairness.

Just as importantly, these two principles call for racial integration of schools to be the heart of any agenda for educational change. Segregation in housing has become the pretext for abandoning the challenge of racially integrating schools, and segregation has devastated the struggle to challenge funding inequities. Urban school systems are more isolated politically for being racially segregated, and as a result, far more vulnerable in battles over funding. Moreover, we know that racial isolation in schools affects achievement. A report from the ERIC Clearinghouse on

Urban Education described research findings about segregated schools this way:

> Racial balance does affect achievement. . . . Something systemic about a school serving predominantly black, or predominantly white, students—covering both resources and expections—contributes to the success or failure of all students who attend.[17]

Activists who lived through the vicious bussing battles of the 1970s are understandably hesitant to renew a struggle that excited such overt racism, but as racism underlies much of the opposition to adequately funding urban schools, it must be confronted. Because of successful school integration struggles, educators know how to improve schooling for all children in integrated schools and classrooms.[18] Now that we have this information, arguments that desegregation inevitably results in lowered academic achievement, for African-American or white children, are indefensible, intellectually and morally. We know how to create integrated schools that help all children to flourish, academically and socially; what American society lacks is the political leadership to address the social and political poison of racism.

Education's Non-economic Purposes

As education's economic functions have been increasingly stressed, its social, moral, and intellectual purposes have been diminished. Making the democratization of schooling the centerpiece of a progressive agenda for educational reform means restoring and strengthening public education's mission to educate students for citizenship and fulfilling their full human potential. Inevitably these non-economic functions contradict schooling's purpose in providing capitalism with a stratified workforce, so struggles to maintain funding for "frills" like arts programs in schools are essential to protect and expand education's democratic potential.

Why not demand that defense of schooling's non-economic functions should supplant struggles to use education to democratize competition for jobs? Isn't cybernation making the school-to-work transition obsolete? Although cybernation is steadily reducing the workforce, education can "democratize the competition" for jobs until we are much closer to the "jobless future" predicted by Aronowitz and DiFazio. Shapiro is correct in noting the growing absence of synchronicity between schooling and employment, but there is still enough so that a campaign for equal access to the synchronicity that does exist makes educational reform an important vehicle for challenging inequality—and renewing the tension between capitalism's imperatives and the society's democratic ideals. As long as educational credentials are used to rationalize allocation of jobs, the struggle to make those credentials equally accessible to all citizens is an essential element of progressive school reform.

For public education to democratize the competition for jobs, that is, for *all* students to receive an education that equalizes access to jobs, schools must deal with children as individuals, because learning is an individual act. Defending this pedagogical fact of life is revolutionary within institutions that are based on processing and sorting students as if they were identical. The "one best system" pretends that its classification of students into "ability groupings" and academic "tracks" is politically neutral, fair and efficient; and as long as schools accept students' abilities and aspirations as fixed and sort them accordingly, public education cannot fulfill its mission of providing an equal education to children of all races and classes. For schools to carry out their mission of democratizing access to jobs, they must transform the way they conceptualize ability and intelligence, as Howard Gardner's seminal research on multiple intelligences demonstrates. Understood in this way, the struggle to make public education fulfill its *economic* function of democratizing the competition for jobs complements efforts to promote schooling's *non-economic* purposes.

The agenda for educational reform I have proposed here is ambitious, especially in this political climate. But dis-

cussing a progressive vision of schooling's relation to work is essential to reviving opposition to capitalism's exercise of its imperatives. A powerful aspect of the present crisis in education is the public perception that public education can't be fixed, and the absence of ideas about how to address the crisis is itself a factor in the paralysis of will to make schooling and the society live up to their democratic commitments. To alter the terms of debate requires mobilizing a social movement of considerable strength, but there is a significant constituency for such a movement in the parents who rely on public schools, civic organizations, and school workers.

I have written elsewhere about why teachers and teacher unionism are pivotal in creating a movement to democratize the schools,[19] so I will briefly mention here that recent surveys of teachers' attitudes toward reform show that teachers understand the real meaning of the reforms being debated—and oppose them pedagogically.[20] But their unions and professional associations have supported the drive for national standards, so classroom teachers are demoralized about their ability to influence debate and policy. Their commitment to another view of education mirrors the sentiments that inspired the birth of teacher unionism a century ago, as the factory model for schooling was being established.

John Dewey's slogan of "Education for democracy; democracy in education" used to have a prominent place in publications of the American Federation of Teachers, the union he helped create. The maxim no longer has a place in union publications, but the concept has not been lost to American teachers. Their understanding of education's democratic potential is a critical asset in reviving the society's support for a democratic system of public education.

Notes

1. Public Agenda, *Assignment Incomplete* (New York: Public Agenda, Feb. 1996).

2. Jeannie Oakes and Gretchen Guiton, "Matchmaking: The

Dynamics of High School Tracking Decisions," *American Educational Research Journal* 32 (1), 3–33.

3. Martin Carnoy and Henry M. Levin, *Schooling and Work in the Democratic State* (Stanford: Stanford University Press, 1985), 4.

4. David B. Tyack, *The One Best System* (Cambridge: Harvard University Press, 1974).

5. Carl Kaestle, *The Evolution of an Urban School System: New York City 1750–1850* (Cambridge: Harvard University Press, 1973), 178.

6. Tyack, 248.

7. Ann Bastian et al., *Choosing Equality: The Case for Democratic Schooling* (Philadelphia: Temple University Press, 1986).

8. Svi Shapiro, *Between Capitalism and Democracy: Educational Policy and the Crisis of the Welfare State* (New York: Bergin & Garvey, 1990), 78.

9. David L. Kirp and Donald N. Jensen, eds. *School Days, Rule Days* (Philadelphia: Falmer Press, 1986).

10. David Rogers, *110 Livingston Street: Politics and Bureaucracy in the New York City Schools* (New York: Random House, 1968).

11. Shapiro, 54.

12. Stanley Aronowitz and William DiFazio, *The Jobless Future: Sci-tech and the Dogma of Work* (New York: Routledge, 1995), introduction.

13. Private conversation with Harley Shaiken, 1985.

14. Henry M. Levin and Carolyn Kelley, "Can Education Do It Alone" *Economics of Education Review* 13 (2), 97–108.

15. The authors of *Choosing Equality* develop this idea, borrowed from David K. Cohen and Barbara Neufeld in "The Failure of High Schools and the Progress of Education," *Daedalus 110* (Summer 1981), 69–90.

16. Michelle Fine, *Framing Dropouts: Notes on the Politics of an Urban High School* (Albany: SUNY Press, 1991).

17. Carol Ascher, "The Changing Face of Racial Isolation and Desegregation in Urban Schools," ERIC Digest, No. 91, May 1993, EDO-UD-93–5.

18. Willis D. Hawley and Susan J. Rosenholtz, *Achieving Quality Integrated Education* (Washington, D.C.: National Education Association, 1986).

19. Lois Weiner, "Democratizing the Schools," *New Politics 1* (Summer 1987), 81–94.

20. Lois Weiner, "Democracy, Pluralism, and the Teaching of English," *English Education* 27 (2), 140–145.

7 ▌ The Last Good Job in America[1]

Stanley Aronowitz

Prologue

There's a wonderful museum of eighteenth and nineteenth century material culture in Shelburne, Vermont. Last summer our family joined thousands who marvel at exhibits of toys, minatures of soldiers and battle scenes and the many transported authentic artifacts or replicas: of living rooms, kitchens and pantries and other objects of everyday life. My favorites were the working blacksmith's and print shops. The print shop reminded me of old movies about courageous small-town editors crowded into a single room with their presses. The Shelburne presses were more industrial but the technology was the same. Amid the clanging hammers hitting the forge, the fire and the heat, one had a vivid picture of what skilled manual work might have been like before the automobile displaced the horse and buggy and cold type all but destroyed the old printer's craft.

These were good jobs. They paid well and, perhaps equally important engaged the mind and the body of the worker. Apart from the laborious task of typesetting—it was done by hand—the printer had to set the controls on the machine just right. It was a time-consuming but supremely intellectual activity.

The present-day blacksmith enabled our daughter, Nona, to participate by forging a metal hook. The Shelburne

museum has two purposes: to help in the current revival of the Vermont economy by attracting tourists; and to remind us, through reenactments of popular material culture as well as representations such as artworks, of how rural and small town people once lived and worked.

Walking through the museum's sprawling acres, I could not help drawing in my head an analogy with the disappearing professoriate. One day some academic entrepreneur—a *Lingua Franca* publisher Jeffrey Kittay of the future—will hit on the idea of exhibiting mid-twentieth century academic material culture. There will be replicas of a professor's study. Lying on her desk sits the old Olympia typewriter and some yellow pads filled with notes for an article or book or the next day's lecture. Another ornament of the by-gone time is the inevitable ashtray. The study is book-lined, many volumes surfeited with dust. A leather jacket and denim work shirt hang on the door's hook.

The magazine rack is filled to the brim with scholarly journals, the *New York Review* and *Lingua Franca*, those quintessentially academic feuillettons which went out of business about 2010 because there were too few professors around to read them. By the near-future time most of us had been retread as part-time discussion leaders—freeway or turnpike flyers—and could manage only to scan the day's video of the famous scholar's lecture on whatever before meeting the fifty students at the local American Legion hall where the group meets. The actual postsecondary faculty member of the future may still own a desk, but the shelves may contain as many video cassettes as books and there might or might not be a magazine rack.

Diary

It's Wednesday, one of my writing days. Today, I'm writing this piece for which George Yudice and Andrew Ross have been nudging me for a couple of days. Our daughter Nona will return home about 3 PM and it's my turn to get her off to her after-school music class and prepare dinner. As it turned out, she brought a friend home, so I have a little extension on my writing time. I couldn't begin working on the

piece yesterday because I go to CUNY Graduate Center on Tuesdays. Even so, after making her breakfast and sending Nona off to school every other day, reading the *Times*, selected articles from the *Wall Street Journal* and *The Financial Times* and checking my email, I usually spend the morning editing my Monday writing. But yesterday our Nona was home with a stomach bug and because Ellen, her mother, had umteen student advisements at NYU it fell to me to make her tea, minister the puking, get some videotapes and commiserate. Anyway, Monday morning after my usual reading routine I had finished an op-ed for *The Nation* on the future of the left. Otherwise I would have started this article a day earlier.

Monday was somewhat out of the writing mode because I had a second oral exam to attend. I'm chair for a candidate who was examined in cultural studies (me), psychoanalysis and feminist theory. She knew her stuff but took some time to get rolling, after which it was quite good. After the exam I answered my calls, wrote two recommendations for job applicants, in the early evening attended a colloqium given by Elizabeth Grosz and Manuel De Landa and arrived home about 9 PM, after which Ellen and I prepared dinner (Nona eats earlier).

On Tuesday afternoons I meet with students. At this time of year (mid-December) many sessions are devoted to discussing their papers, which are due at the end of January. This semester I preside at a seminar on Marx. We are reading only four texts but a lot of pages: the early manuscripts; *The Critique of Hegel's Philosophy of the State*, *Capital* and the *The Grundrisse*. There are about twenty-five students in the group, who form three study groups that meet weekly to address the critiques and commentaries as well as study the texts more extensively than the two-hour session with me could possibly accomplish. Sometimes after class I meet with one of the study groups to help with the reading. Yesterday I did some career counseling in the early evening for a friend who is thinking about quitting his job and trying to work for the labor movement.

Tonight I'll read in the *Economic and Philosophical Manuscripts* because tomorrow one of the groups is making a

presentation. Yesterday, a few of them met with me individually to discuss, among other things, the merits of Althusser's argument for an epistemological break between the early and late Marx, the state/civil society distinction and whether Marx's *Capital* retains the category of alienation in the fetishism section of volume one. Tomorrow after checking my email I will edit some of this stuff I am writing and arrive at school about noon to meet with a student about last semester's paper for a course called "Literature as Social Knowledge." Then I'll try to work on the piece until my office hour, which is simply a continuation of what I do on Tuesday, except some of my dissertation students may drop in to give me chapter(s) or to talk. At 4:15 I'll meet my seminar, after which a small group of students has asked to meet about publication chances of a collective paper they wrote on what the novels of Woolf, Lessing and Winterson tell us about the gendering of social life. I'll probably get home by 9 PM.

Friday is committee and colloqium day in the sociology Ph.D. program within which I work. I serve on no departmental committees; all of my committees, seventeen of them this year, are as dissertation advisor or chair of a CUNY-wide committee that raised some money to help faculty do interdisciplinary curriculum planning. But I will try to attend the colloqium. I often invite my advisees to meet me at home because life is too hectic in my office. My office is a place where students hang out, there are myriad of telephone interruptions, and I am called upon to handle a lot of administrative business such as change of grade forms, recommendation letters and so on.

Over the weekend I'll have time for my family, having hopefully finished a draft of this piece. I also have to finish a longer collectively written article for a book called *Post-Work* which came out of a conference sponsored by the Center for Cultural Studies of which I am director. The group will meet on Monday evening to go over my collation. I may get it done on Sunday or Monday. And, next week Jonathan Cutler, the co-editor of the volume, will work with me on writing an introduction.

I am one of a shrinking minority of the professoriate who

have what may be the last good job in America. Except for the requirement that I teach or preside at one or two classes and seminars a week and direct at least five dissertations at a time I pretty much control my paid worktime. I can't say that everyday life—shopping, cleaning, cooking, the laundry, telephone calls and taking care of the car (my unpaid worktime)—is entirely thrilling, but since we share most of these tasks the routines are not as onerous as they could have been. I carve out some time for frivolous enjoyment: at night I watch the 10 PM crime slot on television and the 11 O'Clock News. Otherwise evenings are taken up with the pleasure I derive from talking to Nona and Ellen, and reading.

I work hard but it's mostly self-directed. I don't experience "leisure" as time out of work because the lines are blurred. What is included in this form of academic labor anyway? For example, I read a fair amount of dectective and science fiction, but sometimes I write and teach what begins as entertainment. The same goes for reading philosophy and social and cultural theory. I really enjoy a lot of it and experience it as *recreation* but often integrate what I have learned into my teaching and writing repetoire. In any case, much reading is intellectual refreshment. And even though I *must* appear for some four hours a week at a seminar or two, I don't experience this as institutional robbery of my own time. It's not only that I like to "teach" or whatever you call my appearance in the classroom. I'm not convinced that even the best of my lectures has genuine pedagogic content (I hardly ever give a "talk" in class that lasts more than ten minutes without student interruptions, either questions or interventions). Most of the time I work from texts; I do close readings of particular passages, inviting critique and commentary and offering some of my own.

When I meet with study groups its always of my own volition. Needless to say, the job description really doesn't require it, since few of my colleagues encourage such groups to form. And my assent to serving on more than twenty dissertation committees, about a quarter outside the sociology program, and agreeing to a number of tutorials and independent studies is by no means "required" by some

mandated workload. Whatever I take on it's for the personal and intellectual gratification or obligation which I have adopted.

As a professor in a research school and a teacher of Ph.D. students I feel I should also raise money to help support students in addition to doing whatever I can to help them find jobs and getting their dissertations published. And as director of a center, I need to find money for its public life: talks, conferences and post-doctoral fellowships. Now in my situation I don't have to do any of this work but I feel that I should go back to undergraduate teaching if I won't or can't contribute to meeting these urgent student needs. So I raise between $15,000 and $50,000 a year for student support and for conferences and research projects.

Finally, for all practical purposes my career is over, so none of this work is motivated by the ambition or necessity of academic advancement. I am a full professor with tenure and have reached the top of a very modest salary scale, at least for New York. I earn more by some $5000 a year than an auto worker who puts in a sixty-hour week but less than a beginning associate in a large New York corporate law firm or a physician/specialist in a New York HMO. But most of them work under the gun of the managing partner(s) and, in the case of the law firm only five of 100 attorneys have a prayer of making partner. If they don't they're out. With a two-paycheck household we can afford to eat dinner out regularly, send our kid to camp, give her the benefit of piano lessons, fix the car, own and maintain a couple of early and late-model computers and a decent audio system. And we pay a mortgage on an old, ill-heated farm house in upstate New York where we spend summers and some autumn and spring weekends. But because in my academic situation I have nothing career-wise to strive for, I'm reasonably free of most external impositions. Before every semester my chair asks me what I want to teach. What's left is the work and with the warts—administrative garbage, too many students (a result of my own hubris) and taking on too many assignments, writing and otherwise—I enjoy it.

What I enjoy most is the ability to procrastinate and control my own worktime, especially its pace: taking a walk in

the middle of the day, reading between the writing; listening to a CD or tape anytime I want; calling up a friend for a chat. And I like the intellectual and political independence the job affords. I can speak out on public issues without risk of reprisal from the administration or from my program. I am able to participate in many different kinds of "outside" intellectual and political activities including union-related activism, starting, writing for and editing radical journals and working with educational and social movements. In their original intent, organizations such as the AAUP fought for tenure, because contrary to popular, even academic, belief there was no particular tradition of academic freedom in the American university until the twentieth century—and then only for the most conventional and apolitical scholars. On the whole, postsecondary administrations were not sympathetic to intellectual, let alone political dissenters, the Scopeses of the day. Through the 1950s most faculty were hired on year-to-year contracts by presidents and other institution officers who simply failed to renew the contracts of teachers they found politically, intellectually or personally objectionable.

For example, until well into the 1960s the number of public Marxists, open gays, blacks and women with secure mainstream academic jobs could be counted on ten fingers. And contrary to myth, it wasn't all due to McCarthyism, although the handful of Marxists in American academia were drummed out by congressional investigations and administrative inquisitions. The liberal Lionel Trilling was a year-to-year lecturer at Columbia for a decade, not only because he had been a radical, but because he was a Jew. The not-so-hidden secret of English departments in the first half of the twentieth century was their genteel anti-Semitism. For example, Irving Howe didn't land a college teaching job until the early 1950s and then it was at Brandeis. Women fared even worse. There's the notorious case of Margaret Mead, one of America's outstanding anthropologists and its most distinguished permanent adjunct at Columbia University. Her regular job was at the Museum of Natural History. She was a best-selling author, celebrated in some intellectual circles, but there was no question of a permanent academic

appointment. Her colleagues Gene Weltfish and and Ruth Benedict, no small figures in Anthropology, were accorded similar treatment.

So its not surprising that in these hard times the University of Minnesota administration decided to try to turn back the clock forty years and rescind tenure. Only the threat of an AAUP-conducted union representation election caused the board of trustees and the president to (temporarily) withdraw the proposal. In the absence of a powerful enough Left there is little, other than market considerations, to prevent university administrations from abrogating the cardinal feature of academic work: the promise that, after five or six years of servitude, mainly to the discipline and to the profession, a teacher may be relatively free of fear that fashion will render their work obsolete and, for this reason, not worthy of continuation of employment. The irony of the present situation is that many who win tenure still work under the sword compounded of no promotions for dissenting intellectual work, harassment and, probably most painful of all, utter marginalization. For those who have been incompletely socialized into their professions, tenure turns out to be a chimerical reward. With some notable exceptions by the time the teacher has achieved tenure, at least in the major schools, internalized conformity is often the condition of long-term survival.

In this respect, in addition to protecting genuine political dissent in conventionally political terms, tenure can protect academic dissidence—scholars and intellectuals who depart, sometimes critically, from the presuppositions of conventional science, literature or philosophy. But tenure is job security only in the last instance. Typically successful candidates must demonstrate their *lack* of independence, originality and hubris. Peer review is often used as a way to weed out nonconformity. It works at all levels to get tenure; in many systems for which pay raises depend almost entirely on "merit", climbing the pay scale often entails publishing in the "right" journals (in the double-entendre sense); and publishing books with prestigious academic presses. For example, I know a wonderful younger scholar coming up for tenure in a quasi–Ivy League college who de-

cided to accept an offer from Stuffy University press rather than one from an aggressive hotter house. He admitted his book might end up in annual sales, but it would do the tenure trick. It's hard to say whether the other choice would have been as efficacious. But he felt in no position to take a chance. The second question is, how much did this decision take out of his chance to become an intellectual rather than a professional clerk of the institution?

Now it must be admitted that most faculty have long since capitulated to the strictures of the conservative disciplines and to the civility and professionalization demanded by academic culture. Many define their intellectual work in terms of these strictures and, in the bargain, measure their contribution not by the degree to which they might be organic intellectuals of a social movement but, at best how they might make piecemeal, incremental changes in the subfield to which they are affiliated. The overwhelming majority do not aspire to genuine influence. Moreover they disdain any discourse or activity that cannot be coded as civil: the idea of confrontation as a means of clarification is beyond the bounds of acceptability. Insofar as institutional power continues to reward conformity, tenure is quite beside the point for the overwhelming majority of the professoriate.

For the time being I write what I please without the sword of unemployment or ostracism hanging over my head. If I was on the job market, most sociology departments would not hire me because I don't follow either the discursive or the methodological rules of the discipline and first and foremost I'm a *political* intellectual whose views occasionally are in public view. Although the department was sympathetic with my political views, it is doubtful I would have gotten a tenured professorship at UC-Irvine in 1977 if the program into which I was hired had grasped that my work in labor was informed by cultural studies and what it has come to mean. But they did and they were stuck with me, just like the CUNY Graduate Center's program, which hired me for the same reason. Having made the mistake, CUNY has treated me relatively well, although like anybody who speaks her or his mind I cannot say I am universally admired.

I work hard but only peripherally for the institution. In this period of galloping reaction, some of which is coded as populism, these privileges may appear to some to be luxuries and our writing and teaching merely the ruminations of a narrow academic elite. Some are even moved to attack my working conditions as evidence that the last good job should be ended. It's subversive for a labor regime that is working overtime to close the doors to work democracy and to freedom and poses endless paid work as the ideal to which we should all strive. For this tendency, I am one of a (thankfully) diminishing fragment of the professoriate whose privileges must be rescinded, the sooner the better. After all, if hardly anyone else enjoys these conditions why should I? Accordingly the task is to reach an equality of misery. I want to suggest a different perspective on academic teacher work.

At it's best, the chief characteristics of academic teacher work are that A) work is largely self-directed; B) much of it is useful, in the direct sense, neither for the economy nor for the political system and may even be opposed to the institutional requirements and C) entails little compulsory labor either in teaching or in administration. Rather than proposing an equality of alienated labor we should fight to universalize throughout society the autonomy and shorter working hours of the senior professoriate at research universities, not just for those in higher education. Contrariwise we should resolutely oppose the tendencies within higher education that have created a large academic proletariat of adjuncts and subordinated most of the full-time faculty and staff to near-industrial working conditions by piling increased course loads and administrative assignments on them. To the claim that state systems of postsecondary education "cannot afford" to pay people to do their own work, including reduced teaching and administrative loads, we should answer that the best teachers are in the first place *intellectuals* possessed of wide knowledge and excited about their writing and reading. Then we must learn to aggressively state the cultural value of the goal of shorter working hours for all. In short to save the last good job, we need to stand for a wholly different philosophy and practice from that of the prevalent ideology.

A Little Political Economy of Teacher Work

Most of us who work for wages and salaries are subject to external compulsion throughout the workday. Signifying one of the most dramatic shifts in work culture, the ten- and twelve-hour workday has become almost mandatory for many factory, clerical and professional employees. Forty years ago looming automation was accompanied by the threat of unemployment and the promise of shorter hours. It was also a time when the so-called mass culture debate exploded in universities and in the media: would the increased leisure made possible by technological change be subordinated to the same compulsions as paid labor? Would television, for example, crowd free time? Or would the late twentieth century become an epoch of such innovations as life-long education, the recreation of civil society (imagine all the cafes filled with people who have the working lives of full professors), a flowering of the participatory arts, a golden age of amateur sports?

One of the predictions of that period has been richly fulfilled. World unemployment and underemployment reached a billion in 1996, 30 percent of the working population. And this is the moment when part-time, temporary and contingent work is threatening to displace the full-time job as the characteristic mode of employment in the new millennium. But the part-timers have little space for individual development or community participation. You may have heard the joke: the politician announces that the Clinton administration has created ten million jobs in its first four-year term. "Yeah," says the voter, "and I have three of them."

This is a time of work without end for many Americans and work-shortage for many others: youth, blacks and other "minorities" and women whose jobless rate is higher by a third than men's. Behind the statistics lies a political and cultural transformation that has already wiped out the gains of three generations. A hundred years ago the dream of the eight-hour day animated the labor movement to a new level of organization and militancy.

In the main, unions embraced technology because, if its benefits were distributed to producers, it could provide the material condition for freedom from the scourge of

compulsory labor and the basis for a new culture where for the first time in history people could enter into free associations dedicated to the full development of individuality. In the aftermath of the defeat of the Paris Commune, where for a brief moment workers ran the city, Marx's son-in-law railed against the dogma of work and insisted on the Right to be Lazy. Some workers, imbued with the protestant ethic, vehemently disagreed with this utopic vision—many of the best labor activists were temperance advocates—but did not dispute the goal of shortening the workday so they could fix the roof or repair the car. Whether your goal was to spend more time fishing or drinking or at "productive" but self-generated pursuits, nearly everyone in the labor movement agreed, mediated for some by the scurrilous doctrine of a "fair day's pay for a fair day's work," to do as little as possible to line the bosses' pockets.

As everyone knows we are having our technological revolution and the cornucopia of plenty is no longer grist for the social imagination; it is a material possibility. As, among others, Robert Spiegelman, Herbert Marcuse and Murray Bookchin have argued, scarcity is the scourge of freedom and, from the perspective of the rulers must be artificially reproduced to maintain the system of domination. Hence, working hours are longer, supervision—call it surveillance—more intense, accidents and injuries more frequent and wages and salaries are lower. The poor may inherit the earth and God must love them because he has made so many of them and they keep coming, but for the present Marx's metaphor that the more the worker produces the more s(he) is diminished, enriching only the owners, seems more relevant now than in 1844 when first he wrote these ideas.

Technology is deployed as management's weapon against its historic implication of freedom. It permits radically shorter working hours but, instead, has been organized to produce a three- or four-tier social system. At the bottom millions are bereft of the Good Life because computer-mediated work destroys jobs faster than the economy creates them. Many are fully unemployed, some still receive government support. Others are casual laborers who "shape up" everyday at the docks of companies such as United Parcel

Service and Fed-Ex for a day's work or are migrant farm
workers. You can see the shape-up any morning in the South
Bronx or Chicago's west side, where mostly Latino workers
await a furniture or vegetable truck for a day's hard labor.

At the pinnacle of the working class a shrinking elite—in-
dustrial workers in the large enterprises, craftspersons, and
technical employees—still have relatively well-paid full-time
jobs and enjoy a battery of eroding benefits: paid vacations,
health care (with the appropriate deductibles) and pen-
sions. In between are the at-risk categories of labor: laid-off
workers rehired as "contractors" or "consultants," both eu-
phemisms for contingent workers; workers in smaller enter-
prises with lower-paying full-time jobs and fewer benefits;
and, of course, the bulk of college teaching adjuncts.

As capital reorganizes and recomposes labor the idea of a
job in contrast to paid labor is increasingly called into ques-
tion. Here I won't dwell on the political economy of Capi-
tal's offensive. Many of its salient features are well known:
as sharpened international competition, declining profit
rates, global mergers and acquisitions. But it is important to
underline the crucial fact of the decline, even disappear-
ance of the Opposition and Alternative to Capital. It's not
only the disarray into which the socialist project has fallen,
but also the inability of powerful national labor movements
to confront global Capital with more than sporadic resis-
tances.

Corporate capitalism and its fictions, especially the
"free market" have become the new ideological buzzwords
of world politics and culture. They penetrate every itch
and scratch of everyday life. Under the sign of privatiza-
tion public goods are being disassembled: health care,
environmental protection and, of course, state-sponsored
culture, signified by, among others, the legislative eviscer-
ation of the National and State Endowments and Councils
on the Arts and Humanities and their replacement by
corporate-sponsored arts programs, notably those aired
by PBS (the Petroleum Broadcasting System), countless
corporate-funded museum exhibits and the reemergence
of corporate sponsorship of all kinds of music, especially
middle-brow classical music. Sixty million Americans

obtain their health care from Health Maintenance Organizations (HMOs), private consortia of hospitals, managers and owners. The mission of these groups is getting rid of patients, not getting rid of disease. And all of these institutions operate under the sign of cost-containment; the ultimate successes are measured by the number of subscribers turned away from service.

No more startling change has occurred than the growing tendency by local school boards to use their funds to outsource instruction, curricula and other educational services to private contractors. Meanwhile, the drum-beat of vouchers gets louder as public perception that elementary and secondary schools are "failing" prompts an orgy of straw-grasping. As a recent report using standard measures indicated, these arrangements do not seem to have a noticeable effect on improving school performance, but it is not clear that panic will not overcome reason. Teacher unions have resisted privatization, but the propaganda campaign on behalf of "free choice", the euphemism for privatization, appears, at times, overwhelming.

It was perhaps inevitable that the steamroller should have arrived at the doorstep of America's universities and colleges. By 1990, in contrast to the general decline of the labor movement's density in the work force, faculty and staff were joining unions in record numbers. By the 1990s some 130,000 faculty and staff (exclusive of clerical workers) were represented by the three major unions in higher education AFT, AAUP and the NEA. Thousands of college and university clerical workers organized into a wide diversity of organizations including AFT, but mostly others such as the UAW and, in public universities, AFSCME. To pay for rising salaries for clerical workers and faculty and compensate for falling revenues for research many administrations imposed tuition increases that exceeded the inflation rate and were beefing up their endowments from—you guessed it—large donations from corporations and the individuals who headed them.

The growing influence of corporate giving on private and public research universities has been supplemented by a cultural corporatization of higher education. Once limited

to community and technical colleges, vocationalization has become a virus infecting the liberal arts undergraduate curriculum. In many institutions social science and humanities departments have been reduced to service departments for business and technical programs. Many colleges have agreed to offer degrees, majors and specially tailored courses to corporate employees in return for company reimbursements of tuition and other revenues and have accepted money from corporations to endow chairs in vocationally oriented fields. In some cases, notably the Olin Foundation, not only chairs are offered to universities but also the right-wing professors to sit on them.

This configuration is not confined to technical and managerial areas: it has become one of the solutions for the sciences, which have progressively lost public funding for research in fundamental areas. Now, many scientific departments must justify their faculty lines by raising outside money to perform (mostly) product-oriented research. Most famously MIT molecular biologists entered a hotly contested Faustian bargain with drug companies, which in return for patent ownership have subsidized research. This model has been reproduced in many other institutions and has, to some extent, become the norm. Of course, American scientists are accustomed to subordination to higher authorities; their involvement with the defense establishment is a sixty-year marriage.

Faculty unions are not entirely a solution to the conditions that generate them: an acute power switch from the faculty to administration and to government and corporations over some hiring, curricula and academic priorities; sagging salaries except for the high-profile stars and top administrators; and, at least in the public universities, legislatively mandated budget cuts that, in most instances, buttressed the power switch. These last resulted in some layoffs, a much tighter market for real jobs, increased workloads for those who have them, restrictions on promotions and pay raises calibrated to the inflation rate. In sum, faculty see their unions as a means to restore their lost autonomy and shrinking power as well as to redress salary and benefits inequities.

Academic labor, like most labor, is rapidly being decomposed and recomposed. The full professor, like the spotted owl, is becoming an endangered species in private as well as public universities. When professors retire or die their lines frequently follow them. Instead many universities, even, as we have recently learned, in the Ivy Leagues, convert a portion of the full line to adjunct-driven teaching whether occupied by part-timers or by graduate teaching assistants. At the top, the last good job in America is reserved for a relatively small elite. Fewer assistant and associate lines are being made available for newly minted Ph.D.s. As the recently organized Yale University graduate teaching assistants discovered, they are no longer, if they ever were, teachers-in-training. Much of the undergraduate curriculum in public and private research universities is taught by graduate students who, in effect, have joined the swelling ranks of part-timers, most of whom are Ph.D.s. Together they form an emerging academic proletariat. They make from $12,000 to $20,000 a year depending on how many courses they teach and where, whether they teach summers and whether they are hired as adjunct instructors or assistant professors. Except for those termed "graduate teaching assistants" most do not get benefits or have offices or, indeed, any of the amenities enjoyed by full-time faculty.

It reminds me of my semester teaching at the University of Paris at Saint Denis. Only the chair of the department had an office. Faculty from part-timers to full professors crowded into a single large room where they deposited their outer clothing and some papers while they taught. After class, they picked up their belongings and headed home. In most French universities the university as a public sphere is simply unthinkable, a situation that once described the American community of technical colleges. The postsecondary scene of the future may, unless reversed by indignant and well-organized students and faculty, resemble more the second-tier European and third world universities than the "groves" celebrated in the popular press.

Administrators offer contradictory accounts of this emerging configuration of academic teacher work. They claim teaching is merely part of the academic apprenticeship of

graduate students and a means to support them through school. On the other hand they are wont to claim that the proliferation of adjuncts is a sad but necessary aspect of the imperative of cost-cutting. According to this line, if they could they would create many new full-time lines. But they can't. At City University of New York where the number of new full-time lines has slowed to a slow faucet leak, approximately half of all courses in the undergraduate curricula are taught by adjuncts; in community colleges the proportion is 60%. Even in schools such as New York University that have made substantial efforts to rebuild their full-time faculty, some key programs such as the School of Continuing Education and many traditional departments' undergraduate lower-division offerings are largely taught by adjuncts.

In the largest middle-level state systems such as California State University and CUNY where the research function is not genuinely encouraged except for the natural sciences (but remains a sorting device to get rid of faculty by denying tenure to those who fail to meet the criterion of producing the requisite quantity of publications), many full-timers teach four and five courses a semester and have dozens of student advisees. In some instances, the professor who defies gravity's law by remaining intellectually active is labelled a rate-buster by the exhausted or burned out majority of her or his colleagues. When all this is combined with committee work many faculty have been transformed into human teaching machines while others, in despair, desperately seek alternatives to classroom teaching, even stooping to accept administrative positions, and not just for the money or power. The old joke that the relationship between a tenured professor and a dean is the same as that between a dog and a fire hydrant has become one of the anomalies of the waning century. Now the administrators are the cat and the faculty the catbox.

A Margin of Hope?

In *The Jobless Future* William DiFazio and I have argued that academic teacher work is heteronomous. Salaries, working conditions and expectations are crucially shaped by

where the teacher is employed and in what capacity. Briefly: I have already alluded to the heavier teaching loads in middle- and lower-tier colleges. In community colleges and state non-research four-year institutions, teaching loads and student advisement have been rising in the 1990s. And many more professors are teaching introductory courses where texts are prescribed by the department, especially but not exclusively in community colleges, which enroll half of the 15 million students in postsecondary education. As teacher/student ratios skyrocket class size increases; at one campus of CUNY an introductory course enrolled eighty students. The graduate assistant told me that she had no TA or grader. And this narrative is fairly typical of many public four-year colleges. When the course load was three for full-time faculty and classes enrolled no more than thirty, the professor had time to read and write. It was at least one of the better jobs. Now many institutions of postsecondary education have an industrial atmosphere, especially with the increasing vocational curricula in the liberal arts.

Research universities have smaller classroom teaching loads in order to facilitate faculty research, especially the money, at least in the social and natural sciences. Apart from composition and other required introductory courses, which have increasingly become the meat and potatoes of English departments in community colleges and middle-level universities, philosophy, criticism and history are activities treated as ornaments by many universities. The leading figures in these disciplines enhance the institution's prestige, which has implications for fund-raising. In some instances, such figures provide administrative leaders for elite schools. Deans, provosts and presidents are frequently recruited from the humanities in high-prestige liberal arts colleges and private research universities, although the public universities lean towards natural scientists.

Many faculty maintain their intellectual and social distance from students, even graduate students. Its not only that they are busy with their grant-funded research, their writing and their celebrity even if in rather narrow circles. The distance is produced by the growing gap between the professoriate, who in the elite universities almost com-

pletely identify with the institution, and graduate students' growing recognition that collective action rather than individual merit holds the key to their futures. For example, when I was invited to address a meeting of hundreds of members of the recently organized Yale graduate assistants union in Spring 1995, I was dismayed but not surprised to find three senior faculty in attendance, one of whom promptly resigned his job in the sociology department to return to the labor movement. The other two, David Montgomery and Michael Denning (and a few others who could not make this particular event), are union stalwarts in this otherwise snow-blinded community of scholar-managers. "Left" critics and scholars along with more conservative faculty were prominent by their absence. A year later I was informed that a distinguished historian turned in a graduate assistant who had participated in an action to withhold grades as a protest against the administration's refusal to recognize the union.

The formation of an academic proletariat even in the elite universities must be denied by the professoriate which has gained richly from the labor of their "students." The professors must continue to believe that those who teach the bulk of the undergraduate classes are privileged cry-babies destined to become the new privileged caste. Strikes, demonstrations and other militant activity are expressions of graduate students' flirtation with outworn ideologies of class and class struggle and not to be taken seriously. It is not only that the professors are indifferent to the new graduate assistants unions, they are hostile to them. In effect they take the position of the administration and its corporate trustees because they identify themselves as its supplicants.

Some who are acutely aware they hold the last good job in America believe their best chance to preserve it lies in becoming what the infamous Yeshiva decision alleges: that faculty in private schools are managers and therefore ineligible for union protections under the law. It is not merely that they are highly paid and enjoy the prestige of institutions standing at the pinnacle of the academic system. Their identities are bound up with their ornamental role. To

break with the institution on behalf of graduate students would acknowledge that higher education *at all levels* is being restructured and that they may be the last generation of privileged scholars. This admission would prevent them from playing their part in closing the gates.

The Yale struggle is only the most publicized of a growing movement whose main sites are in state research universities. Iowa, Michigan, UC-Berkeley, UCLA and San Diego, SUNY-Binghamton and the parent of them all, Wisconsin, are among the dozen major universities with graduate assistant unions, many of them affiliated to conventional blue-collar organizations such as UAW and, in Iowa, the UE as well as AFT. In many cases the AFT or AAUP contract covers adjunct faculty, but graduate assistants must organize separately.

But academic unionism has, in general, not yet addressed the very core of the crisis: the restructuring of universities and colleges along the lines of global capitalism. Most of us are situated in less privileged precincts of the academic system. We have witnessed relatively declining salaries and erosion of our benefits. And like many industrial workers we have been driven into an impossibly defensive posture and are huddled in the cold, awaiting the next blow. We know that full-time lines are being retired with their bearers, that more courses are taught by part-timers at incredibly low pay and few, if any benefits. We are aware of the tendency of elite as well as middle-tier universities toward privatization, toward aligning the curriculum with the job market and are experiencing the transformation of nearly all humanities and many social sciences into service programs for business, computer technology and other vocational programs.

In short, although more highly unionized than at any time in history, academic labor has not yet devised a collective strategy to address its own future. We know that the charges against us—that university teaching is a scam, that much research is not "useful," that scholarship is hopelessly privileged emanate from a Right that wants us to put our noses to the grindstone just like everybody else. So, far we have not asserted that the erosion of the working conditions for the bulk of the professoriate is an assault on one of the

nation's more precious resources, its intellectuals. Guilt-tripped by mindless populism whose roots are not so far from the religious morality of hard work as redemption, we have not celebrated the idea of *thinking* as a full-time activity and the importance of producing what the system terms "useless" knowlege. Most of all, we have not conducted a struggle for universalizing the self-managed time some of us still enjoy.

Note

1. A slightly different version of this chapter first appeared in *Social Text* no. 51, Summer, 1997.

8 ▊ Unthinking Sex
Marx, Engels and the Scene of Writing

Andrew Parker

> . . . man first sees and recognizes himself in other
> men. Peter only establishes his own identity as a
> man by first comparing himself with Paul as being
> of like kind. And thereby Paul, just as he stands in
> his Pauline personality, becomes to Peter the type
> of the genus homo.
>
> —Marx, *Capital, Volume One*
> (Moore/Aveling trans.)

> I was also happy in the auditorium itself since I
> found out that—contrary to the representation with
> which my childish imaginings had for so long pro-
> vided me—there was only one stage for everyone.
> I had thought that one must be prevented from see-
> ing clearly by the other spectators, as one is in the
> middle of a crowd; but now I realized that, on the
> contrary, thanks to an arrangement which is like
> the symbol of all perception, each one feels himself
> to be the center of the theatre.
>
> —Proust, *A la recherche du temps perdu*

> A politics, therefore, although it never occupies the
> center of the stage, acts upon this discourse. It
> ought to be possible to read it.
>
> —Derrida, "Economimesis"

Dramatizing links between core elements of
Marxist theory, moments from nineteenth-century political
history, and scenes from Marx's and Engels's "private" lives,
this essay suggests that Western Marxism's constitutive de-
pendence on the category of production derives in part from
an antitheatricalism—an aversion above all to forms of

parody—that prevents sexuality from attaining the signifi-
cance for Marxism that class has exclusively enjoyed. My
title plays on that of a hugely influential essay first pub-
lished in the 1984 collection *Pleasure and Danger*: Gayle
Rubin's "Thinking Sex."[1] Widely noted for its impassioned
defense of the rights and practices of a range of sexual mi-
norities, "Thinking Sex" is also a major revision of Rubin's
earlier analysis of patriarchy as a system predicated upon
gender binarism, obligatory heterosexuality, constraints on
female sexuality, and the exchange of women between men
"with women being a conduit of a relationship rather than a
partner to it." If this conception of the "traffic in women"
has proven to be immensely productive for feminist analy-
sis, Rubin's concomitant elaboration of what she termed the
"sex/gender system"—"a systematic social apparatus which
takes up females as raw materials and fashions domesti-
cated women as products"—has become nothing less than
indispensable, forming indeed one of the cornerstones of
the field of Women's Studies.[2]

Yet Rubin's "Thinking Sex" begins to question the ade-
quacy of this very framework. Recognizing that her earlier
work "did not distinguish between lust and gender" but
lumped the former indiscriminately with the latter, Rubin
challenges in her later essay the assumption that feminism
is or should be the privileged site of a theory of sexuality.
Feminism is the theory of gender oppression. To automati-
cally assume that this makes it the theory of sexual oppres-
sion is to fail to distinguish between gender, on the one
hand, and erotic desire, on the other. (307)

In arguing for the relative autonomy of a new theoretical
object—one separate both from chromosomally-determined
sex and from culturally-constructed *gender*—Rubin now re-
serves the term *sexuality* "for the array of acts, expectations,
narratives, pleasures, identity-formations, and knowledges,
in both men and women, that tends to cluster most densely
around certain genital sensations but is not adequately de-
fined by them."[3] Rubin acknowledges, of course, that "gen-
der affects the operation of the sexual system, and the sexual
system has had gender-specific manifestations" (308)—one
need only recall, as I'll do again later in this essay, Karl Hein-

rich Ulrichs's mid-nineteenth-century account of "sexual inversion" as a mismatch between manifest and latent gender identities: *anima muliebris in corpore virile inclusa*. But Rubin's overarching point is that, though historically and structurally imbricated in one another, gender and sexuality "are not the same thing" (308).[4] Indeed, where in most instances the binary codes governing gender difference leave relatively little room for hermeneutic error, what we now call sexual orientation—in troubling any simple continuity between gender identity and object-choice—tends to produce the more intractable interpretive anxieties.[5]

If Rubin's essay helped to place the thinking of sexuality on the contemporary political agenda, this would appear to be a task for which Western Marxism has been—and remains—generally underprepared. Notwithstanding the contributions of such figures as Alexandra Kollontai, Herbet Marcuse, and Guy Hocquenghem, we might even speak here of Marxism's tradition of unthinking sex.[6] When Marxist theorists *have* concerned themselves directly with sexual issues, they've tended to relate the story (impossible to sustain after Foucault) of how a natural or potentially liberatory sexuality has been set upon, repressed, commodified or otherwise constrained by the institutions of capitalism: as if sexuality were not always already institutional, existing only in its historically-sedimented forms and discourses.[7] In addressing, for example, the question "What Has Sexuality to Do with Class Struggle?" Reimut Reiche seemed to answer *not much* in contrasting his "personal" interests in "sexual theory" with what he called genuinely "political problems": as if the relationship between the two could in fact be figured simply as a distinction between the public and the private.[8] Recognizing these shortcomings, other theorists have proposed instead a materialist analysis of "desire": as if this understanding of desire—in tending in practice almost inevitably toward the monolithic, the unmodified and, hence, the hetero—could possibly perform the theoretical work of an unnamed and seemingly unnameable sexuality.[9] Why has thinking sex proven to be so difficult for Western Marxism? Why, if never simply or entirely absent, has sexuality formed an *aporia*?

What is remarkable by contrast is that Marxism has experienced no such difficulty in thinking gender—from the nineteenth century onward a range of discourses has existed through which the Woman Question could at least be articulated. Gender as a category *registered* even if, for classical Marxism, it was typically classed as an epiphenomenon. The history of Marxist theory has been among other things a history of contesting this secondary and derivative status: not only, for example, has Marx's typical proletarian long since been identified as male (his industrial labors forming the norm against which domestic work appears to be *non*-labor), but even the concept of class, as Joan Scott has cogently argued, can itself be viewed as masculinist in its implicit assumption of a familial division of labor.[10] In consequence, Marxist feminists have created new forms of analysis in which class and gender are accorded commensurate hermeneutic weight—and such work has enabled the important recognition that class makes its influence felt only in and through its gendered embodiments, and vice versa.[11] Yet Marxist feminism, too, "has typically proceeded in the absence of a theory of sexuality and without much interest in the meaning or experience of sexuality. Or more accurately, it has held implicitly to a view of female sexuality as something that is essentially of a piece with reproduction"[12]—which helps to explain why, even among Marxist feminists, the maternal is often construed as a synechdoche for woman as such, and this despite the rather obvious fact that feminine sexuality is not reducible to what is, after all, only one of its possible components.[13]

I should admit, at this point, that Marxism's problems with thinking sex are perhaps not quite as bleak or as totalizing as I've just made them out to be. More and more historical research—I'm thinking of work inspired by John D'Emilio's "Capitalism and Gay Identity"—is currently being compiled on the myriad ways that class position affects the formation of sexual practices and identities.[14] And Jeffrey Weeks has even suggested, following Foucault, that "the very idea of 'sexuality' itself is an essentially bourgeois one, which developed as an aspect of the self-definition of a class, both against the decadent aristocracy and the ram-

pant immorality of the lower orders in the course of the eighteenth and nineteenth centuries."[15] But both D'Emilio and Weeks proceed from what they assume to be a known and invariant category (production) in order to illuminate what is, from this perspective, unknown and contingent (sexuality). Thus, while we have begun to appreciate how class identities impinge upon sexual formations, we still have nothing resembling what might be called a sex-inflected analysis of class formations (this reversal of terms doesn't make any kind of customary sense).[16] Yet if feminist readings have found insistent figurations of gender in Marx's writing even—or especially—when the relation of men to women is not his explicitly thematized concern, this strategy might be adapted in the interest of performing a *sexual* reading of Marx's texts, a reading that could map the (de)structuring effects of eroticism even—or especially—in works whose subjects may seem to be utterly unsexy. The remainder of this essay takes up this latter possibility: if Marxist theory traditionally hasn't thought sexuality, I want to begin to explore some ways that sexuality—in one of its decidedly familiar forms—nevertheless thinks Marx. That this thinking will encounter the theatrical at every turn should prove less and less surprising as we go.

My main text will be *The Eighteenth Brumaire of Louis Bonaparte*, that inspired work of political journalism in which Marx, armed "with the weapons of historical research, of criticism, of satire and of wit," explored the causes and consequences of Napoleon III's coup d'état in December 1851.[17] Written in the early months of 1852 for a German emigré newspaper in New York, the *Eighteenth Brumaire* (as Engels described it) "laid bare the whole course of French history" from the workers' uprisings of June 1848, through the defeat of the petty-bourgeois *Montagne* in June 1849, to Bonaparte's coup on the anniversary of his uncle's ascension to power—the "original" 18th Brumaire of Napoleon I. In Engels's view, Marx succeeded in grasping the essence of these events where other commentators failed because "it was precisely Marx who had discovered the great law of motion of history, the law according to which all historical struggles, whether they

proceed in the political, religious, philosophical or some other ideological domain, are in fact only the more or less clear expression of struggles of social classes. . . . Consequently, events never took [Marx] by surprise" (14).

Despite the studied confidence of Engels's remarks, most contemporary readers of the *Brumaire* would agree that Marx *was* surprised by recent events in France. For Marx confronted not only a crisis in French history but a crisis in his theory as well, a crisis of representation testing the limits of this claim that politics is "only the more or less clear expression" of class antagonisms. Seeking to confirm an important tenet of his earlier writings—the notion that the state functions as "but a committee for managing the affairs of the whole bourgeoisie"[18]—Marx begins the *Brumaire* by trying to match each parliamentary faction with specific class interests. What soon frustrates Marx's design, however, is his discovery of "the most motley mixture of crying contradictions" (43), for rather than representing coherently the interests of any one or even of several classes, the state under Bonaparte seems to have "made itself an independent power" (131), not only freeing itself from but even overwhelming its putative ground in production:

> [T]he state enmeshes, controls, regulates, superintends and tutors civil society from its most comprehensive manifestations of life down to its most insignificant stirrings, from its most general modes of being to the private existence of individuals; where through the most extraordinary centralization this parasitic body acquires a ubiquity, an omniscience, a capacity for accelerated mobility and an elasticity which finds a counterpart only in the helpless dependence, in the loose shapelessness, of the actual body politic. (62)

Far from issuing in the revolutionary upheaval that Marx had predicted would erupt, French history under Bonaparte appears instead to have swerved from its dialectical course, generating only what Marx glumly describes as "confusions of cause and effect" (132): "passions without truth, truths without passions; heroes without heroic deeds, history with-

out events; development, whose sole driving force seems to be the calendar, wearying with constant repetition of the same tensions and relaxations" (43). Bonaparte would seem to have thrown "the entire bourgeois economy into confusion" (135), and in the process confusing the very terms of Marx's account.

Some of the best recent readings of the *Brumaire* have shown how Marx sought to contain this confusion by treating Bonaparte's rule as merely a temporary aberration, a setback that history "even now" is working to correct. "Let there be no misunderstanding," he writes: the state "is *not* suspended in midair" (123); history is still proceeding on its dialectical path; the revolution, despite appearances, "*is* thoroughgoing"; soon "Europe will leap from its feat and exultantly exclaim: Well grubbed, Old Mole!" (121). (We'll shortly see how telling it is that this voice of authentic revolution should end up quoting from *Hamlet*.) Struggling desperately to support this optimism by identifying some social class that Bonaparate can be said to represent, Marx turns first to the peasantry, then to a more narrowly defined "conservative peasantry," only to reject each of these groups in turn in favor of a solution that, given his own terms, is hardly a solution at all: a class with no class, a metonymic assemblage rather than a metaphoric unity, the pseudo-class of the lumpenproletariat who formed "the scum, offal and refuse of all [other] classes":

> Alongside decayed *roués* with dubious means of subsistence and of dubious origin, alongside ruined and adventurous offshoots of the bourgeoisie, were vagabonds, discharged soldiers, discharged jailbirds, escaped galley slaves, swindlers, mountebanks, *lazzaroni*, pickpockets, tricksters, gamblers, *maquereaus*, brothel keepers, porters, *litterati*, organ-grinders, ragpickers, knife grinders, tinkers, beggars—in short, the whole indefinite, disintegrated mass, thrown hither and thither, which the French term *la bohème*. (75)

A grotesque, serialized mass whose heterogeneity is as fully lexical as it is social, the lumpen in Marx's analysis merely

circulate goods but produce no value themselves—Marx's *sine quâ non* for the emergence of an authentically politicized consciousness. His catalog owes much to Adam Smith's inventory in *The Wealth of Nations* of similar kinds of "unproductive" work:

> The sovereign, for example, with all the officers both of justice and war who serve under him, the whole army and navy, are unproductive labourers. . . . In the same class must be ranked, some both of the gravest and most important, and some of the most frivolous of professions: churchmen, lawyers, physicians, men of letters of all kinds; players, buffoons, musicians, opera-singers, opera-dancers, & co. . . . Like the declamation of the actor, the harangue of the orator, or the tune of the musician, the work of all of them perishes in the very instant of its production.[19]

Marx might say that all of these activities are merely *parodies* of production; an actor can represent the labor of others, but such a representation is not to be confused with labor strictly defined. Indeed, if the sovereign can be classed with other "theatrical" professions then Marx can conclude the *Brumaire* on a positive note. For by arguing that Bonaparate is just an actor who belongs as well to a *class* of actors—the "appalling parasitic body" of the lumpen (121)—Marx in effect can salvage the paradigm of representation, of the priority of a productive ground to its secondary and derivative political expression, even as Bonaparte seems to have reduced this paradigm to shambles.[20]

This, at least, would appear to have been Marx's goal. The problem, as he clearly acknowledges, is that this crisis in representation has exceeded the political realm as such in saturating French history and society in a more pervasive confusion of ground and expression. In the famous opening pages of the *Brumaire*, Marx describes this overriding problem as a perverse generalization of the theater, an eruption within civil society of literary relations that have overstepped their textual limits:

Hegel remarks somewhere that all facts and person-
ages of great importance in world history occur, as it
were, twice. He forgot to add: the first time as tragedy,
the second as farce. Caussidière for Danton, Louis
Blanc for Robespierre, the *Montagne* of 1848 to 1851
for the *Montagne* of 1793 to 1795, the Nephew for the
Uncle. And the same caricature occurs in the circum-
stances attending the second edition of the eighteenth
Brumaire! (15)

Marx's point, of course, is not simply that French history re-
peats itself but that it has done so along a scale of descend-
ing literary values. For farce is the most *declassé* of
theatrical spectacles: rather than imitating the nobility of a
tragic action, farce is a secondary and derivative mode that
imitates only the degraded conventions of theater. This is
precisely Marx's diagnosis of the course of French history
since the era of the Revolution; instead of seizing the mo-
ment and acting, the French in the nineteenth century have
only, well, *acted*:

Just when they seem engaged in revolutionizing them-
selves and things, in creating something that has never
yet existed, precisely in such periods of revolutionary
crisis they anxiously conjure up the spirits of the past
to their service and borrow from them names, battle
cries and costumes in order to present the new scene
of world history in this time honoured disguise and
this borrowed language. (15)

Though Marx recalls that even the great French Revolu-
tionaries dressed themselves up as resurrected Romans, he
aims here specifically at later revolutionary movements that
"knew nothing better to do than to parody, now 1789, now
the revolutionary tradition of 1793 to 1795" (15). These
parodies culminate with the rule of Bonaparte, an actor dis-
guised as a statesman (a kind of Ronald Reagan *avant la let-
tre*) who "conceives the historical life of the nation and
their performances as comedy in the most vulgar sense, as

a masquerade where the grand costumes, words and pos-
tures merely serve to mask the pettiest knavery" (76). Under
Bonaparte only "the ghost of the old revolution" walks
about; unable to "get rid of the memory of Napoleon," the
French continually mistake the nephew for his Uncle, the
present for the past: "An entire people, which had imagined
that by means of a revolution it had imparted to itself an ac-
celerated power of motion, suddenly finds itself set back
into a defunct epoch" (17). Marx concludes that only when
real action replaces mere acting, when all costumes have
been returned to the theaters, will revolution once more be-
come possible: "Society seems now to have fallen behind its
point of departure; it has in truth first to create for itself the
. . . conditions under which alone modern revolution be-
comes serious" (19).

Revolution hence is a serious business where seriousness
itself is defined as an ability to distinguish the imaginary
from the real, representations from what they represent, the
theatrical from the authentic. If "men and events appear as
inverted *Schlemihls*, as shadows that have lost their sub-
stance" (44), Marx seeks to invert this inversion by treating
"the spectacle of politics as a farce which, if it is merely ex-
posed as such, will vanish into air like Propsero's masque."[21]
Though Jeffrey Mehlman has claimed that Marx *affirms* this
becoming-theater of history,[22] my reading has argued just the
reverse—that Marx is hardly celebrating an endless profu-
sion of theatrical simulacra but decrying any such mistaking
of history for its other. If the *Brumaire* itself adopts a con-
sistent theatrical rhetoric, describing French history as a
progression of prologues and scenes, it does so not to en-
dorse this imagery but to reduce it *ad absurdum*. For while
Marx's language exuberantly imitates the theater, the text
implies throughout not only that he finds this performance
wanting but—in keeping with an inherently classical con-
ception of theatrical space—that he is not himself on stage:
"the spectacle is represented to a subject who remains out-
side the drama, outside representation."[23] Indeed, prevented
by political events from assuming a leading role, Marx takes
his seat in the non-dramatic space of criticism, an exterior
site from which he can parody the parody while retaining an

ironic distance. This is not of course to say that Marx was disinterested in his theatrical criticism (no one could have been less so than he), but that *his* interests would be circumscribed as wholly different from and external to those portrayed on the stage. For if all of France confuses theater with history, insides with outsides, the imaginary with the real, Marx the critic does not, offering the *Brumaire* as testimony to the fact that he, for one, has not been taken in.

While Marx would remain outside this scene of writing, his texts quite typically act otherwise. In a longer version of this essay I describe how, in the *Economic and Philosophic Manuscripts* as well as in *Capital*, this exterior space of criticism begins to rupture in Marx's "readings" of plays such as *Timon of Athens* and *Faust*. I consider, too, Marx's highly fraught relationship with Ferdinand Lasalle, a rival for the leadership of the German working class movement whom Marx pilloried not only for his Jewishness and (what, for Marx, amounted to the same thing) his promiscuity, but for a play Lasalle wrote (*Franz von Sickingen*) that Marx and Engels criticized in what became ur-texts of materialist aesthetics.

Here, however, I'd like to return directly to the *Brumaire* by asking a question first posed by Rousseau in his *Lettre à d'Alembert*: "Who among us is sure enough of himself to bear the performance of such a comedy without halfway taking part in the turns that are played out? For is being interested in someone anything other than putting oneself in his place?"[24] I raise these issues of identification in connection with the *Brumaire* since its author seems especially to be "interested in someone." For why does Marx hate Bonaparte *so much*? The obvious response (though no less true) is that Bonaparte was the preeminent class enemy who eviscerated the life of a nation. But the more one tries to account for the specifics of Marx's rhetoric—he calls Bonaparte an "indebted adventurer" (68), a foreigner who identified the course of French history "with his own person" (57)—the more one begins to suspect that Marx recognized some kinship between Bonaparte and another indebted foreigner who tended to identify the course of French history with his own person: Marx himself. Indeed,

the only two individuals in the entire *Brumaire* who seem fully aware of what is "really" happening in France are Bonaparte and Marx, both of whom are imputed with the knowledge that essence differs from appearance, insides from outsides, history from theatre. The knowledge they share would thus be unique since they alone are unconstrained by class position—"Bonaparte understood" (110), writes Marx, who similarly, almost empathically understands. But the implications of this secret sharing must have been, at some level, terribly unsettling to Marx, for if Bonaparte detached himself from the class structure, "representing" only a non-representative class, one of Marx's greatest anxieties was that he too did not (simply) represent anyone, that his own writings (even as they traced the effects of the division between intellectual and manual labor) were potentially as unproductive as the lumpen he despised. Perhaps understanding Bonaparte *too* well, finding himself "halfway taking part in the turns that are played out," Marx may have realized, in effect, that it takes one to know one: the very phrase, as Eve Kosofsky Sedgwick suggests, around which male same-sex desire began to be organized in the nineteenth century. Lest one takes this suggestion to be extraneous to the *Brumaire*, an imposition of contemporary concerns upon a text that historically resists them, we need only recall that the last page of the text features not only the famous prediction of the fall of the Vendôme Column but also an image of sexual inversion, Madame Girardin's *bon mot* that France has been transformed under Bonaparte from a government of mistresses to a government of "*hommes entretenus* [kept men]" (135)— a transformation Marx must have felt some ambivalence about having already begun to depend heavily upon Engels's financial support.[25]

Am I seriously implying, despite the immense amount we know about his life, that Marx was "really a homosexual"? Of course not, and for many reasons, foremost among them that no one could have been more indefatigably hetero than he: "Love," he felt capable of writing to his wife Jenny, "not for the being of Feuerbach, not for the transmutation of Molechott, not for the proletariat, but love for the beloved,

and particularly for you, makes a man a man."[26] More to the point, the very notion of "the homosexual"—understood in Foucault's terms as "a personage, a past, a case history, and a childhood"—had not yet come into currency when Marx was writing the *Brumaire*.[27] But Marx lived through the period in which this emerging lexicon of homosexual identities began to vie with an older, pre-existing vocabulary of sodomitical acts. One would think (though hardly anybody has) that the protracted and often wrenching tension between these competing conceptions—the incoherent and hence increasingly urgent question of what constituted male/male desire—must have left *some* discernible traces on his life and writing. Indeed, as someone who, as we will see, identified "not *as* homosexual, but *as against* the homosexual," Marx could scarcely have been a stranger to the culturally pervasive predicament Sedgwick has anatomized as male homosexual panic: "Because the paths of male entitlement, especially in the nineteenth century, required certain intense male bonds that were not readily distinguishable from the most reprobated bonds, an endemic and ineradicable state of what I am calling male homosexual panic became the normal condition of male heterosexual entitlement."[28] By mid-century, in other words, the morphological distance separating prescribed and proscribed male behaviors had become so attenuated that the entire spectrum of culturally-sanctioned masculine relations—"male friendship, mentorship, admiring identification, bureaucratic subordination, and heterosexual rivalry"—could always appear under homophobic pressure to resemble its putative "opposite." Since the threat of persecution regulated not only "a nascent minority population of distinctly homosexual men" but "the male homosocial bonds that structure *all* culture," no man thus could ever be sure of proving—or be exempt from having to prove—"that he is not (that his bonds are not) homosexual."[29]

A classic double-bind, then, in which even the diversionary strategy of accusing "real homosexuals" could backfire by identifying the accuser as a "too savvy reader of homosexual signs": "Interpretive access to the code that renders homosexuality legible may thus carry with it the stigma of

too intimate relation to the code and the machinery of its production."[30] If one effect of this double-bind was a near-paranoic aversion to any act of self-exposure (revealing nothing poses the least epistemological risk), another may have been the century's obsessive fantasy of an authentic self immune from theatrical display, a fantasy that has generated mountains of commentary from Lionel Trilling and Leo Bersani to Jonas Barish and Nina Auerbach. That the languages of homosexual panic and antitheatricalism resonate strikingly with one another can be seen in this passage from David Marshall's *The Figure of Theater*, which describes the ambivalent responses of the writers he discusses to the very thought of a generalized theatricality: "Theater, for these authors, represents, creates, and responds to uncertainties about how to constitute, maintain, and represent a stable and authentic self; fears about exposing one's character before the world; and epistemological dilemmas about knowing or being known by other people."[31]

Marx and Engels were certainly concerned with these uncertainties, fears, and dilemmas given the evidence of several letters recently translated into English for the first time in full. Dating from 1869 (when Marx was revising the *Brumaire* for its first German edition), these letters are remarkable in that they reveal first-hand knowledge of the writings of Karl Heinrich Ulrichs, the Hanoverian lawyer who, in a series of tracts appearing in the mid 1860s with the collective title *Researches into the Riddle of Love between Men*, developed his theory of sexual inversion postulating the existence of a "Third Sex": the *Urning* or Uranian whose anatomically masculine outside misrepresents a spiritually feminine inside.[32] Ulrichs makes his appearance in the Marx-Engels correspondence in connection with the current political situation in Germany, where Wilhelm Liebknecht's pro-Communist organization seemed to be losing ground to the General Association of German Workers (the ADAV) whose leadership, after the death of Lassalle, passed into the hands of Johann Baptist von Schweitzer. The first Social Democrat to hold legislative office in a European parliament, Schweitzer was a lawyer who authored

the four-act comedy *Alcibiades oder Bildung aus Hellas*, a play "with some strikingly realistic references to Greek love." It was only through Lassalle's intervention that Schweitzer could first join and then rise to prominence in the ADAV, for he had been arrested in 1862 when "two elderly ladies enjoying a quiet stroll through the public park of Mannheim came upon Schweitzer and an unidentified young man in a highly compromising situation."[33] Ulrichs had been casually acquainted with Schweitzer, and in response to the arrest composed a legal defense which he sent to Schweitzer in jail. When Schweitzer nonetheless was convicted and barred from the practice of law, Ulrichs began writing his booklets about Uranism in an effort to repeal the anti-sodomy provisions of the North German Penal Code, thereby laying the groundwork for what would later become the German homosexual movement. Schweitzer, meanwhile, was finally admitted to the ADAV over the protests of some of its members when Lassalle argued that "the abnormality attributed to Dr. von Schweitzer has nothing whatever to do with his political character. . . . I could understand your not wishing Dr. von Schweitzer to marry your daughter. But why not think, work, and struggle in his company? What has any department of political activity to do with sexual abnormality?"[34]

Engels, for one, seemed to think the two had something to do with one another. Condemning elsewhere the ancient Greeks for their "abominable practice of sodomy [which] degraded alike their gods and themselves with the myth of Ganymede,"[35] Engels writes the following to Marx when Schweitzer succeeded, Liebknecht's efforts notwithstanding, in unifying the two main wings of the ADAV:

Manchester, 22 June 1869
Dear Moor,
 I don't know whether you have such fine weather there as we have here, but daylight has been so exhausted that, on the longest day, we had to turn the gas on at 4 o'clock in the afternoon. And it is devilish to read or write when you don't know whether it is day or night.

Tussy [Marx's daughter Eleanor, then visiting the Engels household] is very jolly. This morning the whole family went SHOPPING; tomorrow evening they want to go to the theatre. [. . .]

So that is Wilhelm [Liebknecht]'s entire success: that the male-female line [Schweitzer's faction of the ADAV] and the all-female line [the group supported by the Countess von Hartzfeld, Lassalle's former patron] have united! He really has achieved something there. Schweitzer will naturally be re-elected [as head of the ADAV]—in view of the precipitancy with which the business has been conducted—and then he will, once again, be the chosen one of general suffrage. Wilhelm is also preserving an obstinate silence about this event.

The *Urning* [identified by the editors of the correspondence as Ulrichs's *Argonauticus*, but this volume wouldn't appear until September of that year] you sent me is a very curious thing. These are extremely unnatural revelations. The paederasts are beginning to count themselves, and discover that they are a power in the state. Only organisation was lacking, but according to this source it apparently already exists in secret. And since they now have such important men in all the old parties and even in the new ones, from [Johannes] Rösing [a Bremen merchant] to Schweitzer, they cannot fail to triumph. *Guerre aux cons, paix aus trus-de cul* [war on the cunts, peace to the assholes] will now be the slogan. It is a bit of luck that we, personally, are too old to have to fear that, when this party wins, we shall have to pay physical tribute to the victors. But the younger generation! Incidentally it is only in Germany that a fellow like this can possibly come forward, convert this smut into a theory, and offer the invitation: *introite* ["enter," the title of a section from Ulrichs's earlier book *Memnon*], etc. Unfortunately, he has not yet got up the courage to acknowledge publicly that he is "that way," and must still operate *coram publico* "from the front," if not "going in from the front" as he once said by mistake. But just wait until the new

North German Penal Code recognizes the *droits du cul*;
then he will operate quite differently. Then things will
go badly enough for poor frontside people like us, with
our childish penchant for females. If Schweitzer could
be made useful for anything, it would be to wheedle
out of this peculiar honorable gentleman the particu-
lars of the paederasts in high and top places, which
would certainly not be difficult for him as a brother in
spirit.
 [. . .]
 Close of post. Best greetings.
 Your F.E.[36]

Astonishing in the virulence of its misogyny and homopho-
bia, Engels's letter shifts from anticipating a visit to the
theater to reflecting on Schweitzer's recent political vic-
tory—which then puts him in mind of the book Marx had
sent him. Recognizing some resemblance (if only fleeting
and, of course, parodic) between the paederasts's secret so-
cieties and those of the radical left, he jokes about what will
happen to "poor frontside" men—"like us," he adds for em-
phasis—if the paederasts carry the day, a strategy that al-
lows him the freedom to experience vicariously the anal
eroticism he seems to condemn. If it's a good thing, on the
one hand, that Marx and I are too old and unattractive to
have to engage in such acts ourselves, it's even better to an-
ticipate, on the other, the fulsome erotic charge that would
accrue to us from engaging in homophobic blackmail.

 That Engels can imagine this scenario so vividly may in-
dicate his awareness that he could always be targeted him-
self. Indeed, as Alan Bray wrote about male friendship in an
earlier historical context, what is remarkable about Engels's
life is the very ease with which it "could be read in a differ-
ent and sodomitical light."[37] The standard biographies, for
example, seem to draw their narrative energies from the
time-worn staples of queer fiction:

Then, when he was eighteen, Engels left for Bremen
to gain experience in the export trade. While working in
the Free City he also drank, smoked, sang, fenced, swam,
attended theatre and opera, got into debt, studied and

did other things that young men do when they leave the provinces.[38]

Engels sometimes betrayed a tendency to see himself as dependent on older and stronger men. . . . Writing of three fellow members of the London Communist League whom he met at the age of twenty-three, Engels later said: "I shall never forget the deep impression that these three real men made upon me, who was then only wanting to become a man."[39]

Describing himself as a "stick-in-the-mud bachelor" who has housekeepers but "never a wife" (39:249), Engels (like Oscar Wilde's Jack/Earnest) maintained two residences over much of his adult life, one where he had his official address and another where he lived unmarried first with the former mill-worker Mary Burns, and then after her death with her sister Lizzie (whom he would marry only on *her* deathbed).[40] We know that Jenny Marx was scandalized by these violations of bourgeois decorum, so much so that she never assented to be introduced to Mary Burns. When Mary died Marx sent his "condolences" to Engels, but the bulk of Marx's letter was taken up with yet another request for money. Engels exploded, which led Marx to write an apology ("Instead of Mary, ought it not to have been my mother, who is in any case a prey to physical ailments and has had her fair share of life . . . ?")—which, for Engels, appears to have done the trick: "Never mind, your last letter made up for it and I'm glad that, in losing Mary, I did not also lose my oldest and best friend" (41:442, 447).

But if Mary and Marx occupy here strangely commensurate positions, this was not the last time Engels would thus be triangulated. Helen (Lenchen) Demuth had been given as a "gift" from Jenny's parents to the Marx family, for whom she would work for decades as a servant. Demuth became pregnant almost immediately upon her arrival in June 1851, the gestation including the period in which Marx wrote the *Brumaire*. The child's father was long presumed to be Engels, but now it is generally accepted that the boy in fact was Marx's: Engels had "agreed to take Marx's place in order to save Marx from serious domestic difficulties."[41] Christened Henry Frederick Demuth, his first name hon-

ored Marx's father, his second name Engels (we may be re-
minded here of the conclusion to Bram Stoker's *Dracula*,
where the child's "bundle of names links all our little band
of men together"). In Jerrold Seigel's account: "When En-
gels was near death in 1895, however, and had not men-
tioned Frederick Demuth in his will, he let his friend and
housekeeper Louise Freyberger (Karl Kautsky's ex-wife)
know the truth lest he be thought of disowning his own son.
Louise Freyberger told Eleanor Marx who, disbelieving,
made Engels tell her, too."[42] Having "taken Marx's place"
Engels must have felt himself acutely vulnerable to the im-
putation of homoerotic feelings—a vulnerability exacer-
bated by his identification with and subordination to his
closest male friend, of whom he wrote late in life: "I have
done what I was cut out for—namely to play second fid-
dle—and I think that I have done quite well in that capac-
ity. And I have been happy to have had such a wonderful
first violin as Marx."[43] The homoerotic overtones of all this
fiddling around could hardly have been lost on Engels, for
whom proscribed and prescribed male behavior indeed
must have looked terrifyingly similar. Caught in a vise-like
double bind that I can never acknowledge directly (with
Marx above all), my best policy would be to guard against
the threat of imputation by safely attacking "real" inverts—
which will help mitigate my "devilish" fear that I don't really
know if it's day or night.

If Marx replied directly to Engels's letter a copy no longer
survives. (Elsewhere he called Schweitzer a "shitty cur,"
urging a friend to "spread" jokes about him in the newspa-
pers.[44]) We do, however, have a subsequent letter demon-
strating Marx's own familiarity with Ulrichs's work, a letter
that—though far less anxious than Engels's—manages to
register a similar ambivalence (43:403):

London, 17 December 1869
Dear Fred,
 Best thanks for £100. Yesterday I couldn't acknowl-
edge because of the sudden appearance of [Wilhelm]
Strohn [a member of the Communist League]. The poor
fellow had his blood relapse again in May. Because of

> his health, he has had to hang around since then in
> Switzerland, etc.; looks very poorly and is very peev-
> ish. The doctors recommend him to marry. Strohn will
> be returning from here to Bradford, and desires you to
> return him the *Urnings* or whatever the paederast's
> book is called.
>
> As soon as he goes (on Monday) I shall myself buzz
> around town to raise the [J. P.] *Prendergast* [author of
> *The Cromwellian Settlement of Ireland*]. I couldn't do
> it last week because of the filthy weather, which I
> couldn't risk TO UNDERGO in my not-yet-restored
> state of health.

Opening with the first of what will become a series of
strangely regulated exchanges, Marx acknowledges the re-
ceipt of yet another monetary gift from his friend. This cir-
culation of funds, however, immediately gives rise to other
kinds: the circulation of their friend Strohn's blood; the cir-
culation of Ulrichs's book[45] whose title Marx seems to have
forgotten but which Strohn now wants Engels to return; the
circulation between heterosexual marriage and sexual in-
version; and even the circulation of verbal signifiers, the
word *paederast* immediately calling up the name *Prender-
gast*, whose book Marx can "raise" without "risk" now that
the "filthy" weather has abated.

What Engels's and Marx's letters both put into play, of
course, is a way of safely raising something filthy between
themselves. While scholars have often noted (how could
they not?) that their correspondence is smeared liberally
with excremental imagery, these same readers never ac-
knowledge that shit acquires its significance by activating
an economy of anal pleasures, desires, and attachments.
Others similarly recognize that the lumpen—"a coagulating
mass," "the scum, offal, and refuse of all other classes"—
both repel and fascinate Marx and Engels, but what pre-
dictably escapes analysis is just what—or where—this *lump*
may be. When in 1845 Jules Janin called the lumpen "foul
rags that have no name in any language,"[46] his description
reverberates with the Church's condemnation of sodomy as

the act *inter Christianos non nominandum*. Indeed, Marx's and Engels's writings on the lumpen echo strikingly the emerging discourse popularly associated with the gay underworld: the lumpen are "a phenomenon that occurs in more or less developed form in all the so far known phases of society" (10:408); they have "their headquarters in big cities" and are "absolutely venal and absolutely brazen" (21:99); they actively "recruit" new members (10:62); they have "unhealthy and dissolute appetites" and their pleasure "becomes *crapuleux*, where money, filth and blood commingle" (10:50-51). If, as we recall, the French state receives from Bonaparte "an *accelerated mobility* and an *elasticity* which finds a counterpart only in the *helpless dependence*, in the *loose shapelessness*, of the actual body politic" (62; my emphases), we now may better understand why the lumpen would be figured repeatedly through a rhetoric of anality.

If Marx remains both horrified and attracted by this tropology, this may be because he finds that it parodies—theatricalizes—the central categories of his thought. The question of where values come from animates the whole of his evolving critique of political economy, and his dependable answer is labor defined as "life-activity, productive life itself" where production has itself been modeled on procreation.[47] In Hannah Arendt's words, Marx's work "rests on the equation of productivity with fertility"; "he based his whole theory [of production] on the understanding of laboring and begetting as two modes of the same fertile life process."[48] The heteronormativity of this formulation is not to be dismissed as merely figural, for Marx views labor insistently as the "life of the species," as "life-engendering life"; "productive labor" is a fact "imposed by Nature"; labor is the "father" and the earth the "mother" of value.[49] Hence Marx's disgusted fascination with acts (quoting one of Ulrichs's German reviewers) that "*imitate* coitus between male persons," acts that parody production in the "sterile" ways that they eroticize "the final ending of the intestine."[50] Hence, as well, Marx's mordant delight in finding that Bonaparte secured his rule with the sausage—*farce*—his

famous gift to the masses of meat extruded into alien intestinal membranes.

To thus discover farce once more within the body politic is to appreciate why theater and anality can figure each other in the crisis of representation Marx grapples with throughout the *Brumaire*. A sexuality that fails to embody approved gender norms looks, to Marx, nothing so much like Bonaparte's theatricalized France: *both* are travesties in his view, parodies of authentic production relations that systematically confuse proper insides and outsides. Though Marx's normative categories depend for their coherence on the demonization of these parodic others, the *Brumaire* never quite succeeds in expelling them from itself—which may help to account not just for its moments of panic but for the misogyny implicit in its antipathy to theater. Adopting a strategy that, by midcentury, already had been proven tried and true, Marx attempts to manage his ambivalence by recasting it along the axis of gender, the seemingly stable opposition between male and female offering itself as a remedy for sexually-charged relations that seem to have lost all such distinction. As Marx will be relieved to discover, it is the *woman* (Dame Quickly from *Henry IV, Part I*) who is "neither fish nor flesh; a man knows not where to have her."[51] This displacement onto gender has been profoundly generative in its effects and continues to influence recent readings of the *Brumaire*—from Daumier's effeminizing statue of Bonaparte selected for the cover of the International Publishers edition, through Dominick LaCapra's characterization of Bonaparte's voice as "falsetto,"[52] to the following utterly remarkable passage by Terry Eagleton (which I quote here in full):

> It is not just that bourgeois revolution swathes itself in theatrical costume: it *is* theatrical in its essence, a matter of panache and breathless rhetoric, a baroque frenzy whose poetic effusions are in inverse proportion to its meagre substance. It is not just that it manipulates past fictions: it *is* a kind of fiction, an ill-made drama that expends itself in Act Three and totters exhausted to its taudry conclusion. If bourgeois revolu-

tions trick themselves out in flashy tropes, it is because
there is a kind of fictiveness in their very structure, a
hidden flaw that disarticulates form and content.[53]

Breathless and tawdry, dissimulating an inner lack with
tropes and feather boas, French history in Eagleton's syn-
opsis is depicted as an actress, a sordid floozy whose fate
was just what she deserved. Eagleton is altogether faithful
here to the spirit of the *Brumaire*, for it was Marx who in-
augurated this practice of blaming the victim: "It is not
enough to say, as the French do, that their nation was taken
unawares. A nation and a woman are not forgiven the un-
guarded hour in which the first adventurer that came along
could violate them" (21). Completing this predictable pat-
tern of imagery, Marx avers that Bonaparte brings "the bride
[of France] home at last, but only after she had been pros-
tituted" (37). French history as public woman unfettered:
overstepping the bounds of decent decorum, she will be fig-
ured unfailingly as the consummate actress who, in leaving
the confines of home, in making a public spectacle of her-
self, infects her society with her sleazy theatrics.

As Joan Scott has suggested, the category of the domes-
tic sphere tends to operate in political theory "as a double
foil: it is the place where a presumably natural sexual divi-
sion of labor prevails, as compared with the workplace,
where relations of production are socially constructed; but
it is also the place from which politics cannot emanate be-
cause it does not provide the experience of exploitation that
contains within it the possibility of the collective identity of
interest that is class consciousness."[54] Though Marx has
done far more than most to deconstruct the opposition of
the private and the public, the *Brumaire* also honors this
distinction in ridiculing "the *dames des halles*, the fishwives"
(114) who, supposedly notable for their characteristic
odeur, formed in Marx's imagination one of Bonaparte's
constituencies. This engendering of the division between
privacy and publicity would be one last attempt to patrol
the distinction between insides and outsides, theater and
history—one last resistance to performing the scene of writ-
ing. As I've been suggesting throughout, however, Marx

respects such distinctions only in their breach, finding himself acting when he only would be . . . acting, criticizing theater from a position already (up)staged, unthinking sex but performing it instead. I offer as a coda one last theatrical engagement.

"In private life," Marx wrote in the *Brumaire*, "one differentiates between what a man thinks and says of himself and what he really is and does" (47). At home, indeed, Marx was crazy about the theater, reading aloud from *Faust* to his children, playing the part of Mephistopheles in parlor productions, hosting regular meetings of a Shakespeare Club where he was described by a fellow member as "delightful, never criticising, always entering into the spirit of any fun that was going on, laughing when anything struck him as particularly comic, until the tears ran down his cheeks—the oldest in years, but in spirit as young as any of us. And his friend, the faithful Frederic Engels, was equally spontaneous."[55] Marx imparted this enthusiasm to his favorite daughter Eleanor, the future translator of *Madame Bovary* and co-author (with Edward Aveling) of *The Woman Question*. When she fell seriously ill at age nineteen with what Marx described as "one of these female complaints, in which the hysterical element plays a part," he fully supported her decision to become an actress, to exchange a familial for a public audience. She did so, becoming friends not only with Havelock Ellis but also with G. B. Shaw, to whom she wrote on the subject of Ibsen's reception in England:

> How odd it is that people complain that his plays "have no end" but just leave you where you were, that he gives no *solution* to the problem he has set you! As if in life things "ended" off either comfortably or uncomfortably. We play through our little dramas, and comedies, and tragedies, and farces, and then begin it all over again.

Grateful to Marx for his encouragement, Eleanor wrote the following in a letter to a friend: "Our natures were exactly

alike! Father was talking of my elder sister and of me, and said: 'Jenny is most like me, but Tussy . . . *is* me.' "[56]

Notes

1. Gayle Rubin, "Thinking Sex: Notes for a Radical Theory of the Politics of Sexuality," in Carole S. Vance, ed., *Pleasure and Danger: Exploring Female Sexuality* (Boston: Routledge & Kegan Paul, 1984), 267–319. All further references will be cited parenthetically.

2. Gayle Rubin, "The Traffic in Women: Notes on the 'Political Economy' of Sex," in Rayna R. Reiter, ed., *Toward an Anthropology of Women* (New York: Monthly Review Press, 1975), 174, 158.

3. Eve Kosofsky Sedgwick, *Epistemology of the Closet* (Berkeley: University of California Press, 1990), 29.

4. Cf. David M. Halperin, *One Hundred Years of Homosexuality* (New York: Routledge, 1990), 25: "Now sexual identity, so conceived, is not to be confused with gender identity or gender role: indeed, one of the chief conceptual functions of sexuality is to distinguish, once and for all, sexual identity from matters of gender—to decouple, as it were, *kinds* of sexual predilection from *degrees* of masculinity and femininity." As Sedgwick observes, moreover, sexuality extends along dimensions that may have little if any bearing on the *gender* of object-choice: human/animal, adult/child, singular/plural, autoerotic/alloerotic (*Epistemology of the Closet*, 35).

5. See Lee Edelman, *Homographesis: Essays in Gay Literary and Cultural Theory* (New York: Routledge, 1994), especially chapter one, on the resultant invention of "legible" sexual codes—homophobic as well as homophile—for the management of these anxieties.

6. See Kollontai, *Selected Writings*, trans. Alix Holt (London: Allison & Busby, 1977), Marcuse, *Eros and Civilization* (Boston: Beacon, 1955), and Hocquenghem, *Homosexual Desire*, trans. Daniella Dangoor (Durham: Duke University Press, 1993).

7. See Jeffrey Weeks, *Sexuality* (London: Tavistock, 1986), 24.

8. Reimut Reiche, *Sexuality and Class Struggle*, trans. Susan Bennett (New York: Praeger, 1971), 8.

9. See, for example, Richard Lichtman, *The Production of Desire* (New York: The Free Press, 1982).

10. Joan Wallach Scott, *Gender and the Politics of History* (New York: Columbia University Press, 1988), 53–65. See also Donna Haraway's succinct overview of this history in *Simians, Cyborgs, and Women: The Reinvention of Nature* (New York: Routledge, 1991), 127–48, esp. 132: "The root difficulty [for Marx] was an inability to historicize sex itself; like nature, sex functioned analytically as a prime matter or raw material for the work of history."

11. This literature is vast even if confined to the U.S. and the U.K. See, for some classic works, Michèle Barrett, *Women's Oppression Today: Problems in Marxist Feminist Analysis* (London: Verso, 1980); Rosalind Coward, *Patriarchal Precedents: Sexuality and Social Relations* (London: Routledge & Kegan Paul, 1983); Zillah Eisenstein, ed., *Capitalist Patriarchy and the Case for Socialist Feminism* (New York: Monthly Review Press, 1979); Nancy Fraser, *Unruly Practices: Power, Discourse and Gender in Contemporary Social Theory* (Minneapolis: University of Minnesota Press, 1989); Nancy Hartsock, *Money, Sex and Power: Toward a Feminist Historical Materialism* (New York: Longman, 1983); Annette Kuhn and AnnMarie Volpe, eds., *Feminism and Materialism: Women and Modes of Production* (London: Routledge & Kegan Paul, 1978); Catherine A. MacKinnon, *Toward a Feminist Theory of the State* (Cambridge, MA: Harvard University Press, 1989); Sheila Rowbotham, *Women, Resistance and Revolution* (New York: Vintage, 1974); Lydia Sargent, ed., *Women and Revolution* (Boston: South End Press, 1981); Lise Vogel, *Marxism and the Oppression of Women: Toward a Unitary Theory* (New Brunswick: Rutgers University Press, 1983); Eli Zaretsky, *Capitalism, the Family, and Personal Life* (New York: Harper & Row, 1976).

12. Eve Kosofsky Sedgwick, *Between Men: English Literature*

and *Male Homosocial Desire* (New York: Columbia University Press, 1985), 12.

13. An especially egregious instance would be Christine Di Stefano's *Configurations of Masculinity: A Feminist Perspective on Modern Political Theory* (Ithaca: Cornell University Press, 1991). After noting that "what is missing in Marx's theory is, of course, an explicit reckoning with gender," Di Stefano proceeds to castigate Marx solely for his inability to recognize "the laboring mother" (106, 122). As Judith Butler argues, to conflate in this way the feminine with the maternal is "to reinforce precisely the binary, heterosexist framework that carves up genders into masculine and feminine and forecloses an adequate description of the kind of subversive and parodic convergences that characterize gay and lesbian cultures" (*Gender Trouble: Feminism and the Subversion of Identity* [New York: Routledge, 1990], 66).

14. John D'Emilio, "Capitalism and Gay Identity," in Ann Snitow, Christine Stansell, and Sharon Thompson, eds., *Powers of Desire: The Politics of Sexuality* (New York: Monthly Review Press, 1983), 100–13. For one recent descendent see Amy Gluckman and Betsy Reed, eds., *Homo Ecomonics: Capitalism, Community, and Lesbian and Gay Life* (New York: Routledge, 1997).

15. Weeks, *Sexuality*, 37.

16. Indeed, some Left analysts criticize gay and lesbian identities simply because they betray the aroma of the commodity (these same analysts, of course, never smell themselves). On the market as a complicated political nexus rather than an *a priori* evil, see Lauren Berlant and Elizabeth Freeman, "Queer Nationality," in Michael Warner, ed., *Fear of a Queer Planet: Queer Politics and Social Theory* (Minneapolis: University of Minnesota Press, 1993), 193–229, and Danae Clark, "Commodity Lesbianism," in Henry Abelove, Michèle Aina Barale, and David M. Halperin, eds., *The Lesbian and Gay Studies Reader* (New York: Routledge, 1993), 186–201.

17. Karl Marx, *The Eighteenth Brumaire of Louis Bonaparte* (New York: International Publishers, 1963), 8. All further references will be cited parenthetically.

18. Karl Marx and Friedrich Engels, *The Communist Manifesto*, ed. A. J. P. Taylor (New York: Penguin, 1967), 82.

19. Adam Smith, *The Wealth of Nations*, ed. Edward Cannan (Chicago: University of Chicago Press, 1976), 1:352. My thanks for this reference to Peter Stallybrass.

20. On theater as a generalized "parasite," see Jacques Derrida, *Limited Inc* (Evanston: Northwestern University Press, 1988).

21. Peter Stallybrass, "Marx and Heterogeneity: Thinking the Lumpenproletariat," *Representations* 31 (Summer 1990), 87–88.

22. *Revolution and Repetition: Marx/Hugo/Balzac* (Berkeley: University of California Press, 1977), 13.

23. Mikkel Borch-Jacobsen, *The Freudian Subject*, trans. Catherine Porter (Stanford: Stanford University Press, 1988), 44.

24. Cited in David Marshall, *The Surprising Effects of Sympathy* (Chicago: University of Chicago Press, 1988), 44.

25. "During the last thirty years of his life, [Marx] lived off Engels. At first Engels could only arrange relatively small amounts, sent sometimes in stamps or bank notes torn in half and mailed in separate envelopes for security reasons. From the late 1860s, however, Engels was able to settle a generous annual income on Marx. In terms of present-day values, Engels subsidized Marx and his family to the extent of over £100,000" (David McLellan, *Friedrich Engels* [New York: Penguin, 1977], 95).

26. Saul K. Padover, ed., *The Letters of Karl Marx* (Englewood Cliffs: Prentice-Hall, 1979), 107.

27. Michel Foucault, *The History of Sexuality, Volume I: An Introduction*, trans. Robert Hurley (New York: Vintage, 1978), 43.

28. Sedgwick, *Epistemology of the Closet*, 185. Cf. *Between Men*, 116: "[W]hat we would today call 'homosexual panic' . . . is specifically not about homosexuals or the homosexual; instead, heterosexuality is by definition its subject."

29. Sedgwick, *Epistemology of the Closet*, 184–86. See also Wayne Koestenbaum, *Double Talk: The Erotics of Male Literary Collaboration* (New York: Routledge, 1989).

30. Edelman, *Homographesis*, 7.

31. David Marshall, *The Figure of Theater: Shaftesbury, Defoe, Adam Smith, and George Eliot* (New York: Columbia University Press, 1986), 1. See Lionel Trilling, *Sincerity and Authenticity* (Cambridge, MA: Harvard University Press, 1972); Leo Bersani, *A Future for Astyanax* (New York: Little, Brown, 1976); Jonas Barish, *The Antitheatrical Prejudice* (Berkeley: University of California Press, 1981); and Nina Aurbach, *Private Theatrical: The Lives of the Victorians* (Cambridge, MA: Harvard University Press, 1990).

32. See Hubert Kennedy, *Ulrichs* (Boston: Alyson Publications, 1988), which may help to explain why, in Ulrichs's view, *any* "love that is directed toward a man is necessarily a woman's love" (50). "That sexual object-choice might be wholly independent of such 'secondary' characteristics as masculinity or femininity never seems to have entered anyone's head" until Havelock Ellis and Freud (Halperin, *One Hundred Years of Homosexuality*, 16). Freud attacks Ulrichs by name in his *Three Essays on the Theory of Sexuality*, trans. and ed. James Strachey (New York: Basic Books, 1962), 8.

33. See James Steakley, *The Homosexual Emancipation Movement in Germany* (New York: Arno Press, 1975).

34. Cited in David Footman, *Ferdinand Lasalle: Romantic Revolutionary* (New Haven: Yale University Press, 1947), 181–82. For more on Schweitzer's political career, see Roger Morgan, *The German Social Democrats and the First International, 1864–1872* (Cambridge: Cambridge University Press, 1965).

35. Frederick Engels, *The Origin of the Family, Private Property and the State*, ed. Eleanor Burke Leacock (New York: International Publishers, 1972), 128.

36. Karl Marx and Frederick Engels, *Collected Works* (New York: International Publishers, 1988), 43:295–96. All further references will be cited parenthetically by volume and page.

37. Alan Bray, "Homosexuality and the Signs of Male Friendship in Elizabethan England," in Jonathan Goldberg, ed., *Queering the Renaissance* (Durham: Duke University Press, 1994), 53.

38. Terrell Carver, *Engels* (New York: Hill & Wang, 1981), 5. Cf.

McLellan, *Friedrich Engels*, 17: "In 1838 his father sent him to continue his businessman's apprenticeship in the Hanseatic port of Bremen. Here Engels began to enjoy experiences impossible within the narrow confines of [his native] Barmen."

39. Jerrold Seigel, *Marx's Fate: The Shape of a Life* (Princeton: Princeton University Press, 1978), 150. "His own manfulness," Seigel continues, "remained somehow problematic to him."

40. On Engels as a "semi-bachelor," see McLellan, *Friedrich Engels*, 94 and Carver, *Engels*, 72. On the topos of the bachelor as "one path of response to the strangulation of homosexual panic," see Sedwgick, *Epistemology of the Closet*, 188f.

41. Louise Freyberger to August Bebel, in W. O. Henderon, *The Life of Friedrich Engels*, 2 vols. (London: Frank Cass, 1976), 2:284. Carver discounts the story of Engels's deathbed revelation, claiming that the only evidence for Marx's paternity is a letter whose internal inconsistencies—like father, like son?—"throw doubt on its being a genuine copy" (*Engels*, 73).

42. Seigel, *Marx's Fate*, 275. A tighter fit than this for Gayle Rubin's traffic-in-women template would be hard to imagine, but it's just as difficult to fathom, in light of this history, why *Marx* would attack Bonaparte in the *Brumaire* for outlawing research into paternity (124).

43. Cited in McLellan, *Friedrich Engels*, 92.

44. Cited in Kennedy, *Ulrichs*, 135.

45. That Strohn's "blood relapse" called Ulrichs to mind is another indication that Marx had been familiar with his work: "Ulrichs wondered in writing if the transfusion of the blood of an Urning into a Dioning would turn him into an Urning" (Kennedy, *Ulrichs*, 77).

46. Cited in Stallybrass, "Marx and Heterogeneity," 72.

47. Karl Marx, *The Economic and Philosophic Manuscripts of 1844*, ed. Dirk J. Struik (New York: International Publishers, 1964), 113.

48. Hannah Arendt, *The Human Condition* (Chicago: University of Chicago Press, 1958), 106.

49. Marx, *Economic and Philosophic Manuscripts*, 113, and *Capital*, ed. Frederick Engels, trans. Samuel Moore and Edward Aveling (New York: International Publishers, 1967), 1:81, 43.

50. Cited in Kennedy, *Ulrichs*, 146, 133.

51. "The reality of the value of commodities differs in this respect from Dame Quickly, that we don't know 'where to have it' " (*Capital* 1:47).

52. *Re-Thinking Intellectual History* (Ithaca: Cornell University Press, 1983), 287.

53. *Walter Benjamin, or Towards a Revolutionary Criticism* (London: Verso, 1981), 167. Cf. Eagleton's "Nationalism: Irony and Commitment," in Seamus Deane, ed., *Nationalism, Colonialism, and Literature* (Minneapolis: University of Minnesota Press, 1990), 31: "As Oscar Wilde well understood, socialism is essential for genuine individualism; and if Wilde's own outrageous individualism prefigures that in one sense, it also testifies in its very flamboyant artifice to the way in which any individualism of the present is bound to be a strained, fictive, parodic travesty of the real thing."

54. Scott, *Gender and the Politics of History*, 74.

55. Cited in Yvonne Kapp, *Eleanor Marx* (New York: Pantheon, 1972), 1:193. S. S. Prawer further recalls "that the Marx household in London was full of the sound of poetry being declaimed, or novels and plays being read aloud; and that Marx himself loved the sonorities of *Faust* so much that he tended to overdo his declamations" (*Karl Marx and World Literature* [New York: Oxford University Press, 1978], 207). Cf. also Edmund Wilson, *To the Finland Station* (1940; rpt. New York: Farrar, Straus and Giroux, 1972), 259: "Marx would recite *Faust* and *The Divine Comedy*, and he and Jenny would take turns at Shakespeare, which they had learned so to love from her father. They made it a rule on these occasions that nobody was to talk about politics or to complain about the miseries of exile."

56. Cited in Seigel, *Marx's Fate*, 282–84.

9 ▮ The Writer's Voice
Intellectual Work in the Culture of Austerity

Ellen Willis

On the crudest level, the lives of American intellectuals and artists are defined by one basic problem: how to reconcile intellectual or creative autonomy with making a living. They must either get someone to support their work—whether by selling it on the open market, or by getting the backing of some public or private institution—or find something to do that somebody is willing to pay for that will still leave them time to do their "real work." How hard it is to accomplish this at any given time, and what kinds of opportunities are available, not only affect the individual person struggling for a workable life, but the state of the culture itself. This tension between intellectual work and economic survival is thoroughly mundane and generally taken for granted by those who negotiate it every day; but to look at the history of the past thirty years or so is to be struck by the degree to which the social, cultural, and political trajectory of American life is bound up with this most ordinary of conflicts. During that time, the conditions of intellectual work have radically changed, as a culture operating on the assumption of continuing—indeed increasing—abundance has given way to a culture of austerity.

In the 1960s, prosperity and cultural radicalism were symbiotic: easy access to money and other resources fueled social and cultural experimentation, while an ethos that valued

freedom and pleasure encouraged people's sense of entitle-
ment to all sorts of goods, economic and political. For many
of us, the "excess" of the '60s meant the expansion of desire
and fantasy, but also (and not coincidentally) of money and
time. I (a child of the hard-working lower middle class)
found it relatively easy to subsist as a free-lance writer in
New York. With a $50-a-month, rent-regulated East Village
apartment, I could write one lucrative article for a main-
stream magazine and support myself for weeks or even
months while I did what I liked, whether that meant writing
for countercultural publications that couldn't pay or going to
political meetings. When I did have jobs, I didn't worry over-
much about losing them, and so felt no impulse, let alone
need, to kiss anyone's ass. There was always another job, or
another assignment. At one point, while I was living with a
group of people in Colorado, the money I made writing (spo-
radically) about rock for *The New Yorker* was supporting my
entire household.

Throughout this period, cheap housing was the cement
of cultural communities. It allowed writers and artists to
live near each other, hang out together. It invited the prolif-
eration of the underground press and alternative institu-
tions like New York's Free University, with its huge loft on
Union Square, where just about all the leftists and bohemi-
ans in town congregated at one time or another. Prosperity
also financed travel, and with it the movement of ideas; en-
couraged young people to avoid "settling down" to either ca-
reers or marriage; and even made psychotherapy, with its
ethos of autonomy and fulfillment, a middle-class rite of
passage subsidized by medical insurance. This climate of
freedom in turn fomented dissident politics—which, con-
trary to much recent and dubious rewriting of history, in-
cluded class politics. Although the distinctive quality of the
'60s social movements, from ecology to feminism, was their
focus on the kinds of concerns that surface once survival is
no longer in question, economic issues were by no means
ignored. Criticism of capitalism and economic inequality
was part of mainstream public debate. There was significant
liberal pressure to extend the welfare state, while at the
same time the new left was challenging "corporate liberal-

ism" and its social programs as fundamentally conservative, a way of managing inequality rather than redressing it.

Since the early '70s, however, the symbiosis has been working in reverse: a steady decline in Americans' standard of living has fed political and cultural conservatism, and vice versa. Just as the widespread affluence of the post–World War II era was the product of deliberate social policy—an alliance of business, labor, and government aimed at stabilizing the economy and building a solid, patriotic middle class as a bulwark against Soviet Communism and domestic radicalism—the waning of affluence has reflected the resolve of capital to break away from this constraining alliance. In 1973, as the United States was losing both the Vietnam War and our position of unquestioned economic dominance in the world, the formation of OPEC and the resulting "energy crisis" signaled the coming of a new economic order in which getting Americans to accept less would be a priority of the emerging multinational corporate and financial elite. By then the reaction against the culture and politics of the '60s was already in progress. With the end of cheap, freely flowing gasoline—the quintessential emblem of American prosperity, mobility, and power—the supposed need for austerity began to rival law and order as a central conservative theme.

For the cultural right, austerity was not just an economic but a moral imperative; not mere recognition of what was presented as ineluctable necessity but a new weapon against the "self-indulgence" and "hedonism" that had flowered as masses of Americans enjoyed a secure and prosperous existence. For the economic elite, whose objective was convincing the middle class that the money simply wasn't there, whether for high wages or for social benefits, this brand of moralism served a practical function: in diverting people's attention from the corporate agenda to their own alleged lack of social discipline and unrealistic expectations, it discouraged rebellion in favor of guilty, resigned acquiescence.

The determination of corporate capital to enforce a regime of austerity provoked a pivotal event: the New York City fiscal crisis of 1975. New York was not only the chief

national center of intellectual and cultural activity but the proud standard-bearer of a political ethos that reflected its history as a center of working-class activism. New Yorkers maintained a militant sense of entitlement to a high level of public services and social supports—including a free college education—unequaled anywhere else in the country. When the banks pulled the plug on the city's credit, this was not simply a financial decision—indeed, more than one analysis of the situation has concluded that it was unnecessary from a purely economic point of view.[1] It was a political act motivated by the will to destroy New York's pro-worker, anti-corporate political culture, with its immense symbolic importance as a flagship of resistance: if austerity could be imposed on New York, it could be imposed anywhere. In essence, the specter of bankruptcy was a pretext for breaking the power of the municipal unions and forcing the city to shrink its public sector, while successfully convincing the population that there was no point in taking to the streets. To this end, economic restrictions were coupled with a relentless moral attack on the city, particularly the supposedly greedy city workers who had gotten us into this mess. New Yorkers (so the next few years' worth of cliches would have it) had been selfish profligates living beyond their means, but now the days of wine and roses were over, and we would have to shape up, lower our expectations, tighten our belts.

The rhetoric of austerity, embraced by the Carter administration, quickly spread from New York to the rest of the country. By 1980 it appeared that Americans had had enough; rejecting the ascetic Jimmy "Moral Malaise" Carter, they opted for Ronald Reagan's vision of limitless opportunity and his-up-the-rich, damn-the-deficit, guns-and-tax-cuts policy. Yet paradoxically, it was in the so-called "decade of greed" that the culture of austerity became solidly entrenched. As public services and amenities were increasingly deemed an unconscionable extravagance, the very idea of a public life whose rules and values rightly differed from those of the private market came into disrepute. As personal morality was conflated with productivity and adherence to the work ethic, business was held to be the

model for how all organizations, regardless of their purpose, ought to operate: tightly controlled from the top, obsessed with the bottom line, and "efficient," i.e. uninhibited by sentimentality about the welfare of their workers or the surrounding community. Most ominously for the future of democracy, it came to be taken for granted that basic decisions about public spending, taxes, regulation, and economic policy generally would be made not by our elected representatives but by corporations prepared to withhold credit or move their capital and jobs elsewhere in response to any government foolish enough to defy their disapproval. Today all these propositions are virtually unquestioned axioms of economic, political, and cultural common sense.

The culture of austerity has had a profoundly depressing effect on intellectual life. Most obviously, its axioms reinforce and rationalize an actual material scarcity. It is harder and harder to find support for any sort of intellectual or creative work that can't be mass-marketed: public funds for scholarship and the arts are drying up, book publishing and journalism are dominated by conglomerates, full-time faculty jobs are giving way to academic piecework at poverty-level wages. People work longer and more exhausting hours, often at more than one job, just to get by; they have little time, energy, or money with which to launch alternative publications, schools, and other cultural experiments. In New York and other major cultural centers real estate inflation, spurred by tax giveaways to developers, disinvestment in public housing, and creeping deregulation (New York's co-op conversion movement, which went into high gear in the '80s, was essentially a scheme for property owners to "liberate" rent-stabilized apartments), has led to prohibitive rents that chase writers, artists, and students out of convenient downtown neighborhoods while ensuring that discretionary income is an oxymoron. Nor can groups afford to rent large, easily accessible spaces for cultural and educational activities. (Under present conditions, the Free University would have to be on Staten Island.)

Austerity has also reinforced the characteristic anti-intellectualism of American culture, deeply rooted in a combination of business-oriented and populist attitudes, which

takes thinking, imagining, and learning with no immediate instrumental object to be a useless luxury rather than work in any meaningful sense. After all, such activities are not quantifiable in terms of how much they add to the GDP, nor are they easily rationalized in terms of working hours. Furthermore, they are pleasurable; therefore it seems unfair that they should be economically rewarded—in fact, they are regarded not only as pleasure but as infantile narcissistic gratification, as one might infer from such locutions as "They're off contemplating their navels," or "thumbsucker" as a pejorative term for essay. Intellectual occupations excite suspicion because they are always at least potentially outside social control; at the same time, they are perceived and widely resented as a source of power and influence and as the preserve of an elite that is getting away with not putting its nose to the grindstone.

In the service of this *ressentiment*, it is the current fashion to insist that intellectual enterprises like publishing and education prove their mettle in the marketplace by embracing corporate goals, management techniques, and standards of cost effectiveness. The huge media companies that control trade publishing will not tolerate the traditionally low profits on so-called mid-list books, let alone subsidize worthy money-losers as the old independent houses did; at the same time universities are reducing or eliminating subsidies to their own presses, whose decisions about publishing books and keeping them in print are increasingly dictated by market considerations. University presidents at both public and private institutions adopt the language of CEOs charged with reducing labor costs, increasing "productivity" (i.e. faculty workloads and class sizes), cutting and consolidating programs in the name of efficiency, and becoming more "accountable" to their "customers" (variously construed as the taxpayers who fund them or the employers that hire their graduates, rarely the students themselves). Increasingly they demand that faculty become entrepreneurs, raising outside money to support their programs.

Tax law and IRS policy reflect the same mentality. Writers and artists, who may have to live for years on an advance or the income from one major commission, are no

longer permitted to average their incomes over several years for tax purposes, and the rules for deducting the cost of a home office are so strict few free-lancers working in small apartments can qualify. The policy that allowed publishers to deduct the costs of warehousing their unsold inventory was rescinded on the grounds that a book is no different from any other product, a move that in effect penalizes companies for keeping slow-moving books in print; as a result, thousands of books that might have sold a few copies a year are remaindered or shredded. Postal subsidies for books and periodicals have been abolished. Shrinking the space for independent intellectual and cultural activity is no mere unfortunate byproduct of such exercises in corporate-think but their fundamental logic and purpose.

For some time my own working life was relatively insulated from the culture of austerity. During the '70s I was a columnist or contributing editor at various magazines and in 1979 was hired as a staff writer at the *Village Voice*, which had become a highly successful commercial enterprise while remaining, in crucial respects, a countercultural institution. Rupert Murdoch had bought the *Voice* two years earlier, much to the consternation of the staff, which promptly unionized. But after a few initial skirmishes (his first act was to fire the editor; a staff walkout forced him to back down), he had made no serious moves to change the paper's content or its free-wheeling culture.

In contrast to the hierarchical system typical of magazines and newspapers, the structure of authority at the *Voice* was loose and decentralized. Editing was a collaborative process in which a writer and an editor came to an agreement on the final version of a piece; the editor-in-chief might make objections or suggestions, but only in the rarest of cases were the writer or original editor overruled. Both writers and editors were militantly protective of their autonomy and notoriously contentious. Having come of age during the economic boom and cultural revolt, we still had a '60s sense of entitlement, were neither afraid of nor reverent toward authority, and believed that we who gave the paper its character were really its rightful owners. (This

sentiment was not shared by the non-editorial employees, who were much more regimented.) Furthermore, the *Voice*'s identity as a "writer's paper" and its claim on the loyalty of its audience depended on its stable of writers, who knew they couldn't easily be replaced. As a result, management's sporadic and tentative attempts to rationalize the paper and bring the staff under more control met stiff resistance and were, in literal bottom line terms, more trouble than they were worth. The tradeoff was that we were paid much less than journalists in comparable positions at other publications (if no longer the ridiculous pittance of the underground-paper, pre-union days), and partly as a result, the *Voice* made a huge profit. For the most part, Rupert wisely raked in his money and let us be.

And so, through the first years of the Reagan era I still led a free-lancer's life, controlling my own time. My income was small but adequate given my rent, which had gone up quite a bit since the '60s, but owing to rent stabilization was still pretty cheap. The *Voice* office, where I hung out a lot, was a short walk from my apartment (in the West Village now), and most of my friends lived nearby. I belonged to a lively community of journalists and to a feminist group; in these circles the ethos of sex, dope, and rock and roll was by no means passé. Though I felt the chill of the cultural backlash and worried, rather abstractly, about my economic future, my day-to-day habits were unaffected. Then I met a man I wanted to live with and had a baby. Many changes ensued, not least my induction into the new economic order. My apartment was too small for three, and in Reagan's morning-in-America rental market, finding an affordable (i.e., rent-regulated) alternative in the neighborhood required both ace detective skills and large bribes. So we moved away from the Village and eventually bought a co-op in Brooklyn, forty-five minutes by subway from my old haunts and four times as expensive, in terms of monthly carrying costs, as my old rent. (As for its value as an investment, that collapsed with the stock market in 1987.) Since I needed more money—as well as some concrete reason to be in Manhattan regularly so as not to get totally sucked into domestic life—I asked the *Voice* for an editing job. I

would only work part-time, though, and not simply because I wanted to spend time with my daughter; for me it was a matter of principle not to sign on to a forty-hour week unless I had no choice. I hadn't had a full-time job in fifteen years. My personal solution to the tension between earning a living and preserving my autonomy was institutional marginality—while I hadn't rejected institutions altogether, as many '60s bohemians had done, I liked to keep my distance.

This was not an issue at the *Voice*, where writers and editors had all sorts of idiosyncratic arrangements. So long as you did your work, no one much cared when you did it or where. In fact we worked very hard—I certainly put in many more hours than I'd officially agreed to—but we were driven by passion and perfectionism, not subordination. Even as an editor, I preserved as much as I could of my free-lance mentality: one summer, wanting to leave town, I estimated the extra hours I'd worked so far that year and announced that to make up the time I was taking an extra month's vacation. My boss, the editor-in-chief, acceded to my plan, albeit without great enthusiasm. For me, this kind of freedom was worth any amount of the money I might have made at an uptown magazine.

When birdseed tycoon Leonard Stern bought the *Voice* in the mid-80s, it was clear that he and former editor turned publisher David Schneiderman were impatient with an editorial culture that, from the viewpoint of conventional business practice, bordered on anarchy. To be fair, their perception of an impossibly unruly staff was not wholly unjustified. Freedom of expression at the paper was often indistinguishable from egomania and bullying, as certain writers were in the habit of throwing tantrums—at editorial decisions they disagreed with, editors' suggesting that their deathless words might be a tad fewer in number, or underlings' insufficient servility. The long-running culture war at the *Voice*—the old guard of straight male lefty politicos and "hard" newswriters (dubbed "the white boys" by their antagonists) versus the "thumbsucking" critics and essay writers, many of them feminist and gay activists (though only marginally less white)—kept erupting into vicious public

fights. Trying to run a railroad in the midst of this constant fractiousness was no enviable task. And as the culture of austerity tightened its grip, the effort must have begun to seem not only anomalous but an exercise in antediluvian masochism.

Since moving to the business side of the paper, Schneiderman had hired two editors-in-chief, neither of whom had taken charge the way he'd hoped. In 1988 he settled on a third who, unlike his ill-fated predecessors, was utterly disdainful of the *Voice*'s democratic tradition. This editor—I'll call him J.—embarked on a systematic effort to centralize authority, relying on a small, loyal band of top editorial managers to carry out his decisions and limiting the control of individual writers and editors over the pieces they worked on. He was also determined to rationalize office time and space, ending the crazy quilt of individual arrangements that left computer terminals idle before eleven A.M. and most of Tuesday (the day after the paper went to press) while they became the object of fierce competition at more popular times.

The *Voice*'s content underwent parallel changes. The paper was rigidly divided into sections devoted to particular kinds of stories. As a result, there was no more room for the uncategorizable, serendipitous piece of great writing or idiosyncratic weirdness that had once been a *Voice* specialty. There was also less and less room for genuine thought. Even in its best days, the *Voice* had never truly transcended the conventional journalistic values whereby reporting was considered both more important and harder work than essay writing or criticism. *Voice* reporters were generally rewarded with higher pay and more prominence in the paper: there was the front of the book, which was supposed to be news, and the back of the book (or the bus) with the cultural sections. Still, this distinction was regularly violated, and major staff freakouts could often be traced to a story on the arts or cultural politics that had made it onto the front page, scandalizing the "white boys." (There was, for instance, C. Carr's cover piece on the then obscure Karen Finley, which included graphic descriptions of her act and inspired an outraged column by Pete Hamill, months of let-

ters-to-the-editor, graffiti wars in the restrooms, and endless jokes about yams and where you could stuff them.) Now the increasing balkanization of the paper, along with J.'s own anti-intellectual bent, shored up the conventional mindset. Once, my proposed headline for a cover story I'd edited was rejected because "it sounds as if the piece is an essay"—evidently something to be avoided at all cost. Cultural politics didn't go away, but like everything else it was institutionalized and ghettoized; on J.'s watch the paper that had been home base for the most radical and iconoclastic feminist voices instituted a version of the "Hers" column called "Female Troubles, " as well as columns for various ethnic groups. On the other hand, to my great puzzlement one indubitably good thing did happen during J.'s editorship—the flowering of a lively and diverse group of black writers. My theory was that J. was so eager to enhance his liberal credentials with black bylines that he printed interesting stuff by black writers he wouldn't have accepted from white writers.

While individuals resisted the process of corporatization, it went forward without the concerted protest it would once have provoked. Though the *Voice* was still a highly profitable business—which is to say that the new regime was motivated more by ideology than by bottom-line concerns—changes in the surrounding economic and social environment had finally eroded the paper's internal culture of opposition. The cost of living had risen while opportunities in journalism had shrunk, especially opportunities for paying jobs at publications that featured serious writing, left politics, or any sort of "alternative" outlook (the *Voice*'s last serious competitor, the weekly *Soho News*, had folded several years earlier). The ethos of austerity and the celebration of corporate values had permeated the culture for a decade or more. A younger generation of *Voice* writers and editors had grown up under these conditions. Not only were their economic prospects far dicier than ours had been, their character formation was different: however "progressive" their politics or bohemian their cultural proclivities, many of them lacked the self-confidence (or arrogance), visceral anti-authoritarian impulse, and faith in the efficacy of

collective action that were second nature to those of us imprinted with the '60s.

It did not take long for my relationship with J. to devolve into total war. I had been on a leave of absence when he arrived; when I came back I found that my "office" (which like most *Voice* offices was actually a small cubicle) had been allotted to someone else. I kept pestering the managing editor to give me my office back or assign me a new one, till she finally admitted that the boss didn't think I needed the space because "You're not here all the time." It seemed that when I *was* there I was expected simply to tote my stuff around, using whatever space was vacant, and doing without such amenities as my own telephone extension, let alone a terminal. I filed a grievance with the union, since our contract did not permit management to unilaterally change our working conditions. Having won my point and inspected my new cubicle, I assured J., "It will be fine—all it needs is a window and a carpet." His face registered a split second of panic before he realized I was joking—a moment that foreshadowed an unbridgeable sensibility gap.

After innumerable clashes with J. over his devaluation of my ideas, his interference with projects I was supervising, and even his definition of my job (while I thought I had certain agreed-on responsibilities that allowed me to concentrate on my areas of interest and expertise, he thought I should be on call for whatever editing needed doing), I knew I had to get out of there. The question was how, in the age of austerity, I could get what I needed—a job that fit my skills, was reasonably engaging, was not morally offensive, and offered a decent income plus a modicum of freedom to do the writing I wanted to do. So far as I could see, there were no suitable possibilities in journalism: I already had the best job available to someone of my inclinations, and it wasn't good enough. Book publishing looked equally unappealing (though I did consider starting a freelance editing and editorial consulting business; perhaps there was a market for the Maxwell Perkins figure publishing houses had long since dispensed with). The alternative was the university: I had no advanced degrees, but perhaps

with my credentials as a writer, an editor, and a feminist I could teach journalism or women's studies. The more I thought about it, the more I saw the academy—which I'd rejected nearly thirty years ago when I dropped out of graduate school—as my best shot. Whatever the realities at particular schools (and living with a professor, I knew a bit about those realities), at least in principle the university was an institution that supported the life of the mind, that considered one's "real work" part of one's job. In my experience, it was easier to maneuver by demanding that bosses live up to their professed principles than by insisting on principles they'd repudiated or never had in the first place.

In 1990 I left the *Voice* and joined the journalism faculty at New York University (of which more later). By my lights, the paper—which I continued to read assiduously, as if I were keeping a fever chart—became steadily duller and less influential. Its articles weren't talked about; hardly anyone I knew read it anymore. Apparently this defection was not limited to my friends; the *Voice's* circulation dropped, even as costs, especially the cost of paper, were rising. By 1994 alarms were going off: while the *Voice* was still profitable, it was increasingly marginal to the public conversation, widely regarded as the mouthpiece of a tired, outdated leftism at a time when conservatism and free-market libertarianism were hip, and for the first time in years pressed hard by competitors, the *New York Press* and *Time Out* (both offered extensive listings of cultural events; neither bore the leftist stigma). J. quit or was fired. And then David Schneiderman did something that amazed and delighted me: he hired Karen Durbin as editor-in-chief.

Durbin was a cultural radical, a visceral democrat, passionate about ideas, a champion of the individual writer's voice. She had been nurtured on the *Voice's* oppositional culture, having first become a *Voice* writer, and then an editor, in the early '70s. She was arts editor when J. was hired; when she saw that he had no intention of allowing her any power, she had left to be arts editor at *Mirabella*. She was also a longtime close friend of mine, and I felt much the way the FOBs must have done when their man ascended to the White House. I was ensconced at NYU and didn't want

a staff job, but I accepted with gusto the offer of a column on media. It seemed to be one of those rare moments of vindication: evidently, Stern and Schneiderman had realized that corporatizing was not only bad for journalism, but bad for business, and were ready to try letting the *Voice* be the *Voice*. Two years later Durbin was gone, and so was I.

Score another for the culture of austerity. J. had destroyed the old *Voice* culture and left a timid, unimaginative bureaucracy in its place. There was no way one person could substantially change this without wholehearted support from management—especially the financial kind. Revitalizing the paper would have taken a huge investment in new writers and editors and an equally substantial outlay for firing people humanely, either by giving them large severance packages or keeping them on till they found other jobs (a necessity not only for ethical reasons, but to forestall a debilitating atmosphere of panic in the office). And then, having made big changes, management would have had to launch an expensive promotional campaign to make sure the public knew about them. But Stern, in echt-90s fashion, was determined to cut costs. As a result, the *Voice* became a reverse roach motel—you could get out, but you couldn't get in. Durbin undertook a few highly publicized firings and faced down the inevitable controversy, only to be told that she couldn't fill the vacated jobs. Furthermore, unlike previous *Voice* editors, she was not simply given an editorial budget and permitted to allot it as she pleased, but had to justify major expenditures to Schneiderman. Whether this policy reflected a touch of sexism (the previous editors were male) or just the mania for control that had infected the business world, it effectively vitiated Durbin's independence. The double whammy of hand-tying and cost-cutting was crippling. The *Voice* did improve, but not enough. Circulation went up—especially after the paper instituted free distribution in Manhattan—but not enough.

After Durbin's departure, Schneiderman strongly intimated that he wanted a young editor, on the assumption that such a person would attract a young readership, and his first offer went to Michael Hirschorn of *New York* magazine. But when Hirschorn didn't bite, he hired Don Forst,

the former editor of *New York Newsday*, a 64-year-old with a classic newsman's sensibility. Clearly the *Voice* is suffering a massive identity crisis: the J.-Durbin-Hirschorn-Forst trajectory evokes the image of a drunk lurching from one direction to another with only the vaguest idea of a destination. The glib explanation is that the *Voice*'s historic identity as the cultural left's newspaper of record is no longer commercially viable in a conservative climate, but I don't think that's the real issue. In New York there is still a sizable base of readers for such a publication—a base that eroded in the first place not because the *Voice* was too left, but because it was too boring. Besides, I believe that if you publish a paper that's lively, iconoclastic, well-written, and full of stories that can't be found elsewhere, people will read it even if they hate your politics—and that includes a lot of those panted-after young people, especially the ones who are drawn to the libertarian right not because they think Hayek was a genius but because they want to be where the energy is.

Anyway, the *Voice* in its shakiest moments has never been in danger of losing money. It's just that a *Village Voice* chastened by the new economic order and out of sync with cultural-political fashion can't be expected to *roll* in money, as it did when it was riding the economic boom and the countercultural wave. It's hardly surprising that a businessman with no personal stake in the matter would be reluctant to accept less profit for the sake of preserving the paper as an oppositional force—especially in an era when accepting less profit for any reason is regarded as effete if not downright perverse. Yet it would arguably make good business sense to take advantage of the *Voice*'s distinctive character—which is, among other things, a marketing niche—to secure its core audience while appealing to others precisely because it departs from the general trend to bland, editor-driven and idea-free journalism. Instead, the apparent strategy is to move the paper toward that "mainstream" where the (relatively) mass readership and its concomitant ad rates reside. But this strategy inevitably poses the problem of why anyone should read a publication that's so much like everything else out there, it has no compelling reason to exist.

In quest of a solution to this dilemma, the *Voice* is inexorably transforming itself from an editorial vision seeking an audience to a marketing vehicle seeking a formula. Its feature articles are conspicuously shorter, simpler, and dumber, its writing less personal and more homogeneous. Increasingly, it begins to take on the denatured flavor of the glorified pennysavers that mostly pass for an "alternative press" these days. The irony, of course, is that the *Voice* was the original model for all its canned versions: imitating them, it becomes a simulacrum of itself.

Meanwhile, Leonard Stern has acquired several alternative weeklies and designed suburban versions of the *Voice* for Orange County and Long Island. In this context, management recently announced the imposition of a new contract that would force *Voice* free-lancers to give up virtually all rights to their work, which would among other things allow it to be recycled with no further payment to all the papers in Stern's chain. This is an open break with the *Voice*'s pro-writer tradition, as well as a unilateral amendment to its union contract. Yet in contrast to the spontaneous outrage that would once have greeted such a move, an organizing campaign by the National Writers Union has gone nowhere. Many of the free-lancers affected must sense that the game is up: that once the individual voice has been radically devalued, so has the source of their power. In effect, they are becoming anonymous content-providers, nearly as interchangeable as classified-ad takers; and if their jobs can't be exported to Bangladesh, there is always the army of hungry would-be free-lancers—the ones who still imagine their individual voices matter, and for whom solidarity's just another word for nothing left to lose.

As I write this, I'm on spring break from my classes at NYU, finally getting the block of time I need to finish an essay I've been working into the interstices of my schedule. My present life in the academy is, as the hounds of austerity view it, scandalously privileged. I teach three courses a year and, in lieu of a fourth course, direct a concentration in the journalism department's M.A. program. I have tenure. I have spring break, winter break, and those "three big reasons for becoming a professor"—June, July, and Au-

gust. I'm about to spend a year-long sabbatical, at three-quarters pay, working on a book. I have considerable control over my courses, my working hours, and the administration of my program. My salary and benefits are better than they were at the *Voice*, and my family and I live in affordable faculty housing (back in the Village, after all these years!) I am one of a shrinking minority of academics who enjoy such working conditions, which in my view are not pampered but merely humane.

When professors defend their perquisites they like to invoke the special nature of their work: tenure is not about job security (perish the thought) but about academic freedom; summers off and sabbaticals are not vacations but a recharging of intellectual batteries; and so on. This line of argument not only incites the hounds all the more, since they think our work is a boondoggle to begin with, but reveals the extent to which they've colonized our minds. The truth is that in a rich post-industrial economy like ours, everyone should have job, or more to the point income, security; everyone should be able to speak their mind without being fired; and everyone should have time off to recharge their intellectual batteries, their sexual batteries, or any batteries they like. The university isn't Shangri-la; it's (for some of us) a decent workplace in a time when indecent is the norm.

On balance, academia has served my purposes well—or as well as I can reasonably expect at this unpropitious moment. Yet it has also subverted those purposes by plunging me into the kind of entangling institutional alliance I always tried so hard to avoid. In the first place, the classroom consumes much more of my energy than I naively imagined it would: unlike editing, which I experienced as a relief from the psychic demands of writing—an intellectual game of sorts—teaching makes intense demands of its own. It soon became important to me to teach courses that reflected my intellectual obsessions, and to have students who shared them—so I started a new concentration, which made me an administrator, involved me in department politics, led me to sit on certain committees and plot how to raise money. The voice of austerity at NYU tends to whisper of future

problems rather than proclaim crises, but in one respect it's very loud: if faculty want their projects to prosper, they had better be entrepreneurial. In June I'll dive into my book, but for now I have a proposal I'd like you to read. . . . For me, the sabbatical that lies ahead is at once a great gift and a great paradox: for a year it will give me back what used to be my life. Imagine an antelope transported from the African veldt to a lovingly constructed, meticulously detailed simulated habitat in a state-of-the-art zoo, while the hounds growl that in an age of austerity, a cage should be enough.

Note

1. See, for example, Jack Newfield and Paul Du Brul, *The Abuse of Power: The Permanent Government and the Fall of New York*, New York, Viking Press, 1977; or Eric Lichten, *Class, Power, and Austerity: The New York City Fiscal Crisis*, South Hadley, Mass., Bergin & Garvey, 1986.

Index

and, 162–163; need for, 153, 157;
role of advocates in, 156–157, 164
post-industrial capitalism, 169
postmodern condition, 145–146, 147
post-scarcity culture, 63, 72
poverty: child rate of, 158; cycle of
dependency and, 58; discursive
marginalization of poor and, 149; as
indentured servitude, 142; number
of Americans in, 47; ordinariness of,
47, 142; scapegoating the poor,
58–59, 89
power: knowledge and, 144–145;
micropolitics of, 144
private/public distinction, 247
production: category of, 225; fertility
and, 245; as invariant category, 229;
sexuality and the deconstruction of,
245
productivism: construction of, 22; as
means to increased happiness, 63
professionals, 51

racism, 189
radical democracy, 147, 149, 151
Rawls, John, 135
Reagan, Ronald, 122
Reich, Robert, 48
Reiche, Reimut, 227
representation: crisis of, 232, 238, 246
Reuther, Walter, 14–15, 41
Rubin, Gayle, 226
runaway shops, 32, 34, 51

Sadaat, Hossein, 153
Sameboat Coalition, 146
scarcity, 61, 69, 214
Scott, Joan, 247
segregation, 196
sexuality: in Marxist theory, 226–249;
and gender, 226–227; as unknown
category, 229; unstructuring effects
of, 229, 241, 243, 244, 246

Shaiken, Harley, 185
Shakespeare, 117
shorter hours: automation as response
to, 21; demand for, 7, 37–38, 50,
59–64, 212; guaranteed annual
income and, 100; history of, 18–19,
59–61; missed opportunity for,
62–63; New Deal and, 59; relation-
ship of productivity to, 21, 62; rela-
tionship of wages to, 62; as strategic
logic of labor movement, 20–21,
33, 40
skill: degradation of, 10
Smith, Adam, 151, 232
social movements: theory of, 6, 20
Social Security, 34, 129, 150
Spiegelman, Robert, 214
Sr. Bernadette, 152–153
Stern, Leonard, 265
strikes: auto workers, 37, 61; for
shorter hours, 60; French truck
drivers, 37; sit down, 13; strike
breakers, 16; wildcat, 13
Summers, Larry, 121
sweatshops, 32
Sweden, 114
Sweeney, John, 4, 92
syndicalism, 16–19

Taft-Hartley, 5
Teamsters, UPS strike and, 1
Temporary Assistance for Needy Fami-
lies (TANF), 129–130, 158
Trilling, Lionel, 209, 238

Ulrichs, Karl Heinrich, 238
unemployment: rate of, 36, 41,
101–103, 213; skills mismatch and,
39; structural problem of, 39
Unions: business unionism, 15; col-
lective bargaining and, 6, 13; co-
operation with management, 13;
corruption of, 3; decline in member-

▌Contributor Notes

Stanley Aronowitz is Professor of Sociology at the Graduate Center, City University of New York. He is author or editor of 15 books, including, *The Death and Rebirth of American Radicalism* and *The Jobless Future: Sci-Tech and the Dogma of Work*. His forthcoming book, *From the Ashes of the Old: American Labor and America's Future*, will be published in the fall of 1998.

Lynn Chancer is Assistant Professor of Sociology at Barnard College, Columbia University. She is the author of *Sadomasochism in Everyday Life* and of a forthcoming volume, tentatively entitled *The Beauty Context: The Splitting of Sex and Sexism in Contemporary Feminism*.

Jonathan Cutler is a Doctoral Candidate in the Department of Sociology at the Graduate Center, City University of New York. His dissertation is entitled " 'A Slackers' Paradise': The Fight for 30 Hours Work at 40 Hours' Pay in the United Automobile Workers, 1941–1966."

William DiFazio is Professor and Chair in the Department of Sociology, St. John's University. He is co-author, with Stanley Aronowitz, of *The Jobless Future: Sci-Tech and the Dogma of Work*, and author of *Longshoreman: Community and Resistance on the Brooklyn Waterfront*.

Dawn Esposito is Associate Professor of Sociology and Associate Academic Dean of St. Vincent's College, St. John's University. She has published work in the areas of feminist studies and film criticism.

Joan Greenbaum is Professor of Computer Science at LaGuardia Community College, City University of New York. She is author of *In the Name of Efficiency: Management Theory and Shopfloor Practice in Data-processing Work*, *Design at Work: Cooperative Design of Computer Systems*, and *Windows on the Workplace: Computers, Jobs, and the Organization of Office Work in the Late Twentieth Century*.

Michael A. Lewis is Assistant Professor of Social Welfare at the SUNY School of Social Welfare at Stony Brook. He has a Masters Degree in Social Work from the Columbia University School of Social Work and a Ph.D. in Sociology from the CUNY Graduate and University Center. Lewis is currently working on a book on the application of economics to the analysis of social welfare policy issues which are of interest to professional social workers.

Andrew Parker, Professor of English at Amherst College, is coeditor of *Nationalisms and Sexualities* and *Performativity and Performance*. An expanded version of the essay included in the present volume will appear in his forthcoming book, *Re-Marx*.

Lois Weiner was a high school teacher of English for fifteen years and an active participant in school reform for teacher union politics. She now teaches education at the College of Staten Island, City University of New York. She writes about school politics and teacher education and is the author of *Preparing Teachers for Urban Schools: Lessons from Thirty Years of School Reform*.

Ellen Willis directs the Cultural Reporting and Criticism concentration in the Department of Journalism at New York University and is a former senior editor and columnist at the *Village Voice*. Her articles on politics and culture have appeared in numerous publications, including the *New Yorker*, the *Nation*, *Rolling Stone*, *Dissent*, *Transition*, and *Salmagundi*, and have been collected in two books, *Beginning To See the Light: Sex, Hope, and Rock & Roll* and *No More Nice Girls: Countercultural Essays*.

Margaret Yard is Professor of both Sociology and Nursing, and teaching at three of New York city's major medical centers. Dr. Yard, the first Associate Director of The Center for Cultural Studies at The Graduate Center of The City University of New York and editor of *Workforce 2000* published by the U.S. Department of Labor, has published several articles on medicine and health, authored *Psychiatric Instructor*, and is currently adapting her doctoral thesis "Social Silencing" for publication.